Vermeer
& the Art of Painting

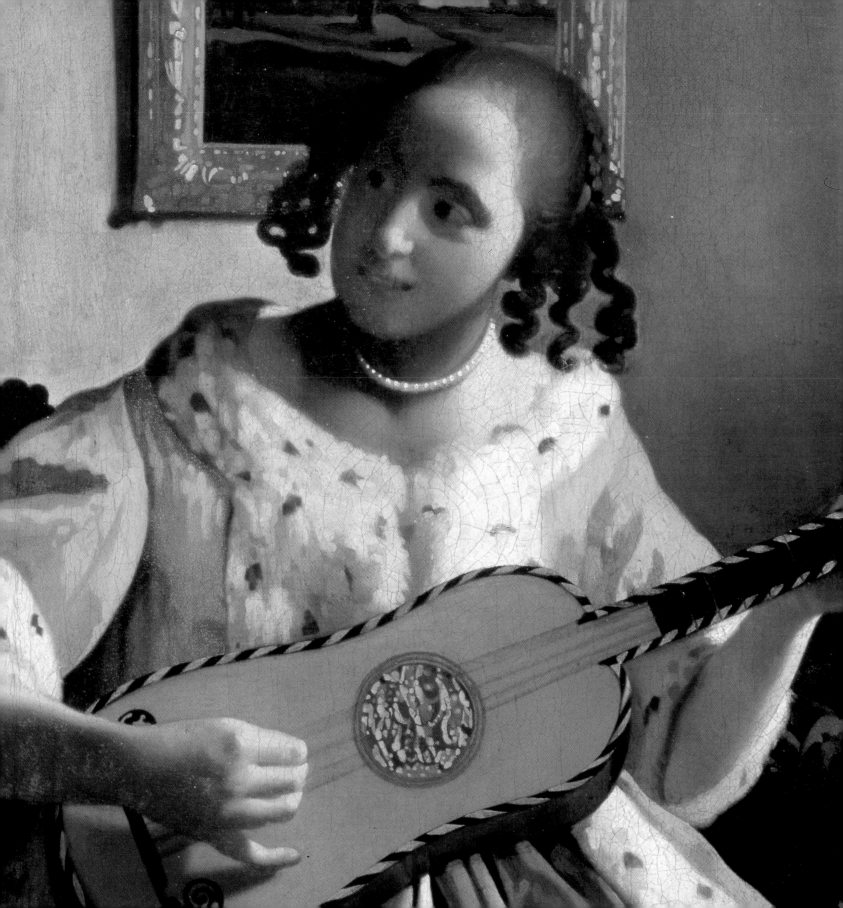

Vermeer
& the Art of Painting

ARTHUR K. WHEELOCK, JR.

Yale University Press

New Haven and London

FRONTISPIECE: DETAIL FROM *THE GUITAR PLAYER*,
KENWOOD, ENGLISH HERITAGE AS TRUSTEES OF THE IVEAGH BEQUEST.

PUBLISHED WITH ASSISTANCE FROM THE LOUIS STERN MEMORIAL FUND.

DESIGNED BY LISA C. TREMAINE.
SET IN ADOBE GARAMOND TYPE BY HIGHWOOD TYPOGRAPHIC SERVICES, HAMDEN, CONNECTICUT.

PRINTED IN SINGAPORE BY C.S. GRAPHICS.

LIBRARY OF CONGRESS CATALOGING-IN-PUBLICATION DATA
WHEELOCK, ARTHUR K.
VERMEER AND THE ART OF PAINTING / ARTHUR K. WHEELOCK, JR.
P. CM.
INCLUDES BIBLIOGRAPHICAL REFERENCES AND INDEX.
ISBN 0–300–06239–7 (ALK. PAPER)
I. VERMEER, JOHANNES. 1632–1675—CRITICISM AND INTERPRETATION.
2. VERMEER, JOHANNES, 1632–1675—THEMES, MOTIVES. I. TITLE.
ND635.V5W48 1995
759.9492—DC20 94-40119
CIP

A CATALOGUE RECORD FOR THIS BOOK IS AVAILABLE FROM THE BRITISH LIBRARY.

THE PAPER IN THIS BOOK MEETS THE GUIDELINES FOR PERMANENCE AND DURABILITY OF THE COMMITTEE
ON PRODUCTION GUIDELINES FOR BOOK LONGEVITY OF THE COUNCIL ON LIBRARY RESOURCES.

IO 9 8 7 6 5 4 3 2 I

CONTENTS

ACKNOWLEDGMENTS

~

The idea of writing this book about Vermeer's technique of painting dates back to the late 1970s and has been a driving force in my research during the intervening years. It has been an extraordinarily exciting project, since it has meant that I have had the great privilege to examine closely all of Vermeer's paintings, and virtually every one of them in laboratory conditions. This study has only been possible through the generous cooperation of colleagues who have kindly consented to arrange for my careful study of the paintings in their care. I also am enormously grateful for the enlightening discussions I have had with conservators and scientists about Vermeer's techniques, frequently when I was examining paintings in their laboratories. Although I do not discuss all of Vermeer's paintings in this book, I would like to try to acknowledge those individuals who assisted me over the years in the learning process.

The origins of this study can be traced to my experiences at the National Gallery of Art when I arrived there as a Finley Fellow in the fall of 1973. The Kress professor that year was A. B. de Vries, former director of the Mauritshuis and a great connoisseur of Vermeer. Together, and with the assistance of the gallery's conservator of paintings, Kay Silberfeld, we began a study of the gallery's Vermeer paintings. We arranged to take the paintings to the laboratory where we could study them under the microscope. During that year we expanded our framework for the analysis of Vermeer's style by visiting the Frick Collection, where Bernice Davidson kindly arranged for us to examine *Officer and Laughing Girl, Girl Interrupted at Her Music,* and *Mistress and Maid* off the wall, and the Metropolitan Museum of Art, where similar arrangements were made by the Met's conservator, Hubert von Sonnenburgh.

In 1979–80 I extended this study by examining Vermeer paintings in Europe with the aid of a year-long grant from the National Endowment for the Arts. During the 1980s and early 1990s I was able to complete the examination of Vermeer paintings in Europe and find time for writing because of generous grants from the Center for Advanced Study in the Visual Arts at the National Gallery of Art. These included the Ailsa Mellon Bruce Curatorial Fellowship, which I received in 1983 and 1987, and the Robert H. Smith Curatorial Research Leave stipend, which I received in 1990 and 1993.

Colleagues in the Netherlands have over the years been extremely helpful and generous

with their time and energy. In Amsterdam I would like to thank Wouter Kloek and the former conservator at the Rijksmuseum, L. Kuiper, for their enthusiastic cooperation. At the Mauritshuis I am much indebted to the former director, Hans Hoetink, and to the present director, Frederick J. Duparc, who has generously supported this study from its inception. I am enormously grateful that I was able to study Vermeer's paintings at both institutions under such optimum circumstances. I have also benefitted enormously from discussions with Luuk Struick van der Loeff and Jørgen Wadum, conservators at the Mauritshuis.

I was extremely fortunate that J. R. J. van Asperen de Boer was interested enough in this project that he accompanied me to the Rijksmuseum and the Mauritshuis so that we could examine the paintings with infrared reflectography. He provided the equipment and expertise that produced the first reflectograms ever made of Vermeer's paintings, some of which are reproduced here. I am also grateful to Ernst van de Wetering, who kindly sent me some excellent detail slides of the Vermeer paintings in the Rijksmuseum after they were restored in the mid-1980s.

Colleagues in Great Britain have been extremely helpful. At the National Gallery in London, Christopher Brown has made arrangements for me to examine *A Lady Standing at a Virginal* and *A Lady Seated at a Virginal,* which I have also discussed extensively with the gallery's conservators, Martin Wyld and David Bomford. In London I was also able to examine *The Music Lesson* when it was lent to the National Gallery. Since then I have had a number of conversations about the techniques Vermeer used in that painting with the Queen's restorer, Viola Pemberton-Pigott. I have been able to examine *The Guitar Player* at the Iveagh Bequest at Kenwood at two separate occasions due to the kindness of John Jacob, Anne French, and Julius Bryant. At the National Gallery of Ireland I was able to study *Lady Writing a Letter with Her Maid* from the Beit Collection and profited greatly from discussions with its conservator, Andrew O'Connor. In Edinburgh, Hugh Macandrew, together with the conservator at the National Gallery of Scotland, John Dick, arranged for me to study *Christ in the House of Mary and Martha.*

The reception I received in Germany, France, and Austria was most cordial. In Berlin the director of the Gemäldegalerie, Henning Bock, and the curator of the Dutch paintings, Jan Kelch, arranged for me to examine *The Glass of Wine* and *Woman with a Pearl Necklace* in the laboratory, where I also profited from discussions with conservators Gerhard Pieh and Beatrix Graf. In Brunswick I was made welcome by former director Rüdiger Klessman and former restorer Knut Nicklaus, who also made reflectograms of *The Girl with the Wine Glass.* At the Städelsches Kunstinstitut in Frankfurt, former director Klaus Gallwitz

arranged for me to examine *The Geographer* in the laboratory, where it was also possible to examine the painting with infrared reflectography. In Dresden I have had close contact with former director Annaliese Mayer-Meintschel, who has also been extremely interested in Vermeer's working process. In France I am particularly grateful to Pierre Rosenberg, who not only arranged for me to be able to examine *The Lacemaker* in the Louvre, but who also helped arrange a visit to the Rothschild home where I was able to study closely *The Astronomer*. Finally, at the Kunsthistorisches Museum in Vienna, Klaus Demus kindly arranged for me to examine *The Art of Painting* in ideal circumstances.

In recent years I have continued my research on the Vermeer paintings at the National Gallery, where I have worked closely with members of the conservation and scientific departments. Primary among these are Melanie Gifford and David Bull, whose knowledge of Vermeer's painting techniques has been enormously helpful. I am also indebted to Molly Faries, who, as a visiting scholar, first examined these paintings with infrared reflectography.

To further my understanding of Vermeer's techniques, I revisited the Metropolitan Museum of Art, where Everett Fahy and Walter Liedtke kindly arranged for me to reexamine the five Vermeer's paintings in that collection. Maryan Ainsworth, who had already studied *The Woman Asleep* with neutron-autoradiography, generously provided me with infrared reflectograms. I was also able to restudy the Vermeer paintings at the Frick Collection through the assistance of Edgar Munhall and Bernice Davidson. I was fortunate to be able view *The Concert* at the Isabella Stewart Gardner Museum when it was being restored by Gabriela Koppleman. I would like to thank her and the painting conservator at the Gardner, Jack Soultanian, for sharing their observations about Vermeer's painting techniques.

It was also during the mid-1980s that I was contacted by the New York dealer Spencer Samuels, who brought to my attention *Saint Praxedis*, a painting I did not know. Samuels then agreed to send the painting to the National Gallery, where I was able to examine it in the conservation laboratory.

Many friends and colleagues, in addition to those mentioned above, have also helped guide my understanding of this fascinating artist. I would like to thank H. Perry Chapman, whose good judgment about Dutch art, and Vermeer in particular, I greatly respect. I also appreciate the insights of Jane Sweeney, who read the manuscript at a critical point. Over the years I have also benefitted greatly from the observations of my students at the University of Maryland, whose collective critical eye and acute judgments have helped refine my thoughts. Among these students, I would like to thank Aneta Georgievska-Shine for her careful reading of the manuscript and her many editorial suggestions, and, in partic-

ular, Quint Gregory, both for his scholarly input and for assisting me in bringing the man-uscript into final form. At the National Gallery of Art I am also greatly indebted to the library staff, in particular Neal Turtell, as well as Valerie Guffey, Megan Teare, and Kathryn Haw for their administrative assistance.

I have been very fortunate to be able to work together with Yale University Press, not only Judy Metro, who helped usher the manuscript through the approval process, but also Noreen O'Connor-Abel, whose careful editorial comments have greatly enhanced the text. I am also grateful to the Art History Department of the University of Maryland for provid-ing me with a subvention to help defray expenses associated with the production of this book. Finally, I would like to thank my parents and my family for all their support over the years, and, in particular, my wife, Perry, for the ways she helps me see.

Vermeer

& the Art of Painting

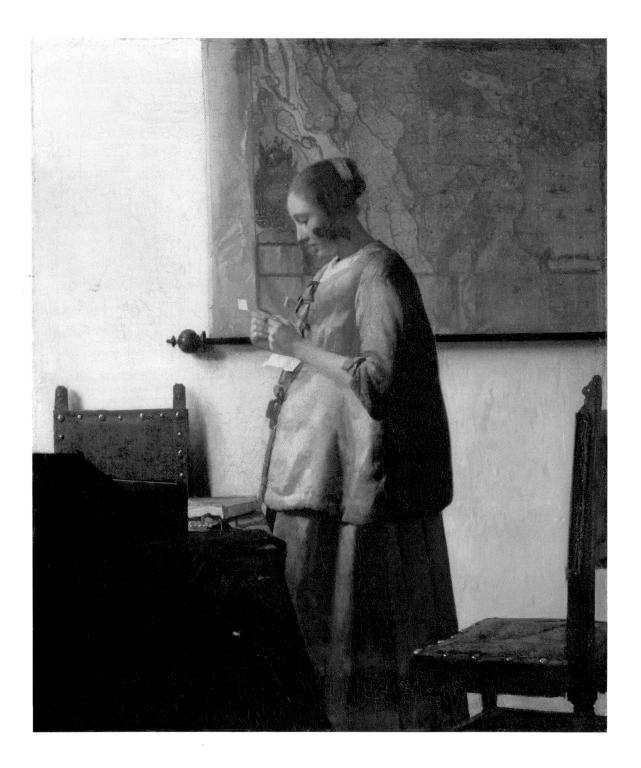

AN APPROACH TO VIEWING VERMEER

A "Vermeer," like a "Rembrandt" or a "Van Gogh," is something more than a painting. Although we might make a special effort to see a Vermeer, whether it be a painting of a young girl in a turban, a woman with a water pitcher, or a music lesson, a Vermeer brings associations with it that transcend any one of these specific images. Hidden somewhere within an appreciation of it are memories of other impressions he has left for us: the quiescence of a woman reading a letter, the soft light effects that play across a woman adjusting her pearl necklace, or the delicate nuances of blues and yellows that transmit the serenity of a woman writing a letter.

Although the individual paintings are well known, their cumulative impact is all the greater because the stylistic and thematic relationships among them reinforce and enhance each work. Vermeer's images, whether of a single figure lost in thought or of a quiet street scene, are intimate ones that remind us of moments or events in our lives so fleeting that we hardly are aware of their existence. Vermeer's genius was to capture their beauty in ways that we can relate to our own experiences.

Despite the intimate poetry of Vermeer's paintings, he does not seem to insert himself into his paintings. Unlike when we view a Rembrandt or a Van Gogh, we are unaware of any personal struggles that may have affected his life or art. Part of the reason is certainly that Vermeer's life story is not well known, and the biographical questions that ring out when we look at a Rembrandt or a Van Gogh do not even occur to us before a Vermeer. We accept the strong, sturdy milkmaid as a figure who embodies the wholesomeness of Dutch life without asking who she is. Likewise, it does not seem crucial to know if the beautifully serene woman holding a balance is Catharina, Vermeer's wife. As with all abstract concepts, the actual character of Vermeer's oeuvre is more complex than the image of a Vermeer easily allows. Paintings at the beginning and end of his career do not fit comfortably into this vision of the artist, and a few well-known masterpieces like *View of Delft* and *The Art of Painting* likewise have to be considered apart. In some of these exceptional paintings, moreover, Vermeer reveals aspects of his personality and character that are otherwise muted.

Attempting to discover the essence of a Vermeer painting is akin to describing a sunset or reflections off a sparkling body of water; the description works only when it also takes into account the viewer's emotional relationship to the scene. Although such discussions are

by necessity subjective, they are nevertheless important in any analysis of Vermeer's works precisely because his paintings elicit such a response from the viewer. The underlying focus of this book is to try to give some framework for these subjective feelings by delving into the process by which Vermeer arrived at and created his images.

This book is not a traditional monograph on the artist. Instead of briefly discussing all of his known works, as is usual in Vermeer monographs, the approach here has been to analyze closely seventeen of his paintings, almost half of his known oeuvre.[1] By examining in depth these carefully selected paintings, which represent the full chronological range of the artist's work and a relatively wide thematic range as well, a broad sense of Vermeer's attitude toward his work can be gained. Even though each of Vermeer's paintings has its own special character and contributes to a broad understanding of his artistic concerns, the approach taken here is transferable to works not analyzed in this study. The choice of which paintings to discuss was a difficult one, but, in general, I decided to write about works where laboratory examinations have yielded new information about Vermeer's creative process. I am confident that a different choice of paintings would not have affected the basic conclusions about Vermeer's stylistic evolution, nor about his various painting techniques and their relationship to his subject matter.

THE HISTORICAL SITUATION

The Delft in which Vermeer lived was a venerable city with a long and distinguished past, dating to 1246 when it received its charter. Vermeer's *View of Delft* from the early 1660s (see fig. 51) depicts what was at that time the primary entrance to the city by virtue of the harbor that had been built in 1614. Because Delft was a walled city, it was chosen by William the Silent, Prince of Orange, as his residence during the Dutch revolt against Spanish control. This great leader lived there from 1575 until his assassination in 1584.

After the departure of the court and the seat of government to The Hague, Delft remained an important if not leading city within the province of Holland. Although allied with the policies of the States General, Orangist sympathies continued strong during the first half of the seventeenth century because of the city's historical link with William the Silent, a link that was visually reinforced by the presence of his tomb in the Nieuwe Kerk (the New Church). By the mid-seventeenth century, the city was attractive and prosperous. Although its Delftware factories, tapestry weaving ateliers, and breweries were thriving, the city attracted travelers more for its charm, monuments, and historical associations than for its mercantile importance. One Englishman wrote that "Delft has as many bridges as there

are days in the year and a like number of canals and streets with boats passing up and down."[2] Another traveler admired the great marketplace in the center of the town flanked by the imposing town hall and the soaring steeple of the Nieuwe Kerk, the sunlit tower seen in Vermeer's *View of Delft*.[3]

The proximity of the court in The Hague meant that a number of Delft artists enjoyed the patronage of its members. While this connection gave a certain stability to the artistic environment in Delft, it also seems to have created a conservative atmosphere, where established forms of expression, in portraiture in particular, were preferred to the new stylistic innovations found in works by artists in Haarlem, Amsterdam, and Leiden. Only with the unexpected death of Prince William II (6 November 1650) and the subsequent decision of the seven provinces to assume all the sovereign powers of the State did artists in Delft seem liberated from the pictorial traditions to which they had been so wedded. The most dramatic transformation in style occurred in architectural painting, where Gerard Houckgeest (c. 1600–1661), Emanuel de Witte (c. 1617–1692), and Hendrick van Vliet (1611/12–1675) captured in their works the sense of the dramatic interior spaces of the two Delft churches, the Nieuwe Kerk and the Oude Kerk (the Old Church), by focusing on views of significant tombs and monuments, particularly that of William the Silent in the choir of the Nieuwe Kerk. For the first time since it had been erected in 1622, the tomb was portrayed in its actual setting, not a fanciful one. With naturalistic light illuminating the choir, Houckgeest depicted the tomb surrounded by those who had come to view it, not only to pay homage to the Princes of Orange and to reflect on the role the House of Orange had played in their national heritage, but also to contemplate, in a far more general way, the inevitability of death. Ironically, it was only after the death of William II and the establishment of the Stadholderless Republic that Delft artists began to acknowledge, and even celebrate, the important historical presence of the House of Orange in their city. Their paintings, and these thematic concerns, must have made a deep impression on the young Johannes Vermeer, who by the early 1650s would have already made his decision to become an artist.

The history of Vermeer's life and that of his extended family is important to this story and provides a framework for the subsequent discussions. Much information has come from the careful archival studies of John Michael Montias, who has unearthed a wealth of material about the relationships within Vermeer's extended family.[4] Certain facts are well established—for example, the date of his christening in the Nieuwe Kerk in Delft on 31 October 1632, and the date of his burial in the Oude Kerk on 16 December 1675. It is also known that Vermeer registered as a master painter in the Saint Luke's Guild in Delft on 29

December 1653 and that he was elected headman of the guild in 1662–63 and again in 1671–72.[5] Vermeer's interest in becoming a painter may have stemmed from his father, Reynier Jansz., who had registered as an art dealer in the Saint Luke's Guild the year before his son's birth.[6] It also appears that Vermeer took over his father's interest in selling paintings, for he seems to have made much of his income from that activity, if one is to judge from his widow's lament that he sold little during the latter years of his life when the Netherlands was at war with France.[7]

Many important facets of Vermeer's life, however, remain an enigma. Nothing is known about the artist's training. Because he is not mentioned in archival documents in Delft before 1653, it is possible that he trained in some other artistic center, perhaps Amsterdam or Utrecht. He may also have traveled to Flanders, France, or Italy, as did so many aspiring artists during that period. The nature of his artistic training is a fascinating question because the thematic and stylistic character of his early history paintings is so different from his later works.

About Vermeer's contacts with other artists we also know very little. A series of documents from April 1653 indicates that he knew well Leonaert Bramer (1596–1674), the most important Delft artist of the day: Bramer served as a witness for Vermeer just prior to his marriage to Catharina Bolnes.[8] Vermeer also knew Gerard ter Borch (1617–1681) from Deventer, with whom he cosigned a document two days after his marriage.[9] No documents, however, provide evidence of further contact between Vermeer and Bramer or Ter Borch after 1653. No document specifically indicates any contact between Vermeer and Carel Fabritius (1622–1654), an artist who had trained under Rembrandt and who some believe may have been Vermeer's teacher after he arrived in Delft around 1650.[10] Nothing is known of Vermeer's relationships with Jan Steen (c. 1625–1679) and Pieter de Hooch (1629–after 1684), painters active in Delft in the 1650s who would seem to have shared his artistic interests. Likewise, no documentary evidence exists that indicates that Vermeer ever met with genre painters from other artistic centers, for example, Nicolaes Maes (1632–1693) from Dordrecht, Frans van Mieris the Elder (1635–1681) from Leiden, and Gabriel Metsu (1629–1675), who was active in Leiden and Amsterdam.

Vermeer's marriage to Catharina Bolnes appears to have had a number of important consequences for his artistic career. Catharina, who was living with her mother, Maria Thins, in Delft at the time of their engagement, was Catholic. Almost certainly in deference to his future mother-in-law, who had close associations with the Jesuits in Delft, Vermeer converted to Catholicism before the marriage was finalized in December 1653, a

decision that may have affected the religious content of paintings he executed at various stages of his career. Also of great consequence to the young artist was the modest collection of paintings—most, it seems, from the Utrecht school—that Maria Thins had inherited from her family. These were listed in the inventory of jointly held property after her rancorous marriage to Reynier Bolnes ended with a legal separation in 1641.[11] Of the works cited in the inventory, at least two later appear in the backgrounds of Vermeer's own paintings: Dirck van Baburen's *Procuress,* which appears in *The Concert* (see fig. 80) and *A Lady Seated at a Virginal* in the National Gallery, London (see fig. A35); and a *Roman Charity,* which hangs on the rear wall of *The Music Lesson* (see fig. 60).[12] These, as well as her distant familial relationship to the Utrecht painter Abraham Bloemaert (1654–1651), may have helped motivate Vermeer to become a history painter.[13] Specifically, Baburen's *Procuress* in Maria Thins' collection must have inspired Vermeer's imposing painting of the same subject, which he executed in 1656 (see fig. A4).

For whom Vermeer painted is another question that cannot be answered with any certainty. No commissions are known for any of his paintings. Logically, the large scale of his early history paintings and a few other works like *View of Delft* (see fig. 51), *The Art of Painting* (see fig. 90), and *Allegory of Faith* (see fig. A34) would seem to dictate that they were commissioned pieces. Nevertheless, documents after Vermeer's death poignantly detail the struggle of the destitute Catharina Bolnes and Maria Thins to insure that *The Art of Painting* was not taken from them and auctioned off to pay debts.[14]

Because no fewer than 20 of his paintings were listed in an inventory in Delft of 1682, including *View of Delft,* it has been recently proposed that these works had been painted for a specific patron, the father of the deceased, Pieter Claesz. van Ruijven (1624–1674).[15] The evidence, however, is not conclusive, for it is possible that many of these paintings remained in Vermeer's possession and were sold only after his death.

Only a few owners of Vermeer's paintings can be identified from his own lifetime. The most interesting of these was Hendrick van Buyten, a baker who was visited in 1663 by the French traveller and diarist Balthasar de Monconys because he wanted to view the painting by Vermeer in his possession.[16] After Vermeer's death, Van Buyten acquired two more paintings from the artist's widow. One contained "two persons, one of whom is sitting writing a letter" (probably *Lady Writing a Letter with Her Maid;* see fig. 107). The other painting depicted a person playing a "cytar" (probably *The Guitar Player;* see fig. 102). Van Buyten may also have acquired paintings from the sale of Vermeer's possessions since the inventory taken after Van Buyten's death in 1701 contained, in addition to the three paint-

ings by Vermeer, a depiction of Moses (almost certainly the one Vermeer depicted on the rear wall of *Lady Writing a Letter with Her Maid*), and three paintings by Van Asch, perhaps one of them the landscape hanging on the wall in *The Guitar Player*.[17]

The biographical information, interesting though it may be, does little to explain how Vermeer became the artist he was. Citing pictorial sources and stylistic influences only points out how different his paintings are from those of his contemporaries. Although such information enhances our understanding of Vermeer's achievement by providing a framework for discussion, it remains the paintings themselves that offer the means for judging the character of his artistic genius.

Vermeer was an extraordinary craftsman who carefully conceived and structured his compositions to achieve the purity of expression he sought to convey. He appears to have had great sensitivity to optical effects found in the world about him, for he translated these effects into his paintings through his use of light and color. He mastered a wide range of painting techniques to allow his vision to take form, and used the finest of pigments to help achieve his effects. The mechanics of his painting techniques can, in fact, be assessed and analyzed. Examining his paintings in this manner can determine the types of changes in style and subject matter that occurred over the course of his career, as well as those more constant threads of his artistic approach.

Vermeer's craftsmanship was not an end in itself, however, but rather a means toward creating a work of art that conveyed a mood, introduced abstract ideas, or otherwise reflected upon some aspect of the human experience. Many of the scenes he chose to depict are those encountered in daily life, passing moments seemingly of little consequence. In his hands they take on almost metaphysical significance. Other paintings have explicit allegorical connotations, where ideas about human endeavor are introduced through complex emblematic and symbolic elements. Finally, his representations of biblical and mythological subjects are forceful far less for their narrative than for the mood that they project. The study of the structure and execution of his paintings must likewise not remain an end unto itself, but rather be understood as a means for exploring the emotional and intellectual framework within which each of his works was created.

As an introduction to this way of looking at Vermeer's works I have chosen *Woman in Blue Reading a Letter* from the Rijksmuseum, Amsterdam. Painted in the mid-1660s, *Woman in Blue Reading a Letter* epitomizes those qualities of serenity and balance that are so admired in Vermeer's mature paintings. After the analysis of this work, the subsequent discussions of Vermeer's paintings are organized in a roughly chronological fashion, begin-

ning with *Saint Praxedis*, 1655 (see fig. 8), which is his earliest dated painting, and concluding with *Lady Writing a Letter with Her Maid*, which can be dated to the early 1670s (see fig. 107). A precise chronology for Vermeer's paintings is, unfortunately, virtually impossible to establish because only three of the thirty-six paintings generally attributed to the artist are dated. Illustrations of the other two dated works, *The Procuress* (1656) (see fig. A4), and *The Astronomer* (1668) (see fig. A27), are included a catalogue of the artist's paintings in the appendix at the end of the book.

WOMAN IN BLUE READING A LETTER

In *Woman in Blue Reading a Letter* (fig. 1), which is among Vermeer's most beautiful works from the mid-1660s, the viewer encounters an image so radiantly pure and simple in its elements, and so familiar in its subject, that one immediately empathizes with the woman and accepts her world as completely as one's own. Yet, the viewer is at the same time aware that this woman and her world are not exactly like reality. The viewer approaches the work with a certain reverence, in part because it was painted by Vermeer, but also in part because the image demands that response. It is a quiet image without sound and without movement. The viewer is drawn to the painting by the warmth of the light and the serenity of the scene, but is kept at a distance as well. The woman is so absorbed in her letter that she has no awareness of anyone having intruded upon her privacy. Seen in pure profile against a flat wall that is decorated only with a map of the Netherlands, neither she nor her environment welcomes the viewer into her physical or psychological space. Her pyramidal form, which is centrally placed in the composition, is partially concealed by the dark table on the left and by a chair, turned slightly away from the viewer, on the right. The physical barriers thus effectively isolate her even though she seems quite close to the viewer. A subtle tension exists in the viewer's relationship to the scene, a tension that pulls one back and forth as one subconsciously tries to reconcile these conflicting signals.

By creating this psychological tension Vermeer emotionally involves the viewer in the painting and prepares him or her for the focus of the work, the emotional response of the woman to the letter she reads. He suggests her intense concentration subtly, without dramatic gesture or expression. The depth of her response, however, is clear in the way she draws her arms up tightly against her body, clasps the letter, and reads it with slightly parted lips. Vermeer was interested in revealing neither the contents of the letter nor its origin, merely in that quiet moment when communication between the writer and the woman is at its fullest.

Vermeer captured the privacy of that moment by creating an environment that echoes and reinforces it. A subtle light playing across the woman and the objects surrounding her helps locate her in the corner of a room. By falling most sharply in the upper left, the light implies the presence of a wall and window just outside the picture plane. The rectangular shapes of the table, chairs, and map surrounding the woman, their colors of blue and ocher, and their inner design patterns both complement the static nature of the woman's pose and act as a foil for her intense concentration on the letter. The blue-black rod stabilizing the bottom of the map passes directly behind the woman's hands and provides a visual accent that draws the viewer's attention to the letter she is holding. The map, its muted ocher tonalities echoing the flesh tones of the woman's face and browns of her hair, forms a field against which her emotions are allowed to expand. Although Vermeer separated the head from the map by juxtaposing the woman's highlighted forehead with the dark tones of the cartouche, the patterns of rivers and inlets seem to flow from her own form.

Finally, the clearly articulated areas of the white wall defined by the objects in the painting bind together visually the various compositional elements. Vermeer has established three basic blocks of wall, balanced though not symmetrical: the upper left, the area adjacent to the woman's stomach, and the area between the woman and the chair. These distinct shapes take an active role in the composition. Their bold and simple shapes read as positive elements, help provide a framework for the figure, and enhance the quality of stillness and tranquility that pervades the scene.

Vermeer's *Woman in Blue Reading a Letter* seems so harmonious in color, theme, and mood that it is hard to imagine any other compositional solution. Indeed, as in other of his paintings, one has difficulty imagining Vermeer at work, as an artist who had to somehow compose and make tangible a concept he had conceived in his mind. Part of the problem in visualizing Vermeer's working procedure stems from a lack of available information. No drawings, prints, or unfinished paintings—indeed, no records of commissions—offer clues as to his intent or aspects of his working process. No contemporary accounts comment on his work or his ideas. Our entire appreciation of Vermeer's achievement is focused on his 36 extant paintings.

In recent years, however, it has been possible to look far more closely at the artist behind these paintings than ever before. Although little has been discovered about Vermeer's attitudes toward painting, new information about his artistic procedure has been gathered through a variety of technical examinations of the works themselves. Some of Vermeer's paintings have been restored, so that discolored varnish and old repaints have

2. X-radiograph of
Woman in Blue Reading a Letter

been removed. Pigment analyses have been made.[18] Many of his works have now been examined with a microscope to determine more about the types and the layering of the paints Vermeer used. Further technical examinations have been undertaken with the use of ultraviolet light, infrared light, and x-radiography. Infrared reflectography has been utilized in a number of instances, and, at the Metropolitan Museum of Art in New York and at the Staatliche Museen in Berlin, Vermeer's paintings have been studied with neutron autoradiography.[19] Although the availability of technical information varies greatly from painting to painting, which rules out any truly systematic assessment of Vermeer's working process, the multiple types of examinations that have been undertaken thus far provide a wealth of new information about Vermeer's working methods, much of which is used for the first time in this study.[20]

As in *Woman in Blue Reading a Letter*, Vermeer conceived and executed his paintings with exceptional care. His final compositional solutions often came only after he had modified his initial design. Understanding the nature of Vermeer's changes and the ways in which he adjusted the proportion and placement of his compositional elements to achieve specific results helps determine those qualities he wished to emphasize in his work.

In *Woman in Blue Reading a Letter*, for example, Vermeer made two compositional modifications that are visible in x-radiographs of the painting (fig. 2). X-radiographs record

3. Infrared reflectogram of woman
in *Woman in Blue Reading a Letter*

the various densities of materials and help determine the patterns of the use of lead-bearing paint, particularly lead white and lead-tin yellow. One alteration occurs along the left edge of the map on the back wall, where the lead white of the wall color extends about 3–4 centimeters under the left edge of the map as it now exists. Whether Vermeer altered the position of the map or decided to enlarge it cannot be determined, but it may be the latter case. The map, which is based on an actual prototype, is accurately rendered. Nevertheless, the map is proportionally larger in the painting than it is in actuality.[21] It is also larger than it appears in his earlier painting *Officer and Laughing Girl* (see fig. 36).

Another compositional change evident in the x-radiograph is that the woman's jacket once flared out in the back, and perhaps also slightly in the front. The shape of the earlier design is visible in the x-radiograph because Vermeer started painting the white wall with lead white around an earlier form of the jacket. An infrared reflectogram shows many of these changes (fig. 3), but gives additional information. Because the reflectogram works on the principle of heat absorption and picks up patterns of black or gray applied over a light ground, the underlying jacket seen in the reflectogram must have been blocked in in grays

over the light ocher ground. In the reflectogram one can see that this original jacket had a fur trim along its bottom edge. As fur-trimmed jackets found in other of Vermeer's paintings are either deep blue or yellow, one might well imagine that Vermeer originally had a different color harmony in mind when he conceived this work.

Paintings can also be examined technically to determine whether or not an artist has changed a color. With microscopic examinations one can occasionally see the various layers of paint used by the artist. X-ray fluorescence and neutron autoradiography can provide information about the various chemical elements present in specific areas of paintings. Because chemicals are almost always pigment specific, their identification can often provide information about the artist's buildup of his images. This type of analysis can be confirmed and often made more specific by taking paint samples and cross sections in areas where confusion exists. Since these two latter examination methods require removing small particles of paint, they are undertaken only in extreme circumstances where art historical questions seem particularly important. Usually such samples are taken at the edges of existing losses or along the edges of paintings where their impact is minimal.[22]

In *Woman in Blue Reading a Letter* microscopic examinations give additional information about the changes found in the x-radiographs and reflectograms. The white that underlies the left edge of the map consists of a white layer on top of a layer in which white is mixed with blue. Because both of these layers lie under the map, it would seem that Vermeer had completed his wall color before changing the contour edge of the map. Microscopic examination also provides more information about the jacket. For the blue of the jacket, Vermeer applied a thin layer of natural ultramarine, an expensive and particularly radiant blue that he frequently used in his paintings. No additional colors underlie the woman's jacket, which means that the shape visible in the x-radiograph and reflectogram must represent a preliminary compositional stage before Vermeer began introducing local color.

Such technical examinations can also reveal the ways in which Vermeer accommodated light effects within his paintings. In *Woman in Blue Reading a Letter*, the light, which comes in from the upper left, passes gently over the image, catching highlights and casting shadows in a variety of ways. The brass nails in the back of the blue chair on the left, for example, have specular highlights facing the upper left. The effect seems quite simple, but an infrared reflectogram demonstrates how carefully Vermeer worked to create it. Vermeer initially painted each nail at its full size with a light color, which from microscopic examination appears to be lead-tin yellow. He then reduced the intensity of the color of the nails by adding shadows with a dark thin glaze that is heavier on the right side of each nail than on

the left. Finally, he added a small dot of lead-tin yellow paint over the glaze to create the accent. Vermeer used similar specular highlights to enliven the painting in a number of places, including the woman's hairband and the map.

Vermeer's depiction of shadows as light plays across the surfaces of objects in *Woman in Blue Reading a Letter* is remarkable. His sensitivity to light effects is evident on the wall to the right of the back chair: the darkness of the chair's shadow varies from a soft blue tint near the finial to a deep blue-black at its lower extreme (fig. 4). The shadow is made even more complex by the presence of a secondary shadow from another light source, presumably the window closest to the back wall. This secondary shadow, which again has a light blue tinge, falls across the primary shadow and softens its rather sharp outer edge. An examination of this area with microscopy and x-radiography indicates how Vermeer established the transparent character of the shadows. The deepest shadow is created by painting the blue-black layer over the ocher ground. The wall color, which appears to be a mixture of lead white, light ocher, and light blue, stops at the shadow's edge. The light blue tones of the secondary shadow and the top of the primary shadow appear lighter because in these instances Vermeer painted a thin blue glaze over the wall color. The artist indicated shadows under the rod at the bottom of the map in a similar way.

Vermeer's use of glazes to suggest shadows approximates the transparent qualities of the natural phenomenon. He employed these same techniques in a variety of ways throughout the painting. In the woman's jacket, for example, he created a mid-tone of blue by applying thin glazes of natural ultramarine over the ocher ground. In the deep shadows along the back of the jacket, Vermeer painted a thin black layer over the ground, which was either mixed with or served as the base for small traces of blue pigment (fig. 5). Yet very little blue paint can be found in either the highlights or deep shadows, for Vermeer established the jacket's overall color with a minimum of blue and relied on the eye to combine the various tonalities into a whole.

4. *Woman in Blue Reading a Letter,* detail of chair and shadow

5. *Woman in Blue Reading a Letter,* detail of back of jacket

Vermeer's sensitivity to the optical effects of light and color and his ability to transmit them in paint is one of the primary reasons why his images have the visual impact they do. Light effects in his paintings, however, are not always consistent. As with his choices of colors and modifications in the scale of objects, he also used light and shade selectively for compositional reasons. As previously indicated, the chair near the wall casts a shadow, or, more accurately, two shadows. A pronounced shadow also falls just below the map. The woman, however, who also stands near the wall, casts no shadow at all. Vermeer emphasized her separateness by giving the wall immediately behind her a brighter tonality, as though her form radiated rather than obstructed light. He even accentuated this effect by softening the juncture of her form and the wall, diffusing the contour of her jacket with a light blue (see fig. 5).

Although the woman exists within a recognizable interior space where shadows of the objects in the room will change as the sun moves in its orbit, by not casting a shadow she exists in a different spatial and temporal framework. The viewer can more or less determine where the woman is standing, but cannot measure her precise location. Similarly, the absence of a shadow provides this moment of great privacy and intense concentration with a permanence that strengthens the psychological impact of the woman as she gazes at her letter. The viewer is drawn to her image and held by it in ways that are not totally explicable, but that clearly have much to do with the way Vermeer has handled light, color, and composition.

Vermeer achieved a sense of permanence in *Woman in Blue Reading a Letter* through many means. The moment he chose to depict was carefully considered, as was the way in which he related the woman to her surroundings through his compositional arrangement. Vermeer, however, also manipulated reality to achieve his effects. He modified the shape and character of the woman's jacket, adjusted the scale and color of the map, and only selectively represented the flow of light as it passes through the scene. In a painting where the figure, her attitude, her accoutrements, and the light that encompasses her seem so real, these adjustments come as a surprise, for they call into question the notion that Vermeer accurately described the physical reality of the world about him.[23] Vermeer, however, consistently altered the character of objects and light effects for his own artistic purposes. Indeed, it would be far more of a surprise if he did not adapt reality in these ways, for the Dutch concept of realism in the seventeenth century is far more complex than is generally recognized today.

Before discussing Vermeer's approach to painting, however, it is important to examine briefly the theoretical framework of realism in the seventeenth century.[24] The closest that one can come to an understanding of the attitudes toward realism in art theory in Vermeer's time is Samuel van Hoogstraten's *Inleyding tot de Hooge Schoole der Schilderkonst: Anders de Zichtbaere Werelt,* published in Rotterdam in 1678. Hoogstraten (1627–1678), who, along with Carel Fabritius (1622–1654) had been a pupil of Rembrandt in the mid-1640s, may have known Vermeer because he lived in Dordrecht, not far from Delft. Hoogstraten was a multifaceted artist who painted biblical subjects in the style of Rembrandt, genre scenes, portraits, and trompe l'oeil still lifes. As a consequence, his theoretical treatise, which is an amalgamation of many ideas drawn from the classics, Italian art theory, and his own experience, provides a relatively reliable glimpse into the intellectual concerns that must have been shared by many of Hoogstraten's contemporaries.

Hoogstraten provided the following ideal for an artist and an assessment of the requirements necessary to achieve that ideal: "I say that a painter, whose work it is to fool the sense of sight, also must have so much understanding of the nature of things that he thoroughly understands the means by which the eye is deceived."[25] According to Hoogstraten, then, the artist's work is to fool the eye, to make the viewer believe that the image seen is an entirely different reality. The success of such an undertaking is not determined by a quick wit and fluid brush, but by a thorough understanding of the laws of nature and "the means by which the eye is deceived." For Hoogstraten the means explicitly included the workings of vision and the theories of perspective, but also implicitly an understanding of the psychological expectations of a viewer encountering an illusionistic image.

It is clear from the fascination with trompe l'oeil in Dutch art that Hoogstraten's contemporaries shared his enthusiasm for paintings that deceived the eye. In 1641, for example, Jan Orlers described his wonder in viewing Gerard Dou's careful technique for depicting figures, animals, insects, and other objects from life.[26] In the following year Philips Angel also cited the awe inspired by Dou's remarkable technique for recording the smallest details in a lifelike manner, for, according to Angel, the most admirable of painting is that which comes closest to nature.[27] Angel stressed that it was important to delight the viewer's eye with illusionistically conceived representations of materials and textures of natural objects.[28] Careful observation of nature, such as that which allowed Jan Brueghel the Elder (1568–1625) or Jan Davidsz. de Heem (1606–1683/84) to produce convincing images of flowers, was essential for any artist who sought to create an illusionistic painting. By studying the shapes and colors of petals, the rhythms of leaves and stems, and the delicate

translucency of their forms, the artist could translate their qualities into paint and elicit the admiration of his patrons. Cornelis de Bie, writing in 1662, admired the still-life painter Daniel Seghers (1590–1661) because he created flowers so real that live bees would want to settle on them. De Bie continued: "Life seems to dwell in his art."[29] The ideal that artists should explore ways to make objects so real that they could be confused with nature itself was perhaps best expressed by Hoogstraten: "A perfect painting," he wrote, "is like a mirror of Nature, in which things that are not there appear to be there, and which deceives in an acceptable, amusing, and praiseworthy fashion."[30]

Hoogstraten's recommendation that an artist should deceive the eye is advice he followed in a number of his own paintings, among them a life-size view through a doorway into an interior space (fig. 6) that was displayed in such a way as to fool the spectator into believing that the "doorway" led to another part of the house. The response to such works must have been similar to the excitement that greeted the small triangular perspective box containing a view of the "great Church of Harlem" that John Evelyn describes in the entry in his diary from 5 February 1656: "so rarely don, that all the artists and painters in towne flock'ed to see and admire it."[31] The admiration for the illusionistic qualities in the perspective box noted by Evelyn is also felt in the delightful story recounted by Roger de Piles about an illusionistic image of a servant girl that Rembrandt placed in his window.[32] "Everybody who saw it was deceived, until the painting had been exhibited for several days, and the attitude of the servant being always the same, each one finally came to realize that he had been deceived."[33] The illusion worked because of the scale, colors, and textures of Rembrandt's image, but also because the expectation of those passing by Rembrandt's window was that a real person would be leaning out—not an imitation of one. The success of a trompe l'oeil painting was due not only to the careful application of the laws of perspective and detailed technique but also to the ability to engage the viewer in the work of art itself.

In their broadest respect, then, such illusionistic ideals are compatible to Vermeer's approach in *Woman in Blue Reading a Letter*. Vermeer not only created a believable space with recognizable textural and lighting effects, he also engaged the viewer in the scene with his empathetic portrayal of the woman. One could hardly imagine, however, that Vermeer's scene would be mistaken for reality in the way that was so frequently commented upon in the work of other artists, even those whose paintings were not conceived as trompe l'oeil works of art. Although Vermeer studied nature and tried to emulate its textures and light effects in his paintings, he did so with an eye and an intent unlike that of a still-life painter. The primary difference is that an illusionistic painter tries to deny

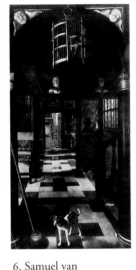

6. Samuel van Hoogstraten, *View Down a Corridor*, 1662, oil on canvas. Dyrham Park, The Blathwayt Collection (The National Trust)

the two-dimensional surface of the painting by making the viewer accept the reality of the objects in the scene. Vermeer, on the contrary, purposely establishes a distance between the viewer and the image. The painting always maintains its independent reality, even though the elements seem real and the psychological characterization is powerful. In this respect, Vermeer's artistic interests and approach in paintings like *Woman in Blue Reading a Letter* are fundamentally different from the illusionism advocated so enthusiastically by Hoogstraten and others.

Illusionism, however, is only one of the artistic ideals espoused by Hoogstraten. Although Hoogstraten delighted in visual deceptions, he also stressed that "the highest and most distinguished level in the Art of Painting, which is above all others, is the representation of the most memorable histories."[34] For Hoogstraten, as for the important early seventeenth-century Dutch painter and art theorist Karel van Mander (1548–1606), depictions of biblical, mythological, or allegorical subjects demonstrated both the artist's imaginative genius and his ability to portray human figures interacting at moments of great historical and moral consequence.[35]

How Dutch artists dealt with these contradictory recommendations—trompe l'oeil realism and idealized, imaginatively conceived history paintings—is a complex problem, but one that is fundamental to coming to terms with Vermeer's artistic career. Hoogstraten's artistic solution was to execute his history paintings and trompe l'oeil images in totally different styles, the one with generalized forms and chiaroscuro effects derived from Rembrandt's style of painting, the other with specific details and natural light. The types of images he created in these two styles are so different that it is hard to believe that they were painted by the same master. Vermeer, who began his career as a painter of large-scale history paintings, accommodated his new subject matter with a change of style, but, perhaps uniquely among Dutch artists, he sought to incorporate the fundamental moral seriousness of history painting into his genre scenes.

This seriousness comes from the fact that, despite the attention paid to naturalistic effects in his genre scenes and landscapes, Vermeer chose the reality he wanted to depict with the same concerns as those evident in history painting. Much as history paintings evoked images and moods that enlarged one's perception and understanding of self, Vermeer infused his scenes of daily life, such as *Woman in Blue Reading a Letter,* with comparable fundamental human concern. Whether he sought to convey the timeless bond between two individuals, the bounty of God's creations, the need for moderation and restraint, the vanity of worldly possessions, the transience of life, or the lasting power of

artistic creation, his works invariably transmit important reminders of the nature of existence and provide moral guidance for human endeavors.

Vermeer never wrote about art, as far as is known, so no certain understanding of his attitudes about pictorial representation is possible. It is evident from his work, however, that somewhere in the course of his training he learned the fundamental principles of artistic practice. To judge from paintings like *Woman in Blue Reading a Letter,* he was remarkably adept at layering his paints to create textural and optical effects that would both simulate reality and enhance the mood he wanted to achieve. He also had a sophisticated awareness of the importance of perspective not only for creating the illusion of a three-dimensional space on a flat surface but also for affecting the psychological impact of the scene. From other paintings in his oeuvre it appears that in his search for new ways to enlarge his artistic vision, he also examined the expressive possibilities of an instrument known as a camera obscura.

The camera obscura works on the optical principle that focused rays of light, whether direct or reflected, will project an image of the source from which they derive. Many camera obscuras were literally darkened rooms into which only a point of light was admitted. The image would then be focused, perhaps with the aid of a convex lens, on a wall or screen placed opposite the light source. By the mid-seventeenth century, portable camera obscuras that could be carried about the countryside were equipped with lenses and focusing tubes to allow sharp images of objects from various distances (fig. 7).[36] Nevertheless, in unfocused areas, specifically where bright lights were reflected off hard or metallic surfaces, diffused highlights were created, similar to the halation of highlights found in unfocused photographic images.

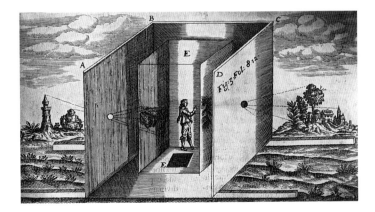

7. Camera obscura, engraving from Athanasius Kircher, *Ars Magna lucis et umbrae.* Library, National Gallery of Art, Washington, D.C.

Vermeer's interest in the camera obscura and its relationship to the more general use of this optical instrument in the seventeenth century is a complex one, as is its role in Vermeer's working process.[37] The camera obscura was fascinating to Dutch seventeenth-century artists because it opened to them a new range of expressive possibilities. It focused one's vision by framing it, and it introduced optical effects, like halation of highlights, not ordinarily visible. Another important consequence for artists was that, in a properly functioning camera obscura, colors appear more intense than in normal vision because the scale of objects is reduced but their color is not. Indeed, the image of a camera obscura was often found to be superior to the painted image. As Constantijn Huygens (1596–1687) wrote in 1622: "It is impossible to express the beauty [of the image] in words. The art of painting is dead by comparison, for this is life itself, or something more elevated, if we could find a word for it."[38]

In a period that witnessed the discovery of the telescope and microscope, optical instruments that were used to great advantage by Vermeer's Delft compatriot, Anthony van Leeuwenhoek (1632–1723), the camera obscura was also widely admired.[39] It was, as Huygens noted, "now-a-days familiar to everyone."[40] One of the primary fascinations of the camera obscura was that it projected an animate image. J. Leurechon, the author of an early seventeenth-century treatise entitled *Recreation Mathematicque,* remarked that: "Above all there is the pleasure of seeing the movement of birds, men, or other animals and the quivering of plants waving in the wind; for although all that is reversed, nevertheless, this beautiful painting, beyond being foreshortened in perspective, represents ingeniously well that which no painter has ever been able to represent in his painting, to realize movement continued from place to place."[41]

Despite the recurrent pessimism that painting could never equal the effect of the camera obscura, the ideal of an animated image of nature is remarkably akin to the interests of Dutch artists. A sense of animation and movement enlivens landscapes, genre studies, portraiture, and even still lifes. At a time when artists consciously sought naturalistic images of the world, it is understandable that they were attracted to the camera obscura and other optical devices as inspiration for their work. Hoogstraten, for example, in his 1678 treatise on painting indicates that he erected camera obscuras on at least two occasions: "I am certain that vision from these reflections in the dark can give no small light to the sight of the young artists; because besides gaining knowledge of nature, so one sees here what main or general (characteristics) should belong to truly natural painting."[42] Although the authors of most sixteenth- and seventeenth-century treatises recommended tracing the camera obscura

image, Hoogstraten, a practicing artist, did not describe such a use. Indeed, it seems unlikely that the tracing of an image would have been the primary interest for professional artists. Far more important would have been the lessons to be gained about creating the semblance of reality, in particular through the relationships of tone, light, and color.

Although seventeenth-century sources indicate a widespread fascination with the camera obscura for both its philosophical implications about the nature of vision and its practical applications as an artistic aid, they do not document Vermeer's specific interest in or use of this device. Because the camera obscura leaves no physical trace on the painting, the only means for determining whether or not Vermeer was interested in the device is to determine whether his paintings contain comparable optical characteristics. Vermeer left explicit traces of the use of the camera obscura in certain paintings: *The Milkmaid* (see fig. 42), *View of Delft* (see fig. 51), *Girl with the Red Hat* (see fig. 83), *The Lacemaker* (see fig. A29), and *The Art of Painting* (see fig. 89b), all of which date from the middle years of his career. He probably used it as a compositional aid for other paintings as well, among them *The Music Lesson* (see fig. 60) and *The Concert* (see fig. 80). Without a clear understanding of the extent to which he used the camera obscura, however, it is difficult to determine the influence it had on his style and technique. Did this optical device reinforce tendencies that already existed in his art, or did it encourage him in new directions? Did it allow him to discover new optical phenomena to enhance the illusion of reality he sought and did it suggest ways to convey those effects in his painted images? Finally, did he respond to the camera obscura in different ways at different points in his career?

Any assessment of Vermeer's oeuvre has to be given cautiously because so many unknowns and intangibles exist concerning his training, contacts with other artists, relationships with patrons, thematic concerns, and painterly techniques. He is in some ways the most accessible and direct of Dutch artists, and in others the most elusive. Although it seems that he worked in relative isolation in Delft, from the very beginning of his career he was aware of artistic developments from a variety of artistic centers. A major focus of this book, thus, is to assess the ways in which Vermeer adapted stylistic, thematic, and even compositional ideas of others, but also to determine how these relate to an overall artistic approach. As has been demonstrated in the discussion of the *Woman in Blue Reading a Letter*, technical examinations have provided new insights about this process of assimilation, which have in turn revealed much about Vermeer's underlying pictorial concerns. The framework for these concerns, which lie at the foundation of Vermeer's later achievements in genre, landscape, and allegory, are found in his early biblical and mythological scenes. It is to these works that we now turn.

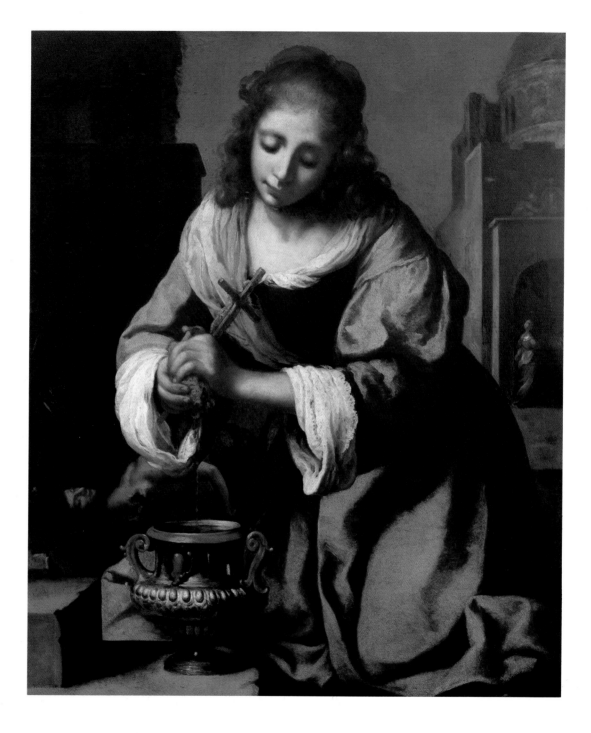

Saint Praxedis

8. *Saint Praxedis,* 1655, oil on canvas. The Barbara Piasecka Johnson Collection Foundation

The history paintings with which Vermeer began his artistic career continue to astound those who have come to know and admire the artist through paintings like *Woman in Blue Reading a Letter.* These works, *Christ in the House of Mary and Martha* (see fig. A1), *Diana and Her Companions* (see fig. 13), and *Saint Praxedis* (fig. 8), all of which were probably painted in 1654 and 1655, seem so different in concept and execution from Vermeer's mature style that it seems difficult to reconcile the idea that the same artist made these images. Scholars have doubted the attribution of each of these paintings. In any event, it seems safe to say that the idea of a Vermeer that many of us carry around in our subconscious does not generally encompass these works. Notwithstanding the difficulty with which we accept these works into our perception of Vermeer's oeuvre, individually and as a group these paintings are fascinating for what they reveal about Vermeer's artistic aspirations at the outset of his career. They also have far more profound connections to his scenes of daily life than might be evident at first sight.

As important as it may be to assess the personal history of Vermeer's family and the artistic and cultural context of Delft during his formative years, the fact remains that many details about his early career are totally unknown. One can postulate about his teachers and his training, his travels and his exposure to works of art, his friendships with painters or contacts with patrons, yet too many lacunae exist to be able to understand fully his artistic aspirations when he entered Saint Luke's Guild in December 1653. The situation is even more difficult to assess due to the few works that are extant from the first years of his career. No student paintings are known, nor are there any informal studies, quick oil sketches, or drawings.

Vermeer's three early religious and mythological paintings are the primary evidence for assuming that his initial goal was to be a history painter. Although this conclusion seems valid enough, it must remain slightly tentative. These paintings are all quite large, yet perhaps other, smaller works existed concurrently with these large images that were precursors of those genre paintings and landscapes for which he later was so acclaimed. These three

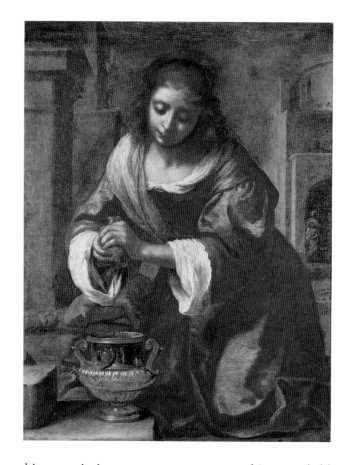

9. Felice Ficherelli, *Saint Praxedis,*
c. 1640–45, oil on canvas.
Private collection, Ferrara

history paintings are, moreover, executed in remarkably varied styles, for which no satisfactory explanation has been advanced.

The distinctive style of one of these works, *Saint Praxedis,* however, can be traced to a specific source, and thus provides an excellent point of departure for a study of Vermeer's early technique of painting. The source of his image is a painting by a mid-seventeenth-century Florentine artist, Felice Ficherelli (1605–1669?) (fig. 9).[1] Vermeer studied Ficherelli's image very closely, making from it an almost exact replica. In his image, as in Ficherelli's, Praxedis kneels directly before the viewer. With downcast eyes, she squeezes blood from a sponge into a decorated silver ewer. The blood she has collected is from a decapitated martyr who lies on the ground behind her. The figure of a second female, perhaps her sister, Pudentiane, is seen in the right background walking near the entrance of a large classical building.

Not only did Vermeer transcribe the mood and arrangement of Ficherelli's figures, he also adapted the Italian artist's vivid color scheme. The large figure of the saint, clothed in a striking raspberry-colored dress, is silhouetted against a deep blue cloudless sky. Despite these similarities, slight differences between these paintings do exist. The most obvious departure from the model is that in Vermeer's version the saint clasps a crucifix in addition to the sponge, thus symbolically mingling the blood of the martyr with the blood of the crucified Christ. Vermeer has also applied the paint more densely, intensified the colors, altered the character of her face, and simplified the folds in the drapery somewhat more than did Ficherelli. The result is that the figure has a physical presence lacking in Ficherelli's sweeter and softer image.

It is not known how Ficherelli's *Saint Praxedis,* which was executed c. 1640–45, could have been seen by Vermeer.[2] Although no record of this painting in the north exists, Italian paintings and copies did exist in Dutch collections.[3] Montias' careful examination of Delft archival records from this period, for example, turned up five paintings attributed to Italian masters, but, Montias speculates, at least three of these works, and perhaps all five, were copies.[4]

Whether Ficherelli's painting came to Delft or was found in another Dutch artistic center is another matter. Although Vermeer's father actively sold paintings, and although his mother-in-law inherited a substantial number of works of art, far fewer Italian and Flemish paintings seem to have been collected in Delft around midcentury than in, for example, Utrecht or Amsterdam. The Amsterdam art dealer Johannes de Renialme, for example, who listed a Vermeer painting in his 1657 inventory, also owned ten Italian pictures. Since Renialme was registered as an art dealer in the Delft guild and was closely acquainted with Willem de Langue, the Vermeer family notary, the probability is great that Vermeer knew these, and similar paintings.[5] In any event, Vermeer was certainly familiar with Italian art, for otherwise he would not have been summoned to The Hague in 1672 to appraise a group of Italian paintings.[6]

Because Vermeer would have had access to a number of Italian paintings, one must ask why he decided to copy this composition by Ficherelli. To begin with, the predominance of copies after Italian paintings in Delft collections indicates that a market for such works existed at that time. The possibility is thus strong that Vermeer was commissioned to paint this copy. Praxedis was one of a number of Roman saints who enjoyed a certain popularity among Jesuits in the seventeenth century as they sought to emphasize the early traditions of the Catholic Church, and it may well have been on behalf of the Jesuits, or a wealthy

Catholic patron, that Ficherelli's painting would have made its way to the Netherlands.[7]

Praxedis, who had lived in Rome in the second century, was the daughter of Pudens, a disciple of Paul. She and her sister, Pudentiane, helped convert people to Christianity and had them baptized in the church founded by their father. Praxedis was honored in particular for the merciful care she took of the earthly remains of murdered Christians. She collected the blood of martyrs and washed their bodies before attending to their proper burial. She then distributed the deceased martyrs' possessions to the poor. Although she and her sister died of natural causes, they were nevertheless included in the canon of Christian martyrs because of their close associations with those who died violent deaths on account of their beliefs.

Although the cult of Saints Praxedis and Pudentiane is associated with Rome, where each had been honored by the construction of a basilica, the cult was revived and expanded at the end of the sixteenth century. The ideal of dedication to one's faith, exemplified by the legends attached to the saints' lives, paralleled closely the concept of sanctity propagated at that time by the Jesuits. Praxedis was also celebrated by the Jesuits because she, as well as other early saints, reinforced the primacy of the Catholic faith. This broader interest in Praxedis on the part of the Jesuits may well underlie Ficherelli's depiction of the saint. One could thus imagine that Ficherelli's striking image of this infrequently represented saint may have struck a chord with a member of Maria Thins's circle of Jesuit friends, who then commissioned a copy by her new son-in-law.

It is not necessary to postulate a patron, however, as the subject may have had a special appeal for Vermeer at this period of his life. He may have painted *Saint Praxedis* for his own pleasure, as a means to study the technique of a contemporary Italian master. Such a close copy of an earlier prototype is unusual for Vermeer, even though he did adapt the style, technique, and even subject matter of other artists' works in his early paintings. It seems most probable, however, that this young artist, only recently converted to Catholicism and married into a family with strong Jesuit inclinations, would have been drawn to the painting more for its subject matter than for its technique. Vermeer must have become involved with Jesuit theological concerns in the mid-1650s at the time of his conversion to Catholicism. One wonders if Vermeer's decision to add the crucifix to Ficherelli's composition came as result of his commitment to his new faith.

Because *Saint Praxedis* appears, at first glance, so different from other Vermeer paintings, its attribution has not been universally accepted.[8] Nevertheless, while no other painting by Vermeer is so directly based on an earlier prototype, *Saint Praxedis* can be firmly

ascribed to the young artist for three primary reasons: the signatures, the painting techniques, and its stylistic and thematic relationships to other early Vermeer paintings.

The painting is signed in two places. One signature, on the edge of a rock in the lower left, reads: Meer 1655. The signature and date are somewhat reinforced but are part of the paint structure. The second signature, in the lower right, reads: Meer N R..o.o. Although difficult to decipher because it is painted in light ocher on an ocher earth tone, the signature is integral to the paint structure and has not been reinforced. The signature may originally have read: Meer N(aar) Riposo ("Meer after Riposo"), the name often given to Ficherelli.[9] Vermeer's reasons for signing the painting twice, however, are not known.

Given that the signatures are integral with the paint surface, what can one say about the age of the painting? All evidence from the structure of the paint layers to the analysis of the individual pigments confirms that the materials and the ways they were used are consistent with seventeenth-century practices. The reds in the dress and on the lips and blood are red lakes painted over a dense layer of lead-white paint. The pigments in the yellow paint on the rim of the urn are lead white and yellow ocher. The ground consists primarily of lead white, iron oxides, and calcium. Hermann Kühn, the author of the only systematic study of Vermeer's use of pigments and grounds, reported that the distribution of the elements in the lead as well as the presence of chalk in the ground were characteristic of Dutch rather than Italian painting techniques.[10] Although Kühn, quite rightly, did not feel that the identification of the individual paints could confirm an attribution to Vermeer since the artist used essentially the same paints as his Dutch contemporaries, the ground layer and the pigments found in *Saint Praxedis* are consistent with those in Vermeer's paintings. One example of an unusual layering of paints is particularly noteworthy: the application of natural ultramarine over a dark layer applied over the ground layer in the sky. Whereas most Dutch artists painted their skies over a light imprimatura layer, this technique for painting the sky is also found in Vermeer's *Diana and Her Companions* (see fig. 13) from about the same date, c. 1655.

Although Vermeer consciously emulated Ficherelli's brushwork and palette in painting *Saint Praxedis,* the visual effect he created is quite different, which became strikingly apparent when the two paintings were exhibited side by side in an exhibition held in Cracow in 1991. Vermeer's image of Praxedis has a physical presence quite different from the somewhat sweeter, more delicately conceived Italian prototype. The most notable difference between the two is in the rendering of the face (fig. 10). Vermeer subtly altered Ficherelli's image by elongating the head and by painting broader planes of light and dark across the forehead

and along the right side of Praxedis' head. He softened the edges of these planes and painted her features with numerous small brushstrokes. The result is that the image evokes a quiet and pensive mood appropriate to her actions.

Although Vermeer patterned the folds in Praxedis' robes on those in Ficherelli's painting, his manner of creating highlights in *Saint Praxedis* has more similarities to that used in his other paintings than it does to Ficherelli's method. He simplified and minimized the number of highlights to give the material more substance (fig. 11). He also used a different technique for creating his highlights. In the lighter areas of the dress he painted a thin layer of madder lake over a lead-white base to suggest the softly luminous material. He used a similar technique in Mary's blouse in *Christ in the House of Mary and Martha* (see fig. A1) and in the red blouse of the nymph seated next to Diana. Indeed, the handling of the folds on the right arms of these three females is quite similar. In particular, the flickering character of Praxedis' left sleeve resembles in technique and style the sleeve of the nymph kneeling before Diana (see fig. 17).

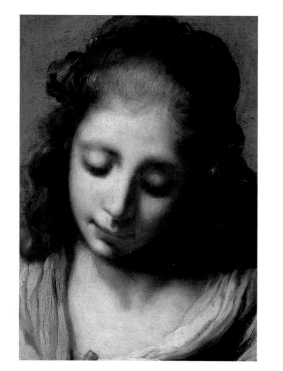

10. *Saint Praxedis,*
detail of face

11. *Saint Praxedis,*
detail of drapery

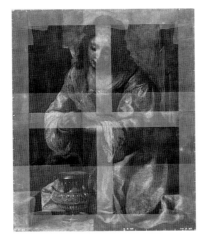

12. X-radiograph
of *Saint Praxedis*

Finally, x-radiographs demonstrate that the buildup of paint in *Saint Praxedis* is comparable to that in other Vermeer paintings (fig. 12). A close comparison can be made between the modeling of the head of Praxedis and that of the woman in *A Woman Asleep,* c. 1657 (see fig. 20). X-radiographs of these heads demonstrate that in each the impastos of the flesh tones are executed with short, feathered strokes while the eye sockets, mouth, and shadows around the nose area are formed with thinly applied, nonleadbearing paints. Beyond similarities in structure and buildup, however, the pensive mood of Praxedis is comparable to that of the woman in *A Woman Asleep.*

Saint Praxedis occupies a pivotal position in our understanding of Vermeer's early work because it is the only instance where one can definitely trace the compositional and stylistic origin of one of his early history paintings. The comparisons with Ficherelli's *Saint Praxedis* indicate Vermeer's capacity for adapting his style to that of his model and explain much about the character of Vermeer's other early paintings, *Christ in the House of Mary and Martha* and *Diana and Her Companions* (see fig. 13). The remarkably varied techniques Vermeer used in these works may likewise have resulted from the way he responded to the models from which he worked. In these other instances, however, Vermeer probably did not rely so heavily on one source, but borrowed ideas from more than one artist. Thematically, *Saint Praxedis* gives visual expression to Vermeer's concern for the importance and dignity of serving others, a theme likewise encountered with *Christ in the House of Mary and Martha* and *Diana and Her Companions.*[12] These relatively large-scale paintings, moreover, have comparable moods, where quiet moments emphasizing psychological interactions rather than active, physical ones are explored.

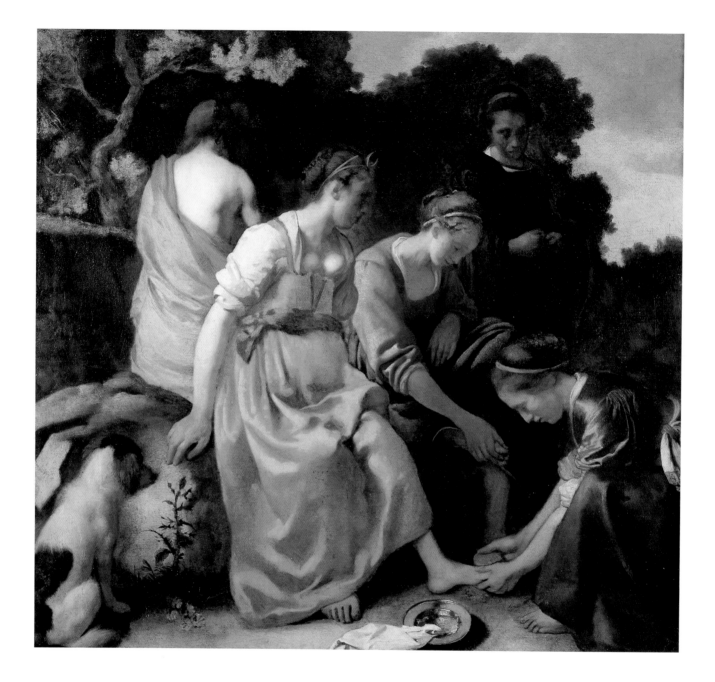

~

Diana and Her Companions

13. *Diana and Her Companions,* c. 1655–56, oil on canvas. Mauritshuis, The Hague

Vermeer's dependence upon a specific source in his *Saint Praxedis* is unique within his oeuvre, even though the subtle transformations he made in the image are indicative of the way the artist would adapt and adjust compositional elements throughout his life. Although the painting is fascinating for the evidence it provides about Vermeer's commitment to the Catholic faith, it does little to answer questions about the nature of his artistic training. *Saint Praxedis* offers no real clue as to the identity of Vermeer's teacher, his contacts with Dutch colleagues who might have influenced him in his formative years, or his artistic aspirations. A far more revealing painting in these respects is *Diana and Her Companions* (fig. 13), even though the reasons Vermeer chose to depict this subject, the only surviving mythological scene by his hand, are not known.

In this large painting, Diana, clothed in a loosely fitting white blouse and yellow robe, sits on a rock in a dark landscape while an attendant tenderly washes her foot with a sponge. Three other companions accompany the goddess, each self-contained, with head bowed and eyes averted. The mood is somber, detached, and reverent. Diana, her face in shadow, stares off into space, as though lost in her thoughts and oblivious to the presence of the others. Even the dog in the lower left sits quietly, no flicker of movement enlivening his form.

Unlike Vermeer's *Saint Praxedis,* this painting has no visual precedent, and, indeed, no obvious literary source. None of the rich and varied legends surrounding the goddess mentions an episode when Diana and her companions convene near the dense woods to share a moment of quiet contemplation. The only attribute identifying Diana is the crescent moon she wears on her head, symbolic of her role as goddess of the moon. Neither bow and arrow nor dead game signify her prowess as a hunter, and her gentle dog is unlike the quick hounds that normally accompany her. The scene depicts neither the abrupt intrusion of Acteon nor the shocking discovery of Callisto's pregnancy, themes that abounded in mannerist painting at the beginning of the seventeenth century. Likewise we do not see Diana's rash temper or the harsh judgments that followed these indiscretions.

14. Jacob van Loo
(1614–1670), *Diana and
Her Nymphs,* c. 1650, oil
on canvas. Herzog
Anton Ulrich-Museum,
Brunswick

As the virgin huntress, Diana personified chastity, and by the mid-seventeenth century
a rich tradition of allegorical portraits had developed in which women were depicted in the
guise of this goddess. One of the most imposing of these is the large-scale *Diana and Her
Nymphs* that was painted in Amsterdam around 1650 by Jacob van Loo (fig. 14). Here the
woman posed as Diana sits in a woodland glade accompanied by a number of female com-
panions. The similarity in the basic compositional concept suggests that this chaste aspect
of Diana's character is at the core of Vermeer's interpretation of the scene. The differences
in mood between these two works, however, are striking. Diana in Vermeer's painting is
most assuredly not a portrait, and the discourse of the companions in Van Loo's work has
been replaced by quiet contemplation. Although Vermeer's Diana is modestly dressed and
has at her feet a brass basin on which lies a white cloth, these indications of chastity and
purity are tempered by an overwhelming sense of solemnity.

The prominence of the thistle in the foreground near Diana gives added poignance to
the scene, for this plant was a traditional symbol of earthly sorrow and tribulation. The

symbolism of the thistle, however, has a Christian rather than mythological origin, stemming from the curse God levied against Adam for his disobedience: "Cursed is the ground for thy sake; in sorrow shalt thou eat of it all the days of thy life; thorns also and thistles shall it bring forth to thee" (Genesis 3:17–18). Vermeer may have included this plant as a symbolic element precisely because he wanted to fuse mythological and Christian traditions in this work. The association with the Christian tradition is particularly strong in the theme of the washing of feet. In Vermeer's depiction of Diana this ritual emphasizes the purity of the goddess, and the dignity with which Diana's companion performs her service is reminiscent of the biblical accounts of Mary Magdalene's washing of Christ's feet with her tears (Luke 7:36–50) and of Christ's kneeling before his disciples to wash their feet at the Last Supper (John 13:1–16). Numerous thematic relationships were seen to exist between mythological and biblical stories in the seventeenth century, although seldom were the two worlds fused so completely as in this work.[1]

Just what inspired Vermeer to portray Diana in such a contemplative manner cannot be answered with certainty, although he may have wanted to suggest that even in a life that seemed to be conducted without the warmth of human sentiment, moments of sorrow and inward reflection must surely also exist. Indeed, by depicting such a moment Vermeer created a sympathetic image of this goddess that is far different from the cold and vindictive personality she was reputed to be.

Vermeer achieved this glimpse into the psychological character of the goddess by depicting her at a moment in which she was oblivious of her surroundings. She does not look down at the ritual cleansing of her foot, but gazes absently into the distance, her face shrouded in darkness. Her self-absorbed mood is given even more poignancy by the quiet, introspective attitudes of the three attendants behind her, each of whom also seems to exist within her own world. In their separateness, even in the midst of their community, one finds the germs of ideas that Vermeer later developed in his genre scenes, from single images like *A Woman Asleep* (see fig. 20) and *Girl Reading a Letter at an Open Window* (see fig. A6), painted only a short time after the painting of Diana, to images of multiple figures, as, for example, his *Lady Writing a Letter with Her Maid* from the end of his career (see fig. 107).

Much of the evocative power of *Diana and Her Companions* derives from the way Vermeer modeled his forms to enhance the mood. As Diana gazes off into the distant landscape, for example, she looks away from the light. Her shaded face is painted thinly, with brown glazes that give virtually no definition to her features (fig. 15). Glazes, which are

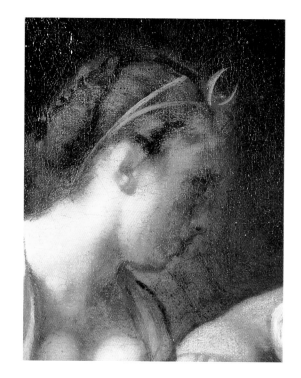

15. *Diana and Her Companions,*
detail of Diana's face

semitransparent, allow the viewer to look beneath the surface to the paint layer below, which is, in this instance, a lighter ocher. The effect is often used by artists to give an added richness to textures, for seeing forms through various layers of paint is somewhat akin to looking into the depth of the material itself. Vermeer almost certainly used the technique to suggest the luminosity of the skin in reflected light, but the glaze here seems to work on a psychological as well as physical level. Its translucent character helps evoke something of Diana's pensive mood.

Vermeer established the basic disposition of his figures by blocking in their forms with black painted contours on top of the ocher ground. The blocked-in forms of Diana's eye, nose, and mouth are not only visible under the glaze, but also are the prime indicators of the goddess' features because Vermeer did very little to model them further. By portraying the face in shadow with the features only vaguely indicated, Vermeer allowed the viewer to enter into the interpretation of her appearance and state of mind. Given that this figure, and her mood, are the central focus of the painting, Vermeer's decision to obscure her expression represents a rather daring approach for the young artist.

Diana's expression, however, is probably somewhat less defined today than it was in the mid-seventeenth century as a result of the added translucency that the paint has gained over time. This phenomenon has meant that more of Vermeer's initial blocking in of the figure has become revealed than he probably intended. In this instance, moreover, alterations he made in his blocking-in stage are visible in Diana's face, which complicates the appearance of her image. Vermeer's preliminary design was to position the face slightly lower and more forward. The initial drawing for the eye is quite visible below and slightly to the right of the existing eye. Indications of an earlier mouth can also be found below the current one. Whether Diana was looking toward the attendant washing her foot in Vermeer's initial design cannot be determined, but the possibility clearly exists. In any event, the shift in the position of Diana's gaze enhances the quiet pensiveness of the scene: it is as though the footwashing takes place without her awareness as she absently concerns herself with imponderable questions. Other black strokes from an underlying blocking-in layer exist through Diana's left breast and along the inner edge of her right arm. Elsewhere in the composition, the initial contour of the left hand of the attendant kneeling before Diana is visible between her present hand and her foot (fig. 16), an indication that the original position of Diana's left foot may also have been different.[2]

16. *Diana and Her Companions,* detail of hand and foot

It is difficult to determine the next stages of Vermeer's process, but it would appear that he blocked in the forms with thin imprimatura layers to create the color foundations for the image. He applied, for example, a dark imprimatura layer as a basis for the blue of the sky, much as he had done in *Saint Praxedis*. Vermeer occasionally left such an underlying layer to establish the final tone in the shadows, as in the bodice of Diana's dress.

Vermeer applied the thick impastos of the sunlit flesh tones on the back of Diana's neck and on her breasts after he had applied the thin glazes in the shaded portions of the body. He followed a similar procedure in the flesh tones of the two nymphs adjacent to her, both of whom also have their faces thrown into shadow. The differences in the density of paint between the impastos and glazes in these three figures are quite pronounced, as though he sought to increase his chiaroscuro effects to enhance the somber emotional character of the scene. Within the sunlit robes the paint is quite dense. Vermeer's modeling techniques, however, vary remarkably from figure to figure, clear evidence that he had not settled on a specific painting style at this early stage of his career. On Diana's white blouse, for example, brushstrokes are broad and bold, and the folds that are formed have an almost blocky appearance. The folds on her yellow robe also have a sculptural quality, as the artist effectively indicated their ridges with controlled yellow highlights that lie over a thin layer with a deeper color.

Vermeer used quite a different modeling technique on the red blouse of the figure adjacent to the right of Diana. Here he established its form with a quite thick white underpaint before applying over it a red glaze of various densities. This technique, which allowed him to suggest the sheen of the material, may also have induced him to conceive of a quite different rhythm of folds, simpler and yet deeper, than found elsewhere in the painting. The long, tubular folds on her blue skirt are unique in this painting.

Vermeer's method is yet again different for modeling the cloak on the woman behind Diana who sits quietly reflecting, with her back to the viewer. Here Vermeer created a shimmering effect by quite vigorously brushing together orange, within the shadows of the folds, and a lighter yellow (lead-tin yellow) for the sunlit portions of the cloth. He has not worked here, as elsewhere, with different densities of paint, and the folds do not have the same crisp, defined forms as those found in the two previous figures' dresses.

The color tonalities of Diana's kneeling attendant are most unusual, and point out the daring character of Vermeer's palette during the early years of his career (fig. 17). Although Diana's robes and those of the two women adjacent to her are executed in primary colors, this attendant wears robes with colors in a minor key. Her purple skirt and rust-colored

jacket are a striking and unusual combination, but their deeper hues do not compete visually with those of Diana's clothing. The rhythm of the folds along the attendant's sleeve are once again different from those found in the other figures. Here, however, the technique Vermeer used is comparable to that found on Diana's dress: impastoed strokes, lighter in hue but complementary to that of the material itself, follow the ridges of the folds of the material.

The range of techniques evident in *Diana and Her Companions* raises fascinating questions about the foundations of Vermeer's manner of painting. The differences in the way he modeled the robes of the various figures may indicate that Vermeer drew his inspiration from a variety of sources. Because the composition has such a unified emotional presence, however, this hypothesis seems less likely than that these differences reflect the various strains of his training or other influences that had not yet been integrated into a cohesive style.

17. *Diana and Her Companions,* detail of kneeling attendant

As is clear from *Saint Praxedis,* which he derived from one identifiable prototype, Vermeer was adept at emulating another artist's technique. This technique, once learned, would then have become part of his own repertoire. It may well have been Ficherelli, for example, who inspired Vermeer to paint a dark imprimatura for the sky. It may also have been from Ficherelli's example that he learned to paint a thin glaze of madder lake over a white base to suggest the sheen of red cloth lit by the sun.

The heavy blockiness of the Diana figure, however, which Vermeer created mainly through thick impastos and brushstrokes that follow the contours of folds rather than lie across them, speaks more of the Rembrandt school than of seventeenth-century Florentine art. Such associations are also reinforced by the technique of allowing imprimatura layers to remain as active design elements in the final composition. Vermeer's use of light and shade, in which he cast the faces in shadow to enhance the expressive potential of his scene, is a device that Rembrandt exploited as did no other artist. Finally, the somber mood of the scene, and even the pose of Diana and her kneeling attendant, are so similar in concept and feeling to Rembrandt's *Bathsheba* of 1654 (fig. 18) that it is difficult to imagine that Vermeer did not know this work firsthand.3

It is not necessary to postulate that Vermeer actually studied with Rembrandt in Amsterdam, for he would have had the opportunity to learn much about Rembrandt's philosophy and technique of painting from Carel Fabritius. Although little has remained of Fabritius' work in Delft and nothing is known about his contacts with Vermeer, Fabritius' presence must have helped transmit to Delft artists an appreciation of Rembrandt's manner of painting. Due to Fabritius a climate must have existed that would have helped Vermeer envision a richer, more painterly approach to large-scale history painting than one would expect from what is known of the Delft tradition. Fabritius, to judge from *The Sentry,* 1654 (fig. 19), also brought to his paintings an emotional character that is not far removed from the quiet pensiveness that pervades *Diana and Her Companions.* Although *The Sentry* is ostensibly a genre painting rather than a mythological scene, and it conveys its somber mood through an expressive architectural setting rather than the amorphous forms of a dark forest, each artist has suggested that the issues at hand were fundamental to human existence rather than specific to a defined moment in the individual's life.4 Whatever the impact Fabritius' painting style eventually had on Vermeer, Fabritius' approach to imagery must have helped lead the way for Vermeer at the beginning of his career as he was attempting to forge his new style.

18. Rembrandt van Rijn, *Bathsheba,* 1654, oil on canvas. Musée du Louvre, Paris

19. Carel Fabritius, *The Sentry,* 1654, oil on canvas. Staatliches Museum, Schwerin

The connections with Fabritius in this painting may well extend to the actual choice of subject matter. Diana, as goddess of the night, is closely associated with death, particularly when seen in conjunction with the thistle, symbol of earthly sorrow. It seems possible that the memory of the gunpowder magazine explosion that ripped through Delft on 12 October 1654—killing, among others, Fabritius—underlies the conception of this painting.

The quiet, reflective countenances of Diana and her attendants are those of individuals who each must come to terms with a shared grief. Perhaps the most telling figure of all in this respect is the attendant dressed in dark robes standing at the rear of the group. Her pose echoes that of Mary mourning beside the cross in countless crucifixion scenes, including *The Crucifixion* by Jacob Jordaens hanging on the rear wall in Vermeer's *Allegory of Faith* from the 1670s (see fig. A34). The downcast attitude is one further means by which Vermeer infused a Christian context into this image drawn from ancient mythology.

A Woman Asleep

20. *A Woman Asleep*, c. 1657, oil on canvas. The Metropolitan Museum of Art, New York. Bequest of Benjamin Altman, 1913. (14.40.611)

The transformation from a history painter to a genre painter seems not to have been easy for Vermeer. Nothing in his early works prepared him for the complex problem of orienting a figure within a realistic architectural space or depicting naturalistic light effects. Textures of materials had not been of great concern. Finally, Vermeer had to find a solution for the most vexing problem that he posed for himself: how to convey the melancholic moods of his history paintings in scenes drawn from daily life. Evidence within *A Woman Asleep* (fig. 20), Vermeer's earliest representation of a scene from contemporary life, suggests that he sought inspiration from the work of two former Rembrandt pupils, Nicolaes Maes and Carel Fabritius.

Vermeer's *Woman Asleep* does not look today the way he originally conceived it. Extensive technical examinations have revealed a plethora of evidence of the artist's struggles to achieve a meaningful artistic statement.[1] Vermeer's original concept apparently was to juxtapose two related but spatially isolated vignettes that, taken together, would indicate the central theme of the painting. Because the information is somewhat incomplete, one can only speculate as to the exact nature of Vermeer's first endeavor; nevertheless, x-radiographs distinctly reveal that a man wearing a hat originally stood in the far room and that a dog stared at him from the doorway (fig. 21). In that earlier stage the painting was larger on all sides and the chair in the lower right was absent. The painting behind the woman occupied less wall space than it does now; however, whether Vermeer enlarged it or shifted its position when he reduced the composition cannot be determined. Aside from these changes evident in the x-radiographs, Vermeer made modifications that are visible only in neutron autoradiographs.[2] The most significant of these is that grape leaves originally lay over the fruit still life.[3] Vermeer later replaced these leaves with the wine glass, presumably to suggest more directly the impact of wine upon the woman's state of being.

The compositional organization of Vermeer's original concept is strongly reminiscent of Nicolaes Maes' *Idle Servant,* 1655 (fig. 22). In this most didactic of paintings the main protagonists occupy the foreground: the slothful young housemaid who sleeps, head in hand,

[39]

with dishes strewn all over the floor before her while a cat steals the chicken; and the mistress who, having had to summon the maid to refill the wine decanter, discovers this mess. The subtheme, the party in the distant room, is seen through the open door at the top of the stairs.

Vermeer changed the scenario and intended the juxtaposition to suggest a more poignant subject than the representation of sloth in members of the lower class. He was probing the difficulties inherent in love relationships among equals. To judge from the costume and the pearl earrings, the woman resting her head in her hand in Vermeer's painting is not a maid, but the mistress of the house. Her pose does not indicate that she is asleep, as is suggested by the title, nor does it appear to represent sloth as it does in Maes' painting.[4] In this context, the woman's pose seems to refer to another iconographic tradition in which a figure rests its head in its hand: melancholia (fig. 23). Melancholia was an affliction widely associated in the seventeenth century with depression, self-absorbed introspection, artistic creativity, and unhappy love affairs.[5] In the same way that the disarray of dishes around Maes' housemaid reinforces the theme of slothfulness, so here the confusion of objects in the still life in front of the woman seems indicative of the woman's unsettled state of mind. Her wine glass half empty, the woman sits brooding in a confined and compressed space in

21. X-radiograph of *A Woman Asleep*

22. Nicolaes Maes, *The Idle Servant,* 1655, oil on canvas. Reproduced by courtesy of the Trustees, The National Gallery, London

23. Hans Sebald Beham (1502–1540), *Melancholia*, 1539, engraving. National Gallery of Art, Washington, D.C.

24. "Love Requyres Sinceritie," engraving from Otto van Veen, *Amorum Emblemata.* Library, National Gallery of Art, Washington, D.C.

a darkly lit corner of the room, hemmed in between the door, table, and wall. The only specific clue that Vermeer provided to explain the cause of her melancholy is the image in the painting behind her. All one can see is a mask and the foot of the cupid, but that is enough to identify the image as a painted representation of an emblem found in Otto van Veen's *Amorum Emblemata* (Antwerp, 1608), which speaks of sincerity in love and the overcoming of deceit (fig. 24).[6] According to the evidence revealed by technical examinations, Vermeer originally intended to expand upon this concept by depicting the dog, a traditional symbol for fidelity, gazing at the man from the doorway. Such a composition would have had a narrative emphasis comparable to that found in Maes' *Idle Servant.*

Although the similarities between *A Woman Asleep* and Maes' genre paintings from the mid-1650s are sufficiently compelling to assume that there was contact between the two artists, none is documented. Nevertheless, Maes at that time was living in Dordrecht, not far from Delft, and it seems likely that Vermeer was aware of the success that this former Rembrandt pupil was having with his moralizing genre images.

The temperaments of these two artists, however, could hardly have been more different. Maes, perhaps influenced by the powerful impact of the Reformed Church on Dordrecht

25. Carel Fabritius, *View in Delft with a Musical Instrument Seller,* 1652, oil on canvas laid down on panel. Reproduced by courtesy of the Trustees, The National Gallery, London

society, painted didactic scenes that explicitly upheld the ideals of proper bourgeois behavior. Whereas one is always prompted to judge the actions of the protagonists in Maes' paintings, Vermeer invites no such response. Vermeer's intent seems more to convey a glimpse into an individual's psychological state of being—whether melancholic or exuberant, isolated or in communion with others—than to moralize about its shortcomings.

Although this approach to subject matter is already apparent in Vermeer's religious and mythological paintings, it is even more fully realized in the artist's earliest genre scenes, *A Woman Asleep* and *Girl Reading a Letter at an Open Window,* c. 1657 (see fig. A6). Two artists—Gerard ter Borch and Carel Fabritius—almost certainly provided Vermeer with the framework for his approach to this type of subject matter. Ter Borch, who in the early 1650s began depicting women engrossed in their love letters or responding to the disappointments of love, provided a framework for Vermeer's examination of such themes in his genre scenes. Ter Borch's refined painting techniques must also have induced Vermeer to search for comparable ways to convey the textures of materials, in particular the sheen of satins. The extent of Fabritius' influence is more difficult to assess because a number of his paintings were presumably destroyed in the explosion that killed him in 1654. However, if one considers only *View in Delft with a Musical Instrument Seller,* 1652 (fig. 25), and *The Sentry,* 1654 (see fig. 19), then it is clear that the quiet, melancholic mood of Vermeer's early paint-

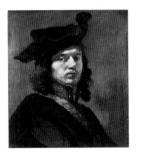

26. Carel Fabritius,
Self-Portrait, c. 1648–50,
oil on canvas. Bayerische
Staatsgemäldesammlungen,
Alte Pinakothek, Munich

ings derives from powerful precedents. The fascination of these paintings is due in part from the fact that Fabritius does not place his figures within a narrative. He does not explain who they are, why he has depicted them, or what the future has in store for them. His musical instrument dealer looks wistfully ahead, seemingly unaware of the Nieuwe Kerk rising in the distance, even though that impressive structure, centrally placed in the composition, draws much of the viewer's attention. The sentry sits slumped on a low-lying bench near an open gate, apparently negligent of his duties, yet no consequences seem forthcoming.

After Vermeer's initial enthusiasm for Maes' narrative schema in *A Woman Asleep,* he apparently returned to Fabritius' more suggestive and poetic approach to subject matter. Vermeer's decision to eliminate the dog and the figure in the back room and replace them with furniture removed important narrative elements that would have clarified the woman's mood, the origins of which are now left undefined. Moreover, by replacing the dog with a large chair Vermeer shifted his pictorial emphasis by denying the viewer easy access to the back room. One is thus forced to confront the woman and to experience the quiet melancholy of her mood.

Links to Fabritius exist not only in the mood of this work but also in the painting techniques. The woman's head, for example, is executed in a manner quite similar to the one Fabritius used in his *Self-Portrait,* 1648–50 (fig. 26). Vermeer applied the impastos on the woman's face with short strokes of flesh color and defined her features with thin gray paint (fig. 27). He used highlights sparingly. Shadows, as in those around the chin, are given deeper resonance by allowing the reddish brown imprimatura to remain visible through thin paint. Fabritius created a comparably rough, textural effect in his *Self-Portrait* by applying impastos on the highlights and achieving deeper flesh tones around the mouth and chin with the underlying paint layer. As with Vermeer's woman, features remain roughly defined and deeper shadows are indicated with an overlayer of gray paint.

This restrained yet broadly executed technique, which ultimately derives from Rembrandt's handling of paint from the mid-1640s, suited Vermeer's artistic temperament perfectly. It allowed him the possibility of modeling his forms with subtle ranges of color and opacity, similar to the way he had worked in his earlier history paintings. He could suggest the luminosity of flesh tones in areas with reflected light by revealing the underlayer of paint, which then served as a unifying tone for the whole. This technique also allowed him to portray a wide range of textures just by manipulating the character of his dabs or short strokes of paint.

Vermeer never described textures with the exquisite detail found in paintings by the Leiden artist Gerard Dou (1613–1675) and artists working in his tradition. Whereas objects in Dou's paintings are so minutely executed that they can be studied with a magnifying glass, Vermeer's forms dissolve before the eye upon close examination as he suggested rather than described their structure and texture. Dou essentially tried to deny the existence of paint and obliterate evidence of brushwork when he created his illusionistic effects. Vermeer never did. In his paintings illusionism exists in and through the paint and the brushwork. Throughout his career he was thus able to adapt his techniques to convey different degrees of illusionism.

In this early genre painting Vermeer made every effort to demonstrate his mastery of the depiction of textures and materials. Such an interest is evident in the many types of objects he represented in the still life on the table, which includes not only a variety of fruits in a Chinese porcelain bowl, but also a white earthenware jug with a silver top. He covered another bowl and a pitcher lying on its side with a thin, semitransparent white cloth. Most remarkable is a glass carafe turned on its side in the foreground. Through its transparent form are visible not only the white pitcher but also the tapestry covering the table and a portion of the bowl covered by the cloth. Although areas of this still life are somewhat abraded today, with the result that the illusionism is diminished to a degree, Vermeer developed a variety of painting techniques to create the textural effects he sought to represent in his scene.

The complexity of Vermeer's layering of paint to achieve realistic textural effects is evident in the elaborate tapestry that covers the table. He took extreme care to re-create the interwoven patterns of the fabric, in particular in the foreground segment, and to suggest the play of light on the folds. As a base color he used a reddish ocher, most clearly visible under the fringe at the lower edge of the table covering (fig. 28).[7] When he built his design upon the base he left the junctures of the individual colors purposefully rough to suggest the character of the wool. In the upper portion of this detail one can see how he filled in the orange before defining the blue of the design with a layer of black. He then applied a thin layer of natural ultramarine over this foundation. White highlights were always the last to be added. In the rear portion of the table, where Vermeer softened the design of the tapestry to suggest its recession into space, he created a mottled effect by applying rapid strokes of a thin reddish glaze, probably red lake, over the reddish ocher base that he then accented by wavy black lines.

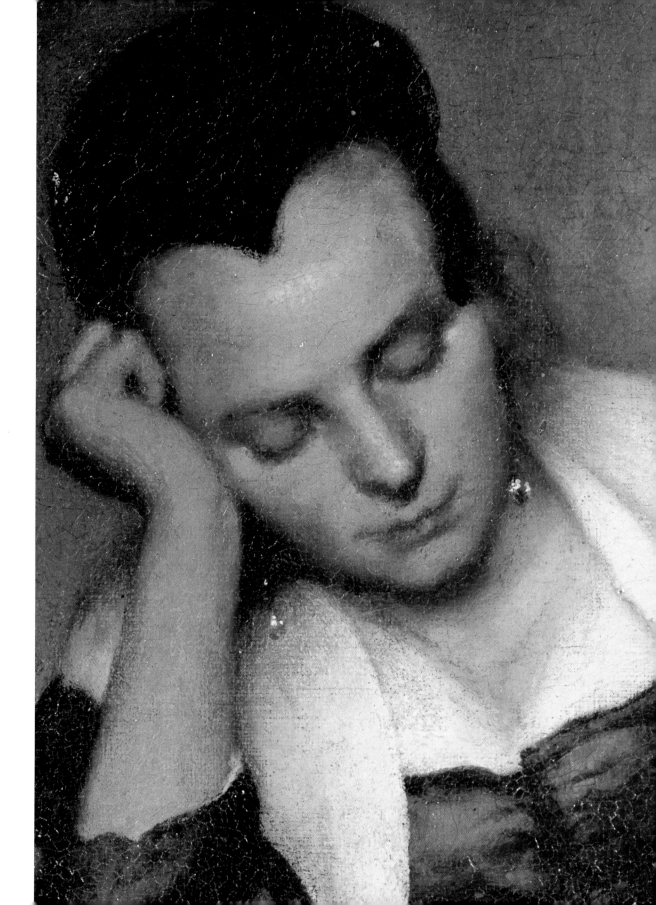

27. *A Woman Asleep,*
detail of woman's head

28. *A Woman Asleep,*
detail of table covering

Perhaps the most remarkable instance of Vermeer's attempt to re-create the textural effect of a material occurs on the chair in which the woman is seated. Here the artist has suggested the subtle variations in the appearance of the fabric as light hits the velvety cloth by alternating a deep, purplish red lake and a lighter tone mixed with a small amount of white. Finally, he applied actual gold, accented with a dot of lead-tin yellow paint, to capture the brilliance of the brass knob at the top of the chair.

These efforts at recreating textural effects notwithstanding, Vermeer was less concerned with creating the reality of the setting than with establishing a framework for the mood he wished to convey. This overriding concern is evident in the subtle manipulation of light effects throughout the composition. Light, for example, appears to come from the right in the foreground room but from the left in the back room. Within each room inconsistencies occur: the lower portion of the front right wall, for example, is strongly lit, but the chair silhouetted against it is in shadow. A similar pictorial device is the shadow across the upper third of this room. This shadow, which makes no logical sense, helps focus attention on the woman and also reinforces the melancholic mood of the scene. Only the glancing

reflections off of the inner edges of the doorframes, accents that bring to life this dark area of the painting and help relieve the somber mood of the scene, anticipate Vermeer's subsequent fascination with the effects of sunlight within an interior.

The emotional impact of this painting comes as well from the unusual vantage point Vermeer devised with his perspective system. He created a rapidly rising sense of space by constructing his horizon at the level of the mirror in the back room, much as Maes had done in his *Idle Servant.* The combination of this high horizon and the table in the immediate foreground creates a disorienting sensation, for it is difficult to comprehend the construction of the space surrounding the woman and its relationship to the door and passageway to the back room. The viewer, moreover, cannot easily situate himself or herself in relation to the interior space because it seems to drop away so rapidly. Vermeer heightens this feeling by establishing visual barriers with the chair and the drawn-up tapestry on the table that prevent easy access into the painting. Through this device and through his perspective construction Vermeer emphasizes both the woman's isolation and her unsettled state of mind.

How Vermeer came to use perspective effects so creatively in this work is not known, but it seems probable that he drew on the example of Carel Fabritius as well as Maes. Fabritius was renowned for the effects of perspective he created in his works, although that fame seems largely based on mural paintings that have been destroyed.[8] To judge from his few remaining works he used perspective as an active component in his paintings rather than as a means for establishing a neutral, albeit accurate, framework for his images. Fabritius, in his *View in Delft with a Musical Instrument Seller,* 1652, for example, apparently combined effects derived from both linear perspective and from a wide-angle lens to produce an image that attempts less to record reality accurately than to create the pensive, and even melancholic mood that pervades the scene.[9]

This bold and evocative approach to perspective, in which its laws could be carefully manipulated for thematic and compositional purposes, was one of Fabritius' most important legacies to Vermeer. The unusual spatial effects Vermeer created here are among his first attempts to understand and utilize the expressive character of perspective. As his sensitivity to perspective and its relationship to optical and textural effects evolved, he continued to recognize it as a tool with tremendous potential for heightening the emotional and thematic content of his work.

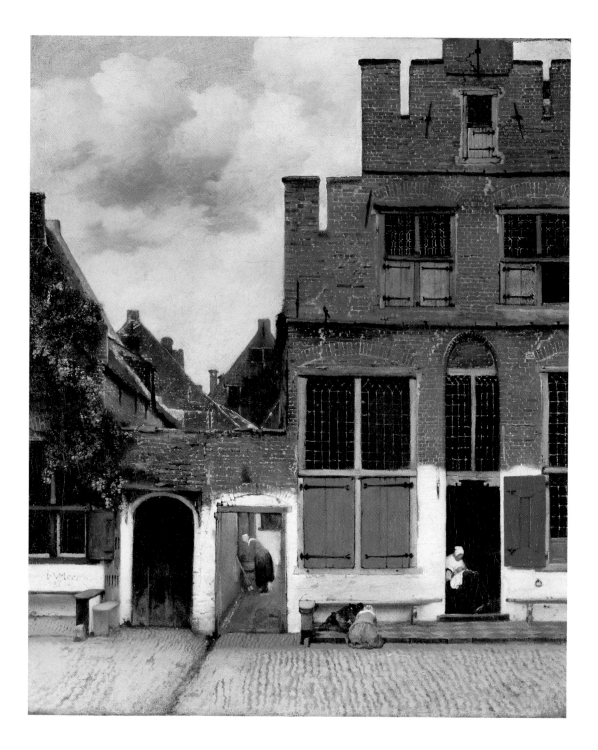

CHAPTER IV

~

The Little Street

29. *The Little Street,* c. 1658, oil on canvas. Rijksmuseum, Amsterdam

The fascination with contained and implied space was at the core of much of Delft painting in the 1650s, but it is nowhere better seen than in *The Little Street,* painted by Vermeer around 1658. The street scene has never been identified, and the probability is slight that it ever will be.[1] Although we may assume that the buildings, which are characteristic of dwellings built in Delft in the mid-sixteenth century, actually existed, Vermeer almost certainly altered their appearance.[2] He was not primarily interested in recording the scene for its historical, topographical, or architectural merit. The fascination here was with the ordinary and unremarkable, the house façades, courtyards, benches, and sidewalks, and the way the people who lived in this environment related to it and enhanced its character.

The Little Street provides an intimate glimpse into a small and self-contained world that must have been characteristic of many of the quiet streets in Delft in the mid-seventeenth century (fig. 29). Although the streetscape of which it is a part stretches left and right beyond the limits of the picture frame, Vermeer has cropped the image closely. The house on the right reaches to the top edge of the support, and only a small portion of the road at the bottom is visible. The two houses that define the streetscape are cut at the sides at architecturally illogical points. Vermeer's intention seems to have been to create a composition that would frame a segment of the street in much the same way that the woman bending over a barrel in the courtyard and the woman sewing at the entrance of her house are framed by their doorways.

The patterns on the surface are slow and deliberate, denoted by the horizontals and verticals of the architecture. A few orthogonals suggest the recession of space, but perspective effects are purposefully minimized. The one recessive diagonal that Vermeer emphasized, which runs from the front left of the composition into the inner courtyard or alleyway, seems to break through the strong façade orientation of the scene and suggest the three-dimensional nature of the buildings. In general, the cobblestones in the foreground, however, recede in irregular patterns rather than strictly according to laws of single-point per-

spective. As a result, the pace at which the viewer enters the painting is slowed down in preparation for the quiet mood of the rest of the scene.

Although Vermeer cut his composition at the edges at seemingly arbitrary points, he carefully calculated his compositional arrangement. The horizontal and vertical axes of the painting, for example, fall along the left and top edges of the large double window with greenish blue shutters. Such an orientation not only provided added stability to the architectural elements; it also allowed Vermeer to play off the diagonal patterns of roof lines on the left with the dominant horizontal and vertical emphasis of the street façades. The diagonals create transitions between the foreground blocks and hence help establish a visual relationship between the buildings. The roof lines also help define the contours of the triangular shaped area of sky. Because of its defined shape and light color, the sky plays an active role in the composition. Instead of receding to the background, the sky comes forward and helps balance the dominant architectural form on the right. To ensure that the sky does not come too far forward, however, Vermeer contoured the gables of the building on the right with a white line (fig. 30) similar to that seen around *The Milkmaid* (see fig. 45).

30. *The Little Street,*
detail of bricks

Because the site Vermeer represented cannot be identified, it is impossible to determine how accurately he depicted the scene. The appearance of reality is certainly strong. The architectural components of windows, shutters, doorways, and the variety of colors of the bricks are convincing. Vermeer was particularly successful in suggesting the mortarwork between the bricks and filling cracks. The technique he used for this effect was simple but effective: he generally indicated the mortar in hues of white paint, with strokes of different widths, over a varied reddish brown layer (see fig. 30).[3] To keep the pattern from becoming too regular he concentrated his strokes, accenting the patterns of mortar in some areas more than in others. At times he altered the effect by painting the mortar with a dark color and sometimes he painted no mortar at all.

Vermeer's technique for defining bricks with mortar is similar to that used by Pieter de Hooch in his courtyard scenes from about 1658 (fig. 31), which may well be an indication that the two artists consulted with one another about this matter. Indeed, the coincidence of similar stylistic and thematic elements in the work of Vermeer and De Hooch in the late 1650s, whether intimate cityscapes or interior genre scenes (see, for example, chapter 5, on Vermeer's *Officer and Laughing Girl*), raises fascinating yet unresolvable questions about the relationships between these two Delft artists. Whatever the extent of communication between them, Vermeer's technique for painting bricks was effective for suggesting their rough texture in the relatively flat light of *The Little Street*. He reserved impasto for the

whitewashed lower portion of the façades, perhaps because the density of this paint helped transmit the weight of the firm foundation upon which the houses stood (fig. 32).

Despite Vermeer's interest in creating a realistic textural effect for the bricks, the architecture of the building on the right of *The Little Street* seems so unusual that the artist must have taken some artistic license in his treatment of it. To judge from the portion of the house that he represented, the house would have been symmetrically organized with two double windows flanking a central door on the first floor, two smaller double windows on the second floor, and a single centrally placed window on the third floor. Yet upon closer observation it is evident that the second-floor windows are not equally distant from the door; the window on the right, moreover, is taller than the double windows on the left. Finally, to judge from the width of the reddish orange shutter, the windows to the right of the door are narrower than those to the left.

Such architectural discrepancies probably reflect Vermeer's conscious manipulation of elements for compositional reasons. One possible explanation is that Vermeer wanted to introduce a red accent in the lower right portion of the painting with a shutter and at the same time wanted to maintain the flatness of the façade. Microscopic examination as well as infrared reflectography confirm that the artist painted this red shutter over the white layer of the surrounding façade. The open shutter, thus, seems not to have been his original design concept. That he wanted to have the shutter resting flat against the wall can be extrapolated

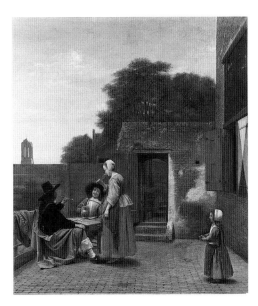

31. Pieter de Hooch (1629–1684), *A Dutch Courtyard,* 1658–1660, oil on canvas. National Gallery of Art, Washington, D.C. Andrew W. Mellon Collection

32. *The Little Street,* detail of façade

[51]

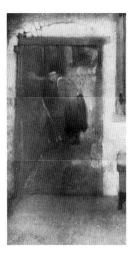

33. Infrared reflectogram of window in *The Little Street*

34. Infrared reflectogram of doorway in *The Little Street*

from an examination of a reflectogram of the window directly above on the second floor (fig. 33). Here only the left half of the shutter was blocked in in a light color. Because the shutter has two iron bars across it, the only inference that can be made is that Vermeer originally painted the shutter half open, then changed his mind and painted it closed.

Vermeer's concern with patterns of windows and shutters in his composition was both to balance the composition through color and shape and to give the sense of a self-contained image in a scene where buildings appear to be rather arbitrarily cut at the edge of the canvas. The rust-colored shutter in the lower right creates a vertical accent that gives that sense of completion to the composition on the right. A more subtle nuance is the variation of tones from blue-gray to light brown in the window frames. Although these tonal shifts may have existed in the building Vermeer used as a model in the painting they add variety to the façade and establish visual connections between different architectural elements. For example, the cool gray color of the second-floor window frame on the left is closer in tone to the window below it than to the one on the same level. Thus Vermeer subtly opened the horizontal divisions between floors by establishing such vertical relationships.

The concerns evident in Vermeer's treatment of architecture also occur in the arrangement of figures. Vermeer clearly intended to suggest the essential privacy of the scene by creating individual environments for his figures. They all exist within their own architectural framework: a woman concentrating on her handiwork within her doorway; children quietly playing game on the sidewalk, their forms nestled into the niche of the bench in front of the house; and, finally, a woman in the alleyway leaning over a barrel, seemingly unaware of the others' existence.

This arrangement, however, came only after Vermeer made a compositional change. Infrared reflectography reveals that he initially painted a seated woman doing handiwork at the entrance of the alleyway between the houses (fig. 34). Her profile form, which can be distinguished with the naked eye through the existing paint layers, was eliminated only after it had been completed and, thus, at a late stage in the painting's evolution. Vermeer may have felt that her form obstructed the passageway between the buildings, an essential ingredient in the composition because it helps establish the three-dimensionality of the architecture.

The Little Street is such an unassuming yet familiar image that it is difficult to appreciate its unique and even revolutionary position in the development of Dutch art. Although other street scenes preceded this work—Jan Steen's *Burgher of Delft and His Daughter,* 1655 (fig. 35), and Nicolaes Maes' *Milk Girl,* c. 1656 (Lord Anthony de Rothschild, Ascott [National Trust])[4] are two examples—these always focus on the interaction of large-scale figures in the fore-

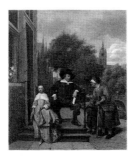

35. Jan Steen
(c. 1625–1679), *Burgher
of Delft and His
Daughter,* 1655, oil on
canvas. Penrhyn Castle

ground. No other streetscape from this period is so devoid of the type of human activity that usually passes for a painting's subject. In this respect, *The Little Street* also differs fundamentally from the courtyard scenes of Pieter de Hooch (see fig. 31), which De Hooch must have begun executing in 1658, about the same time that Vermeer painted this work.

As a genre, the streetscape offered Dutch artists a fascinating opportunity to depict various types of interaction between the public and private spheres, particularly the transactions that occur at the front door, whether it be a beggar asking for alms, a hurdy-gurdy player making music, or a milkmaid delivering her wares.[5] But *The Little Street* is a painting without beggars or musicians; indeed, it does not even include couples strolling down the street or comparable activities that might animate the scene. The figures, in particular the children kneeling on the sidewalk, are so subtly incorporated into the setting that they are almost overlooked. Nevertheless, their presence is not insignificant. The women, as they quietly go about their daily activities, create an aura of domesticity that infuses the entire scene. Even though they remain physically and psychologically removed from the viewer, without them the buildings would appear cold and remote—houses, not homes—and the painting would lack the intimacy it so profoundly conveys.

Vermeer's scene has the tranquility of a cloudy summer midafternoon, and with it the assurance that life will continue in patterns that will be reiterated from one year to the next. In *The Little Street* there are no strong shafts of sunlight or deep shadows, effects that would model and give depth to the buildings but also emphasize the movement of the sun and clouds and, hence, the passing of a moment. Vermeer reinforced this sense of timelessness in the deliberate patterns in the architecture, specifically in the emphasis on the horizontal and vertical lines of the buildings' forms, and in the self-containment of the figures as they pursue their daily concerns in their own spheres. Part of the timeless quality of the painting comes also from the venerable appearance of the buildings themselves. Not only is the architectural style of the buildings old, probably mid-sixteenth century to judge from the style of the gables, but the worn and weathered character of the bricks, whitewash, and window frames also gives the houses the patina of age. Though old, the buildings are not in a state of disrepair or decay. Bricks are not missing, windows are not broken, and hinges for the shutters are attached. In all these respects this painting that seemingly represents a simple view across a street in Delft hints at concerns of transience and permanence that become fundamental to Vermeer's paintings of the late 1650s and 1660s. These concerns, as well as the impulse to infuse abstract ideas into depictions of everyday life, are particularly important for the next painting to be discussed, *Officer and Laughing Girl.*

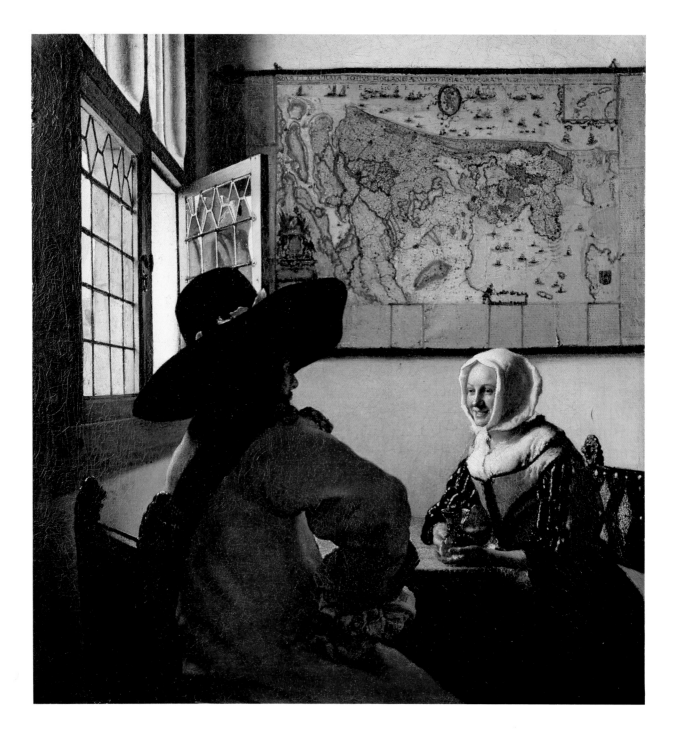

CHAPTER V

∽

Officer and Laughing Girl

36. *Officer and Laughing
Girl,* c. 1658–60, oil on
canvas. Copyright The
Frick Collection, New
York

Sunlight bursts into the scene with amazing brilliance in Vermeer's *Officer and Laughing Girl* (fig. 36). In none of his other works does light so glowingly infuse an interior and its figures with such sparkling vivacity. The transformation from the dark interior and melancholic mood of *A Woman Asleep* from about 1657 (see fig. 20) to the joyful gaze of the girl in this work is almost as remarkable as what ensued between that earlier painting and *Diana and Her Companions* (see fig. 13). The changes that occur in each of these works, however, are not just in subject matter and mood, but also in Vermeer's painting techniques.

The light that floods into the corner of the room reinforces the feeling of warmth and spontaneity conveyed by the informality of the figures' poses and by the joyousness of the girl's expression. It strikes her face, highlights her features, and emphasizes the flushed colors of her cheeks. The sparkle of light dances all around her, from the white of her blouse and the kerchief covering her head to the brilliant glitter of yellow on her dress. It accents as well the light-filled greenish yellow tablecloth and the back of her chair. The yellow tonalities around the woman are picked up and reinforced by the glimpse of sunlit houses seen through the window and by the warm tonalities of the window frame and map hanging behind her.

The naturalistic light that plays across the surface of the painting bespeaks an entirely different awareness of optical effects than is evident in *A Woman Asleep*. Here Vermeer has observed how light is alternatively refracted and reflected off the uneven surface of window glass, created that effect with an extraordinarily abstract pattern of painted reflections (fig. 37). No artist prior to Vermeer had attempted to convey this optical phenomenon. No other artist, moreover, had depicted as boldly as does Vermeer the blueness of shadows, seen in the corner of the room behind the open window and along the left text edge of the map. To give an added sense of the recessive nature of shadows Vermeer often painted these areas thinly. The shaded portion of the girl's kerchief, for example, is more thinly painted than its illuminated portions and is given a cool cast with thin strokes of blue (fig. 38).

[55]

37. *Officer and Laughing Girl,* detail of window

38. *Officer and Laughing Girl,* detail of girl

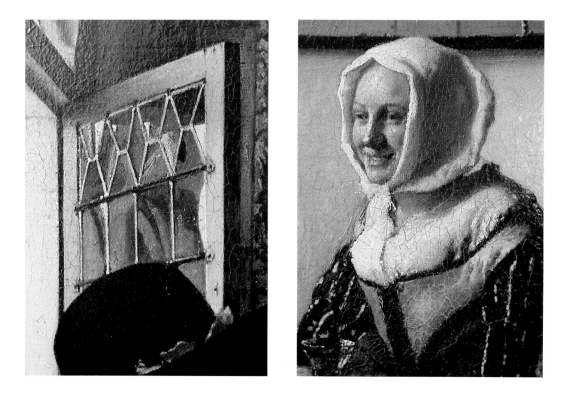

39. *Officer and Laughing Girl,* detail of finial

The most dramatic of the techniques that Vermeer used to capture naturalistic light effects in *Officer and Laughing Girl* are the specular highlights that suggest reflections of light glancing off objects. It is hard to imagine how daring Vermeer's treatment of the lion-head finial on the girl's chair must have seemed to his contemporaries (fig. 39). Instead of a carefully delineated finial painted in a light color to indicate the sunlight falling upon it, Vermeer seemingly dissolved the form with a succession of white, ocher, and gray specular highlights. Light no longer remains a passive phenomenon: it works upon the form, transforming its presence. Likewise the blue and gold patterns of the seat back, as well as the brass nails attaching it to the frame, become a dynamic field articulated by small dabs of lead-tin yellow on the diamonds and light blue on the field between them.

Specular highlights are not unique to Vermeer, but the way he used them was. They occur, for example, in genre paintings by Nicolaes Maes as well as in still lifes by Jan Davidsz. de Heem. Willem Kalf (1619–1693), in particular, used specular highlights to give luster to silver and gold objects. To some extent Vermeer may have been indebted to these

[56]

artists for suggesting to him the effectiveness of this technique for indicating the play of light on an object, but he completely transformed the method. Whereas Kalf applied his specular highlights to indicate light reflecting off a shiny surface, Vermeer applied specular highlights on the finial of the chair to help create its structure. Vermeer's finial would be undefined without the globules of paint that capture the light upon it. To further emphasize the active role of light in defining both the shape and character of the finial, Vermeer painted a white contour along its shaded back edge.

Although the light that pervades the scene intensifies the image, so do the gazes that pass between the figures. As though frozen in time, the two stare at each other, unaware of their surroundings. Vermeer conveyed the intensity of their communication through their expressions, but also through his careful control of the composition and the adjustments he made to their poses and costumes. For example, Vermeer almost certainly depicted the large silhouetted figure of the officer in a red jacket because of the color's associations with passion and power. Had he portrayed him in a green or tan coat the mood would have been entirely different. The red contributes to the sense of self-assuredness that his pose conveys and to which the girl responds. The vivid yellow of her jacket has traditional associations of warmth and receptiveness. That Vermeer felt it important to emphasize the color is evident in a pentimento visible in an x-radiograph of the painting (fig. 40). Vermeer originally painted her with a large white collar over her shoulders, which would have obscured the yellow accent on her dress that so effectively counterbalances the red of the officer's coat. The x-radiograph also reveals another change in her costume that Vermeer

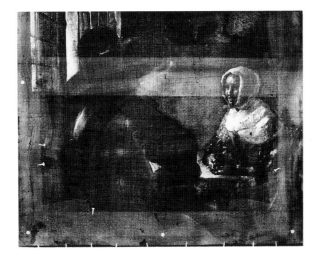

40. X-radiograph of *Officer and Laughing Girl*

[57]

probably made to heighten the intensity of her relationship with the officer. Vermeer originally depicted her wearing a small cap that covered only her hair. By enlarging the cap and bringing it forward to frame her face he further focused the direction of her gaze.

Because of the intensity of their gazes the two figures appear to remain oblivious to their environment. Vermeer, however, has carefully integrated them into their surroundings through visual connections between their forms and objects around them. He established a tangential relationship between the girl's head and the bottom edge of the map. The black rod along the map's bottom edge not only reinforces the direction of the woman's gaze, but also helps bond her to the officer by intersecting visually with his hat. In a similar manner Vermeer used the broad brim of the officer's hat to visually link the window frame and the map. By this means, as well as the angle of the brim as it intersects with the officer's face just below his eye, he gave added emphasis to the officer's gaze and to the force of his personality. That Vermeer considered the position of the hat important for this function is evident in the care he took to paint it at its proper scale. A pentimento evident in the x-radiograph and visible to the eye shows that he reduced the size of the brim to let it lead the eye more easily across the picture plane.

Such structural relationships between the figures and the map may offer a clue to a peculiar characteristic of the map that has never been satisfactorily explained. In this map, which is an otherwise extremely accurate record of a wall map of Holland and West Friesland designed by Balthasar Florisz. van Berckenrode in 1620 and published shortly thereafter by Willem Jansz. Blaeu, Vermeer colored the land mass light blue.[1] Although it is possible that the map he depicted may have been hand-colored, the only existing exemplar of the map is monochrome.[2] When Vermeer represented the map in later paintings, most clearly seen in *Woman in Blue Reading a Letter* (see fig. 1) but also dimly visible in the foreground left of *The Love Letter* (see fig. A31), he represented the map in shades of ocher. Vermeer thus almost certainly added color to the land mass in the map in *Officer and Laughing Girl* for compositional or iconographic reasons. Perhaps he did so to bring attention to the land; perhaps he felt that blue, the third and most recessive primary color, would harmonize with the active contrasts of red and yellow on the clothes of the figures immediately below. That Vermeer felt free to adjust the character of the map even while appearing to represent it accurately is also evident when one compares the relative size of the map in these two paintings. The map is considerably larger in *Woman in Blue Reading a Letter* than it is in *Officer and Laughing Girl*.

In establishing relationships between figural and inanimate objects Vermeer was particularly conscious of the negative shapes—the shapes of the spaces between objects—thus created. The most important of these in this painting is the broad triangular wall area between the officer and girl. Its simple yet dynamic shape provides a further bond between the two figures and to a certain extent reiterates the triangular form of the light blue landmass in the map. Finally, Vermeer carefully constructed the perspective of the room so that the vanishing point falls within this space, directly in line with the figures' gazes.

Although Vermeer's carefully calculated composition seems at first glance to be inconsistent with the apparent spontaneity expressed in the woman's smile, it is clear from the rest of Vermeer's work that he was fascinated with the problem of how to transform a momentary expression into a lasting image. In this instance he established structural bonds between the figures and their surroundings to reinforce the intensity of the relationship between the figures. They are at one with each other partly because they are in harmony with the world around them. Because the woman's pose seems too frozen to be truly spontaneous, one must admit that Vermeer did not entirely resolve the compositional problem he set out for himself in this painting. Nevertheless, the approach that he used here established the framework that Vermeer followed throughout the rest of his career.

Just how Vermeer developed this interest in representing a momentary scene set in a light-filled interior soon after he had painted the quiet, broodingly reflective *A Woman Asleep* cannot be answered with any certainty. *Officer and Laughing Girl* is one of three paintings Vermeer executed in the late 1650s that depict men and women socializing around a table. Compositionally and thematically this work, as well as *The Glass of Wine* (see fig. A10) and *The Woman with a Wine Glass* (see fig. A11) relate closely to paintings by Pieter de Hooch from the mid- to late 1650s. In these scenes, De Hooch had clearly developed an interest in representing naturalistic light effects through windows and doors in a convincing way. In his *Card Players* (fig. 41) he has carefully controlled the way in which light enters the room by closing the right bottom window with a shutter. Strong light thus falls on the table, the card players, and the woman standing near the brightly illuminated back wall. Only the foreground and the corner near the window are in shadow. De Hooch then used these naturalistic light effects to reinforce his composition by juxtaposing the illuminated hand of the soldier holding up his ace against the darkened wall and curtain in the corner.

Vermeer may well have had this painting in mind when he decided to paint *Officer and Laughing Girl*. The placement of the window, the emphasis on naturalistic light effects, and

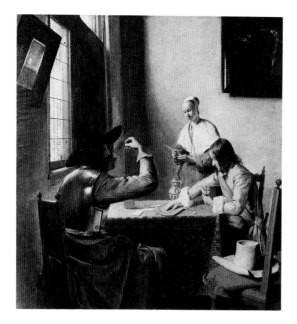

41. Pieter de Hooch (1629–1684),
Card Players, c. 1656–58, oil on canvas.
Private collection, Switzerland

the arrangement of figures around the table are similar, as is the focus on a momentary action. Yet the differences in feeling are significant. Vermeer brought the figures to the immediate foreground of his painting so that the viewer almost feels as though he or she is looking over the officer's shoulder. He intensified this sense of space by exaggerating the difference in scale between the officer and the girl. Just how he arrived at this compositional idea is not known, but from the evidence of *A Woman Asleep* it is clear that Vermeer was extremely conscious of the expressive character of perspective. In this instance he may well have derived his idea for such an intensified spatial arrangement through an awareness of optical effects seen in a wide-angle lens or other optical device that operates with a monocular rather than binocular visual system.[3] Whether he utilized such a device in this work or not, he calculated the scale of the officer by adjusting the perspective system. The officer's chair has a much higher horizon line than does the room and the other objects in it; instead of falling at the level of the girl's eyes, it lies above the level of the officer's hat.

Aside from intensifying the spatial effects, Vermeer, as he had in each of his works heretofore discussed, transformed the thematic precedent with which he was dealing to minimize the narrative component of the scene. In De Hooch's painting the card player's gesture emphatically proclaims the outcome of the game while a moralizing commentary is offered by the presence of a painting of *Christ and the Adulteress* on the back wall. Vermeer

is not so explicit about the nature of the relationship between the officer and the girl in this light-filled interior. His primary concern may have been to depict a scene from daily life in which a woman sits with her wine glass and shares a convivial moment with her guest. Nevertheless, if his intent were merely to represent an officer's visit to the well-appointed home of an attractive woman, why did he take such care to transform a momentary exchange of expressions into a lasting image where their relationship is so bound to their environment?

As he often did later in his work, Vermeer conceived this genre scene as a means for making a larger statement, and a major component of that statement is the map. Although maps often appear in the background of Dutch genre paintings, no artist had ever depicted one with the care Vermeer used in *Officer and Laughing Girl*. The way he suggested its texture with multiple short strokes of blues and ochers, even to the point of depicting the rolled edge of one of the segments of the text, argues that he viewed the map as a venerable yet tangible reality, one whose significance was not to be underestimated.[4]

Vermeer chose his map almost certainly because of its shape, but even more so because it represented the provinces of Holland and West Friesland. He carefully recorded the title of the map along its top edge: NOVA ET ACCVRATA TOTIVS HOLLANDIAE WESTFRISIAEQ. TOPOGRAPHIA. He also colored the land to draw attention to it. The band of text at the bottom of the map, which occupies such a central position in the painting, richly praises the land and the Dutch people. As Hedinger has rightly stressed, the text emphasizes the steadfastness of the Dutch, their defense of their homeland, their artistic accomplishments, and the positive attributes of Dutch women.[5]

The carefully integrated relationship between the figures and the map in this sunlit interior expresses not only an unmistakable pride in the land but also the communion between the people who live there and enjoy the fruits of peace. Indeed, the girl, so visually bound to the map of Holland, guarded, as it were, by a lion peering over her back and protected by a strong military presence, might be seen as a distant reflection of the Dutch Maiden, the allegorical symbol of the Netherlands. Nationalistic expressions of pride in the power and prosperity of the Dutch Republic, which have been identified in contemporary prints, maps, landscape paintings, and allegories, seem to have influenced the nature of genre painting as well.[6] The maps Vermeer included in other interior scenes almost certainly reflect aspects of that pride, as in his two greatest expressions on this theme, *View of Delft* and *The Art of Painting*. A similar expression of pride in the goodness of the people and the prosperity of the land underlies *The Milkmaid*, the following painting to be discussed.

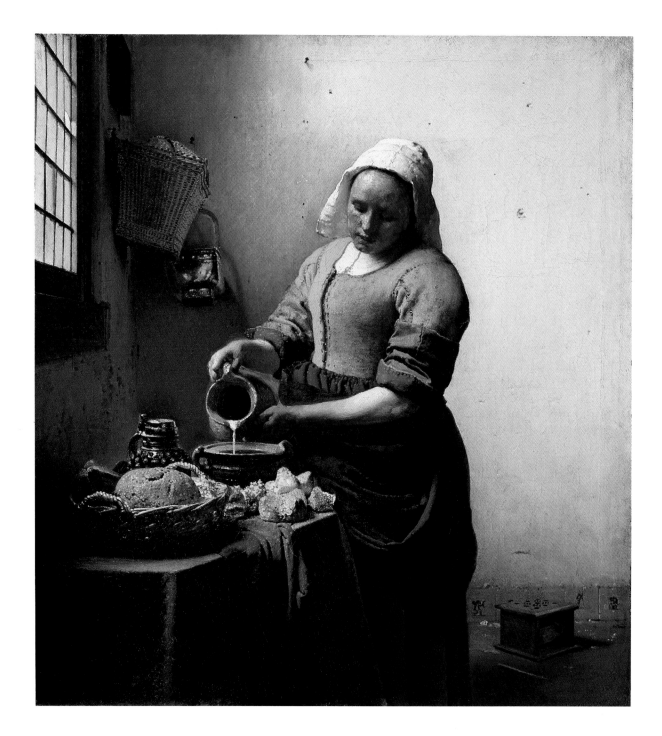

CHAPTER VI

~

The Milkmaid

42. *The Milkmaid,*
c. 1658–60, oil on canvas.
Rijksmuseum,
Amsterdam

The renown of *The Milkmaid* (fig. 42) has been longstanding: by 1719, when Vermeer's works were known to only a small group of connoisseurs, it was listed in an auction catalogue as "The famous *Milkmaid,* by Vermeer of Delft, artful."[1] The vigorous, or *krachtig* brushwork with which the artist modeled this figure was particularly admired at the beginning of the eighteenth century, and has been ever since.[2]

The sturdy figure of the milkmaid commands a presence so great that one has difficulty reconciling it to the modest scale of the painting. Just how Vermeer succeeded in imbuing this woman with such uncommon stature is a fascinating question. The forcefulness of the image is in large part due to the concentrated focus on the milkmaid, which creates a seriousness of tone quite different from that of comparable depictions of young Dutch women engaged in domestic activities. In 1655–56, for example, Nicolaes Maes painted his *Woman Plucking a Duck* (fig. 43), in which a young woman is likewise earnestly engaged. She would seem to be, every bit as much as the milkmaid, an exemplary image of labor and diligence, an ideal of virtue that was especially espoused in Dutch society.[3] Maes has indicated, however, that her singleminded industriousness has allowed her to neglect other duties, for objects are scattered on the floor and she is unaware of the cat stalking the dead duck. Sexual allusions exist in the scene as well, through the implied presence of a hunter and the wine glass and pitcher in the back room.[4] Whatever the specific moralizing message Maes wished to convey, this young woman, as opposed to Vermeer's milkmaid, becomes only one element in an involved narrative. Her individuality is of less consequence than her role in the story that is presented to the viewer.

The Milkmaid has an entirely different character than Maes' *Woman Plucking a Duck* and other genre scenes by his contemporaries. The milkmaid, even as she stands before a table and pours milk into a bowl, remains first and foremost an individual. She is the very core of the painting, not a figure within a narrative to be told or a moral to be learned. Though it is not a genre scene, *The Milkmaid* is not a portrait, either, despite the careful characterization of the woman's features, which were almost certainly derived from a model.

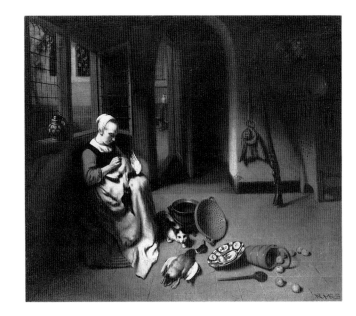

43. Nicolaes Maes, *Woman Plucking a Duck,* c. 1655–56, oil on canvas. Philadelphia Museum of Art: Given by Mrs. Gordon A. Hardwick and Mrs. W. Newbold Ely in memory of Mr. and Mrs. Roland L. Taylor

Her pose and her total absorption in her task have an entirely different pictorial purpose.

The closest one can come to an understanding of the unique characteristics of this painting is to think of it as allegory. Although executed in an extremely realistic and even physical manner, the painting was conceived to convey an abstract concept. As so often with Vermeer, however, he veiled his intent. The milkmaid has no traditionally identifiable attributes, as do, for example, Rembrandt's *Flora,* 1634, Hendrick ter Brugghen's *Sleeping Mars,* 1629, or the personifications of ideas in Cesare Ripa's *Iconologia.*[5] Nevertheless, in her dedication to her task and in her outer and inner strength, the milkmaid, at the very least, embodies an ideal of human dignity. Vermeer captured that quality here by depicting her in a moment when, absorbed in her activity and unaware of any intrusion into her space, she has lost all consciousness of self. It was a moment he favored, and whether it took place with a woman reading a letter, opening a window, or pouring milk, he found that it provided him with a means of reaching into the human psyche and drawing from it something that was universal.

Unlike *The Little Street* and *Officer and Laughing Girl, The Milkmaid* does not fit easily into an existing visual tradition. The closest comparisons to this work are not with other seventeenth-century paintings, but with images from the 1560s and 1570s by Pieter Aertsen (1509–1575) and Joachim Bueckelaer (c. 1530–1573). Aertsen's *Cook,* 1559 (fig. 44), for exam-

44. Pieter Aertsen
(1509–1575), *The Cook,*
1559, oil on panel.
Copyright IRPA-KIK,
Brussels

ple, depicts a single heroic figure who grasps a skewer and ladle with a firmness and vigor that many a military commander would have done well to emulate when they posed with sword and baton. Vermeer's woman is likewise imposing; the sleeves of her yellow jacket are pushed up on her arm, revealing her strength as she cradles the pitcher in her hands. Aertsen's cook stands adjacent to the tools of her trade, the well-chosen meats and vegetables from which she fashions her meals. On the table before Vermeer's milkmaid, the bread basket, the red earthenware bowl, and the ceramic pitcher have a comparable weighty physicality, while the specular highlights on the loaves of bread enliven the still life as much as does the flow of milk. The differences between these two paintings, however, are many. The dignity of Aertsen's cook is enhanced through the imposing architectural forms of the fireplace behind her.[6] Vermeer situated the milkmaid in the corner of a simple room, whose whitewashed walls are pitted with imperfections. Two black nails, hammered into the wall, are marks of the utilitarian nature of the room, where preparation and production of food is at issue rather than the enjoyment of the nourishment and sensual pleasure. A wicker basket and copper pail, useful for marketing, hang near the simple, unadorned window. Finally, far from observing the viewer as does Aertsen's cook, the milkmaid concentrates on pouring milk from a red earthenware pitcher into a two-handled bowl crafted from the same material, unaware that her actions are observed.

One of the qualities of *The Milkmaid* that gives it its extraordinary power is the three-dimensional character of the image, an effect achieved by both the force of light entering from the left and the textural effects of Vermeer's painting techniques. Although the milkmaid's white cap, wide forehead, and full figure are vigorously lit by light from the window, Vermeer has further accentuated her body by manipulating the play of light against the rear wall of the room. Where the milkmaid's body is illuminated by the sun, Vermeer has thrown the rear wall into shadow; where her body is shaded, he has painted behind her the full force of the sunlight. The play of light against dark and dark against light, however, appears so natural that one is unaware of the artificiality of Vermeer's construct or of the fact that the pattern of light falling into the room is illogical. Too little light falls on the wall to the left of the figure and too much to her right. Vermeer also heightened the light-dark contrast of the milkmaid's body against the wall by contouring her entire right side with a thin stroke of white paint (fig. 45). Given the realistic character of the scene, the artificiality of this contour line, which also gives the figure a slightly radiant quality, is striking. Its presence, however, is symptomatic of Vermeer's willingness to manipulate light effects for expressive purposes.[7]

45. *The Milkmaid,* detail
of shoulder

[65]

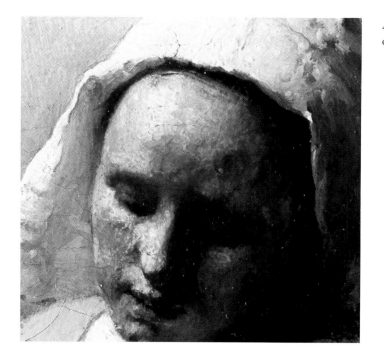

46. *The Milkmaid,* detail of head

The care Vermeer exerted in creating this three-dimensionality is particularly evident in the modeling of the woman's head and body. Small touches of paint—light ocher, reddish brown, brown, greenish gray, and white dabs and specular highlights—are joined together to build the form of her face (fig. 46). Brushstrokes are boldly juxtaposed, with little or no effort to blend the various colors together. The buildup of paint is so pronounced that one has the feeling that Vermeer was trying to sculpt the woman's form with it.

This technique could not be further from that found in his works of the mid-1660s. In *Woman in Blue Reading a Letter,* for example, the face is so subtly modeled that virtually no brushstrokes are visible (see fig. 1). Although x-radiographs indicate that Vermeer did accent her head with some bold strokes of a lead-bearing paint, presumably lead white mixed with ocher, the thin glazes that he subsequently applied to model the face removed all evidence of individual brushstrokes. Eyes, nose, and mouth are indicated in softly modulated tones and never denoted with contours.

The vigor of Vermeer's brushwork in *The Milkmaid* is evident not only in the impastos of the face and shoulders, where the paint is most densely applied, but also in his mastery of translucent glazes. In the greenish area of the sleeve, for example, Vermeer articulated folds

by altering the thickness of his paint as well as the color tonalities. The deepest shadows are created by the black he used to block in the form. No added color was used in these areas. For the rest, he allowed the ocher ground to serve as the intermediate tone. He highlighted the ridges of the folds with yellow paint, and even more expressively rendered is the blue cuff by the woman's left elbow. Although a freely brushed thin layer of blue defines the color, Vermeer used the ocher ground that shows through the blue to help model its form.

Given the expressive character of the brushstrokes in this area, it is not surprising that Vermeer made a number of modifications in the appearance of the sleeve during its execution. The image in the x-radiograph does not conform exactly to the final appearance of the sleeve, and the infrared reflectogram shows how boldly he blocked in shadows on the sleeve and below the arm. In particular he seems to have changed the shape of the blue cuff and extended it downward at the rear.

Perhaps the most fascinating demonstration of Vermeer's masterful use of paint is the extraordinary still life on the table (fig. 47). The sparkling character of this assemblage of baskets, earthenware bowls, jugs, and bread has no equivalent in Dutch art. Its impact is unmistakable. The still life has a luminosity and radiance that seems to elevate it beyond ordinary reality. With specular highlights from its surface glistening in the sun, the bread could be priceless treasure, created in part by the dedication of the woman who carefully measures its ingredients.

47. *The Milkmaid,* detail of still life

The techniques Vermeer used in this area are remarkably varied. In the dark blue jug at the back of the still life, for example, Vermeer used a light gray paint in the initial blocking-in stage. He then indicated the placement of the raised highlights on the body of the jug with small dots of a light gray paint. This decorative pattern was defined and accented with opaque black paint, followed by the application of white accents along the top and ridges on the jug. He subsequently gave the jug its bluish tonality by applying small dabs of blue paint selectively across its surface, primarily over the black layer. Finally, he added smaller white dabs of paint to emphasize the circular highlights of the raised decorative pattern on the body of the jug.

The basket and bread were painted with equally complex layering. Vermeer apparently built up his forms over the light ocher ground without an intermediary imprimatura layer. The modeling of the objects, however, was fully determined beforehand, although he might have changed his mind about the shape or the play of light on the bread on the left in the basket. Microscopic examination of this area reveals that Vermeer initially completed the basket under the bread.

Vermeer seems to have begun by building up the sunlit sections of the still life. He used for the bread and the basket a rich orange brown that, to judge by the strength of the x-radiograph image, must have been mixed with a dense lead-bearing paint, perhaps a combination of lead white and lead-tin yellow. To accent the highlights on the bread, basket, and in particular its handle, Vermeer applied, perhaps in the wet paint, thick dabs of white and off-white paint. He then laid on a glaze of red lake to indicate the shaded areas.[8] Vermeer then used this same red lake glaze to help accent the bread and to give form to the handle of the basket. He applied the glaze between the peaks of the impasto he had applied on the handle and allowed it to seep into the crevices. As the color varied according to the thickness of the layer, it enhanced the three-dimensional effects he sought to achieve. After applying the glaze, Vermeer applied small dots of white paint over the bread and basket as added specular highlights, to suggest sunlight glancing off their forms.

The complex layering of glazes and opaque layers of paint and the succession of diffuse highlights laid over one another were not techniques that Vermeer applied indiscriminately. His use of paint to suggest characteristics of light and texture was not a conceit, exploited in and of itself. Probably no area of a painting in Vermeer's oeuvre is as complex as the still life in *The Milkmaid,* but the demands of the subject matter, the need to suggest light flickering off complex and multifaceted objects, apparently led him to express these effects in this manner. True precedents in his work or in the work of others do not exist, for although specular highlights were commonly used to accent objects, as for example in the paintings of Kalf, they were never integrated into such complex layers of paint.

The question has often been asked whether the character of the modeling on the still life might be related to optical effects seen in a camera obscura. The role of technical aids, or of optical instruments, on an artist's style is clearly an intangible that never can be properly measured, partly because their influence varies according to how receptive the artist is to the effects they create. Vermeer was apparently very receptive to new ideas early in his career. The camera obscura may be responsible for some of the effects in the still life, but only to a certain extent. Brightly illuminated objects, seen slightly out of focus, appear to have a profusion of diffused specular highlights flickering across their surfaces. Such effects are not unknown in normal vision, but they are never as obvious to the eye as when seen under these circumstances. Vermeer's painting techniques, however, do not just stress surface characteristics; they also stress the object's physicality, both its mass and its texture. The camera obscura thus is at best only a partial explanation.

By the time he painted *The Milkmaid* in the late 1650s, Vermeer had already established

an extensive visual and technical vocabulary in his search for ever more expressive means for suggesting effects of light and texture. Moreover, he had a keen interest in composing his works to make the images look unposed, which parallels the character of images seen in a camera obscura. Crucial to this sense was Vermeer's awareness of how to frame an image—where to cut forms at the edge of the painting to suggest both the integrity of the scene as depicted and the world beyond its confines.

Whether it was due to the impact of the camera obscura or not, the care with which Vermeer built up his still life with imprimatura, opaque layers, glazes, and highlights attests to the importance he gave to translating the optical qualities of objects in paint. Paint succeeds in suggesting both the textures of the objects and the flickering quality of light reflecting from their surfaces. In the other areas of the painting different balances exist. In the wicker basket hanging on the back wall, where little direct light hits, the textural patterns of the weave could be created with fewer layers, however intricately involved the juxtaposition of paints might be. The shimmering reflection of the brass basket, however, which is half in shade and half in light, was painted quite differently. Here the highlights

48. X-radiograph of
The Milkmaid

are thickly applied, but softened and modeled with a thin brownish glaze that also continues over the darker parts of the vessel.

The light that illuminates all of these objects enters the room through the window on the left. Vermeer transmitted the sense of light less through the diffused white color of the glass than through the soft shadows created by the window leading on the inner edge of the window frame. To emphasize the translucence of the glass, he also painted one window pane as though slightly broken, so that a small pocket of bright light shines through and illuminates the inner edge of the window frame.

The directional flow of light is one of the elements that focuses attention on the woman as it falls on her white cap, head, upper body, arms, the milk she is pouring, and the still life on the table. The bold color accents of the vivid yellow jacket and blue apron it illuminates at the center of the composition echo the still-life elements.

That Vermeer focused on such concerns can be confirmed through x-radiographs, which indicate that he once blocked in a horizontal shape, probably a wall map, on the back wall just above the woman (fig. 48). This wall hanging would have created a strong horizontal axis at that level and thus would have distracted attention from the left center area of the painting. The decision to eliminate this shape on the wall, whether a map or a painting, could also have been made for thematic or iconographic purposes, but without knowing what this shape depicted, one cannot judge Vermeer's intention.

Vermeer drew the viewer's eye to the central focus of the milkmaid through a variety of other means as well: the perspective of the window panes, whose orthogonals intersect in a general area above and on her right arm; the diagonally arranged sequence of objects hanging at the upper left, objects whose color becomes progressively brighter as they near her; and the shadows cast on the back wall by the brass bucket. The strong diagonal of the table edge in a similar fashion leads up to the woman's body. The peculiar shape of the table, whose sides are not parallel, makes one suspect that Vermeer designed it specifically for the composition.

With so much visual concentration on the milkmaid at the left half of the composition, the footwarmer in the lower right seems at first glance to be an afterthought. The footwarmer does create a sense of space and air around the woman by defining the area behind her; but, in its muted colors, related closely to the ocher floor and grayish tiles, it would seem that Vermeer intended to minimize its visual impact so as not to conflict with the primary focus on the woman pouring milk. Reflectography suggests, however, that the footwarmer was a carefully considered addition (fig. 49). In this space Vermeer had initially

49. Infrared reflectogram of footwarmer in *The Milkmaid*

50. "Mignon des Dames," engraving from Roemer Visscher, *Sinnepoppen.* Library, National Gallery of Art, Washington, D.C.

blocked in the shape of a large basket, seemingly filled with clothes. The remains of the handle of this basket can still be seen on the wall slightly above the tiles. With the basket in place the composition would have appeared quite different, since all access into the background space would have been denied.

The shift may also have been motivated for iconographic reasons. The basket of clothes would almost certainly have emphasized the domestic responsibilities of the milkmaid, but the footwarmer, in addition to its functional use, had associations with love. These were explicitly stated in Roemer Visscher's well-known emblem book, *Sinnepoppen,* where an emblem illustrating a footwarmer was given the motto "Mignon des Dames," or "favorite of the ladies" (fig. 50).[9] Visscher used the motif of the footwarmer as a model for suitors: women preferred men who, like the footwarmer, provided constant attention and caring. Vermeer probably intended such ideas to be associated with the footwarmer because when he added the footwarmer he also added the border of tiles behind it, which contains at least two images of cupids at play.[10] Because it is unlikely that a kitchen space would have a border of cupid tiles, Vermeer must have consciously intended to juxtapose them with the footwarmer.[11]

Vermeer's intention with this compositional change is not entirely clear. It is probable, however, that the footwarmer and tiles, which exist in a minor key in support of the primary visual focus, had a comparably supportive iconographic function. As she carefully steadies the flow of milk from her pitcher to the earthenware bowl, the milkmaid embodies the ideals of constant attention and caring associated in emblematic literature with the footwarmer. It seems as though the milk she pours could never cease to flow, or the bread before her fail to nourish. Through her actions, which are carried out with a sense of dignity and responsibility, the milkmaid expresses a warmth, a caring and human affection that is constant and abiding.

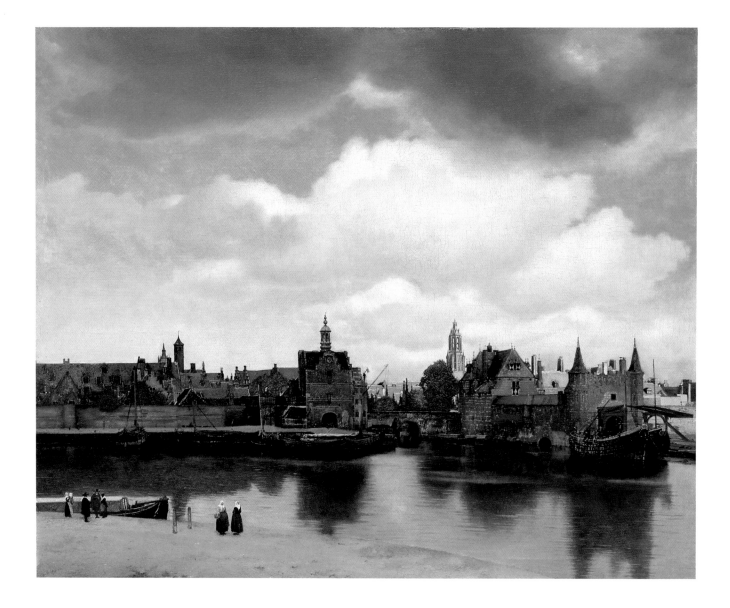

View of Delft

51. *View of Delft,* c.
1660–61, oil on canvas.
Mauritshuis, The Hague

In the stillness of early morning light, the towers, roofs, and walls of Delft stretch across Vermeer's imposing view of the city (fig. 51).[1] Beyond the darkly weathered city walls and fortresslike gates that guard the entrance to Delft, light falls on the orange tile roofs of the houses and the tower of the Nieuwe Kerk as though life were awakening within the city if not without. Although several figures stand and converse near a transport boat on the near shore of the harbor before the city, and a few are seen walking on the quay on the far shore, their forms are no less quiet and subdued than the walls themselves.[2] The painting tells no story, describes no event, and does not even allow access to the town. Yet it is one of the most memorable city views ever created.

So extraordinary is the image that it is difficult to place it within an art historical perspective. *View of Delft* appears to have no direct precedents and, despite being Vermeer's most famous painting, is an anomaly within his oeuvre. Yet it has such fullness of expression that no one doubts the conviction with which it was conceived. This conviction stems to a greater degree than heretofore recognized from pictorial traditions, but it also draws on Vermeer's inherent sense of the dignity, power, and purpose of the city that he depicted.

The impact of this painting on a viewer seeing it for the first time is perhaps best expressed by Thoré-Bürger in his article on Vermeer, written in 1886. Thoré-Bürger discovered *View of Delft* while visiting the Mauritshuis and later wrote that its indelible image motivated him to attempt a reconstruction of the oeuvre of this, to him, unknown painter. He wrote:

> In the museum of the Hague, a superb, unique landscape stops visitors and keenly impresses artists and connoisseurs of painting. It is a view of a town, with a quai, an old portal, the buildings of a varied architecture, garden walls, trees, and in the foreground, a canal and a strip of land with several small figures. The silver gray of the sky and the tones of the water call to mind Philip Koninck. The burst of light, and intensity of color, the solidity of impasto in certain areas, the hyper-real yet very original effect also recall something of Rembrandt.[3]

Thoré-Bürger, however, was by no means the first to recognize the qualities of *View of Delft*. In the Dissius sale of 1696 the painting sold for 200 florins, the highest price paid for any of the 21 Vermeer paintings auctioned at that time.[4] In 1822, when the painting was bought for the Mauritshuis, the sales catalogue described it as "the most famous painting of this master whose works seldom occur; the way of painting is the most audacious, powerful, and masterly that one can image."[5]

The emotional impact of the painting derives from the bold silhouette of the city against the sky, the reflections of the buildings in the water, and above all, from the dramatic use of light to focus the composition and articulate the space. The scene seems bathed in light, yet only the background buildings are directly illuminated by the sun. The dark clouds that cover and close the upper reaches of the sky effectively shade the roofs and façades of the nearby buildings, water, and foreground figures.

Understanding just how Vermeer created such a naturalistic impression while transforming a topographical view into one that is powerful and audacious in the way Thoré-Bürger and others have described is, in fact, central to our perceptions of Vermeer's oeuvre. Here, for once, it is possible to compare his image with the view as it is known in Vermeer's lifetime through prints, drawings, and maps.

Vermeer's painting represents the city of Delft as seen from the south. Beyond the harbor that lies before the town stand the city walls that are broken only by the small Kethel Gate, which is adjacent to the large Schiedam Gate with its clock tower, the bridge, and the Rotterdam Gate with its twin towers. The site was an important one for seventeenth-century Delft since from this area roads and waterways extended to Rotterdam, Schiedam, and Delfshaven. Maps from the period, including the large *Figurative Map of Delft* (fig. 52) from 1675–78, show this harbor to be filled with boats not only lined up at the quay, but also sailing down the Schie.

For Vermeer's contemporaries, however, *View of Delft* must have seemed particularly unusual. Although the location would have been immediately recognizable, the stillness of the scene would have been uncharacteristic. Even though Vermeer includes a large number of boats in this scene, only the small transport craft in the left foreground and the two larger herring ships moored at the shipyards at the right are immediately evident. The other boats are all moored along the far edge of the water, where they visually blend with the background because Vermeer has rendered their colors and textures so similar to those of the adjacent quays, city walls, and buildings. Clearly, Vermeer subordinated the commercial and mercantile activities of the area to focus on Delft's distinctive architectural character.

52. Delft, detail from *Figurative Map of Delft*, 1675–78. Library, National Gallery of Art, Washington, D.C.

The question remains as to whether Vermeer was as consciously selective in his depictions of buildings as he was in his representations of shipping in the harbor. This work has generally been described as being topographically accurate and many have speculated that he created such an accurate image by using a camera obscura.[6] Indeed, comparisons with old maps and town plans convincingly reinforce the sensation that Vermeer has carefully rendered the city's appearance from its southern side.[7] In addition to the distinctive gates and the tower of the Nieuwe Kerk, other elements are identifiable. The façades of buildings lining the three canals that branch out just beyond the bridge, for example, are visible to the left and right of the Schiedam gate. The façades of the buildings on the Kethelstraat just behind the city wall on the left, and the tower of the Oude Kerk, the distant multi-spired tower in the left center of the composition that rises just beyond the dark cone-shaped spire, are all accurately portrayed.[8] Nevertheless, these same comparisons with old maps and town plans, as well as technical examinations of the painting itself, have revealed that Vermeer made a number of small adjustments in his depiction of the site to enhance its pictorial image.

The apparent realism of the scene comes not only from the recognizable shapes of the structures, but also from the truthfulness of their textures. Vermeer used a wide range of

techniques to suggest the rough-hewn character of the orange tile and blue slate roofs, the stone, brick, and mortar walls of the buildings and bridges, as well as the leafy trees and wooden boats. He never precisely delineated these materials, however, devising instead a variety of means for suggesting their tactile characteristics.

One of his most successful effects is found on the red tiled roof at the left of the painting (fig. 53). Here he has rendered its rough and broken surface by overlaying a thin reddish brown layer with numerous small dabs of red, brown, and blue paint. These dots of paint are not blended into the underlying layer but are juxtaposed in such a way that their very irregularity suggests the roughness of the roof. Augmenting this effect is the manner in which Vermeer enhanced the grainy quality of the tile roof with small bumps that protrude from the surface, using large particles of lead white and silica either applied to the ground or mixed with the thin reddish base color for the roof.

These textures are quite different from those found in the sunlit roofs in the middle distance, where Vermeer minimized individual nuances of the tile. Here he emphasized the physical presence of the tiles by using a thick layer of salmon-colored paint. The impastos of the roofs are even more evident in the tower of the Nieuwe Kerk. Vermeer seems almost to have sculpted the sunlit portions of the tower with a heavy application of lumps of lead-tin yellow. The blue roof of the Rotterdam Gate is relatively smooth, with white highlights dotting the surface to enliven it. The chimneys, however, are rendered in a technique similar to that used on the red roofs on the left, including the lumps of lead white that protrude through the reddish layer. The yellow roof above the Rotterdam Gate (fig. 54), the one that Proust so admired, was first painted a salmon color similar to the one Vermeer used in the distant rooftops. The dense yellow layer with which he covered it is similar in texture to that of the Nieuwe Kerk.

Vermeer's painting technique differs again in the boat in the lower right; here he painted highlights that do not suggest texture (fig. 55). Indeed, the diffuse highlights often obscure the underlying structure rather than reinforce it. They seem intended to indicate flickering reflections from the water onto the boat. Painted in a variety of ochers, grays, and whites, these highlights cover a larger area and have a more regular contour than the dots found on the red tile roofs. Over these diffuse highlights Vermeer painted more opaque ones, some of which were apparently applied wet in wet.

Vermeer's efforts to simulate the various textures of the buildings and boats by varying his painting techniques underscore his interest in making this image as realistic as possible. Nevertheless, certain techniques of painting, compositional distortions, and alterations in

53. *View of Delft,* detail of red roof on left

54. *View of Delft,* detail of yellow roof on right

55. *View of Delft*,
detail of boat

the shapes of buildings indicate that, as with *The Little Street*, Vermeer was not concerned primarily with topographical accuracy, but rather with conveying the character of the city that he saw before him.

In giving dramatic impact to this work, Vermeer emphasized Delft's silhouette against the light sky by darkening the foreground buildings and by accentuating their contours with a white contour line, similar in character to that in *The Milkmaid* and *The Little Street*. This line can be seen above many of the roofs, most clearly above the Schiedam Gate. In the center distance Vermeer has tied together the diverse roof lines with a pale blue horizontal shape that is meant to read as a roof, but which has no relationship to reality. The long, horizontal building on the left of the painting, moreover, is almost certainly imaginary; no comparable structure is found in contemporary views.

In all of these changes, Vermeer sought to simplify the cityscape by emphasizing the buildings' parallel orientation. By comparing the site with a section of the large *Figurative Map of Delft* from the mid-1670s, it becomes clear that the topography is more irregular than Vermeer suggested (see fig. 52). The twin towers of the Rotterdam Gate, for example, project far out into the water.[9] Vermeer made the gate virtually at right angles to the picture plane by distorting the perspective. To be consistent with the rest of the composition,

56. Abraham Rademaker (1675–1735), *View of Delft,* n.d., pen and wash on paper. Stedelijk Museum, "Het Prinsenhof," Delft

57. Infrared reflectogram of *View of Delft*

the focal point of the perspective should have fallen slightly left of center. Orthogonals constructed along the gate, however, join far to the left of the painting, meaning that he must have consciously flattened their forms.

A pen drawing of the same site from the early eighteenth century by the topographical artist A. Rademaker offers an interesting comparison (fig. 56). Although the vantage point in the drawing is slightly closer and lower than Vermeer's, Rademaker's view in other respects is comparable. His interpretation of the scene, however, is different. In his drawing the covered portion of the Rotterdam Gate projects forward, thereby creating a more three-dimensional composition. Part of this effect comes from the perspective, part from the detailed articulation of architectural elements, and part from the effect of shadows on these buildings. Rademaker, like many other artists who depicted this area, emphasized the horizontal bands on the side of the Rotterdam Gate that were made by alternating levels of brick and light-colored stone, whereas Vermeer merely suggested their presence with a series of shifting light-colored dots of paint. Examination of the painting with x-radiography and infrared reflectography (fig. 57) has shown that Vermeer initially painted the twin towers of the Rotterdam Gate in bright sunlight.[10] Thus, in his original conception the pronounced light and shadow effects on the towers were comparable to those seen in Rademaker's drawing.

[78]

Comparison of *View of Delft* with Rademaker's drawing illustrates other differences: in the latter, the profile of the city is more jagged and uneven and buildings are taller, narrower, and set more closely together. Vermeer made numerous modifications in his city view to simplify and harmonize its appearance. To emphasize the horizontals of the cityscape, he apparently straightened the bowed arch of the bridge.[11] It is uncertain whether Vermeer elongated the bridge as well. Most views of the city from the south place the two gates somewhat closer together than Vermeer did.[12]

Finally, the tower of the Nieuwe Kerk, though strikingly illuminated, is not as large as one might expect.[13] Vermeer may have minimized the scale of the Nieuwe Kerk to emphasize its distance from the foreground plane. The tower also blends more successfully with the horizontality of the composition than it would were it slightly larger.

Aside from topographical adjustments and changes in light effects, Vermeer made a number of adjustments in the boats and reflections in the water that further enhance the strong horizontal orientation of the scene. Infrared reflectography reveals that Vermeer made a fascinating alteration in the position of the herring boats on the far right of the composition. He originally painted both boats somewhat smaller, subsequently enlarging the stern of the foreground boat and the bow of the second. The most significant change is with the foreground boat, which previously ended just to the right of the left tower of the Rotterdam Gate. The original reflection in the water of this first idea can be seen in the reflectogram. By extending the rear of this boat backward and to the left, Vermeer minimized its recession into space as he had by altering the perspective of the Rotterdam Gate.

A further important change in the composition, visible in x-radiographs and infrared reflectograms, was the adjustment of the reflection of the twin towers of the Rotterdam Gate. The original reflections denoted the architectural forms of the building on the far shore quite precisely. In his final design, however, Vermeer extended them downward so that they intersect with the bottom edge of the picture. The effect of the combined reflection of the Rotterdam Gate towers and the Schiedam Gate in the center (both of which reach the foreground shore) is to bind the city profile and foreground elements in a subtle yet essential manner. The reflections, which function almost as shadows, add weight and solemnity to the mass of buildings along the far shore. Beyond anchoring these structures in the foreground, the exaggerated reflections of specific portions of the city profile create accents that establish a secondary visual pattern of horizontals, verticals, and diagonals across the scene.

Such modifications in topography and intentional compositional adjustments thus force one to reconsider the assumptions that one brings to this work. If *View of Delft* varies slightly from topographical exactitude, how does one approach the question of Vermeer's use of the camera obscura? Although the assumption has often been made that Vermeer used the camera obscura to create a topographically accurate image, this clearly was not the case. In a broader sense, however, he might have viewed the image produced by the camera obscura as a means of enhancing the illusion of reality in his painting.

Scholars have noted that Vermeer could have seen such a view of Delft from the second story of a house situated across the harbor from the Schiedam and Rotterdam gates. This house can be located on old maps, and recent scientific projections of his viewpoint have reinforced that hypothesis.[14] Of course, no documentary evidence indicates whether Vermeer actually set up a camera obscura in this location or if even he painted his scene there. Nevertheless, it seems probable that Vermeer used the camera obscura at some stage in his working process because distinctive effects of light, color, atmosphere, as well as the diffusion of highlights associated with the camera obscura are found in this painting.

Although Vermeer articulated his images with small dabs or globules of paint to enhance textural effects from almost the beginning of his career, the diffused highlights on the boat on the far shore of the Schie in *View of Delft* are different. Not only are they more diffuse than in other paintings, but they are also unrelated to texture: their purpose is to suggest flickering reflections off the water. Such reflections would appear as diffuse circular highlights in an unfocused image of a camera obscura, and would appear only in sunlight, not in the shadows as they are here painted. Thus, even when it seems that he used such a device, Vermeer modified and adjusted its image for compositional reasons.

Another optical phenomenon in this painting that relates to an image in a camera obscura is the saturation of light and color. Color accents and contrasts of light and dark are heightened and apparently exaggerated through the use of a camera obscura, thus giving an added intensity to the image. This phenomenon has the subsidiary property of minimizing the softening effects of atmospheric perspective. In *View of Delft*, all of these attributes of an image seen in the camera obscura are present. Contrasts of light and dark are pronounced, colors are vivid, and atmospheric perspective is negligible.

Vermeer apparently responded to such visual stimuli from a camera obscura and recognized that its optical effects reinforced both the naturalistic and expressive characteristics he was seeking. His realism is thus of a most profound type. Although he sought to translate the rich varieties of shape, materials, and textures of the physical world through his paint-

ing techniques, he also gave these objects an aura and significance beyond the confines of time and place.

The circumstances that led to Vermeer's depiction of the view of Delft are not known. Given the mastery of his image, it is extraordinary that no precedent exists for it within his oeuvre.[15] One might imagine that the painting was commissioned, but no evidence of a commission from Saint Luke's Guild or any other civic body exists. Indeed, the painting is not mentioned prior to 1696, the year that it appeared as item number 31 in the Dissius sale as "The city Delft in perspective, seen from the south side, by J. van der Meer from Delft."[16]

Lacking specific evidence of a commission, one hesitates to speculate on Vermeer's motivation for painting this work; nevertheless, certain observations may be offered. In the broadest sense, Vermeer chose a format that was familiar through cartographic traditions: the profile view of a city often accompanied its larger ground plan. Such a profile is found, for example, along the lower border of the large *Figurative Map of Delft* (fig. 58). These profile views of cities, however, generally emphasized the city's most distinctive landmarks. In the case of the map of Delft, that vantage point is from the west where the towers of both the Oude Kerk and Nieuwe Kerk dominate the city's profile. Vermeer's view is uncharacteristic of topographic tradition because it does not highlight these distinctive monuments of the city. In his painting the tower of the Nieuwe Kerk is not as prominent as in cartographic traditions and the Oude Kerk can barely be discerned.

The numerous topographic prints, drawings, and paintings of Dutch cities during the first half of the seventeenth century attest to the great popularity of this type of visual record. Presumably most of these views were made to satisfy market demands, both public and private. One artist who exploited this market by painting many such views was Hendrick Vroom (c. 1566–1640). In 1615 he painted two views of Delft in which he placed the city, with its major monuments plainly visible, beyond a foreground filled with the activities one might find in the surrounding countryside. In 1634 he donated these views to the municipality because of his "deep affection" for the city. As an expression of gratitude, the city offered him 150 guilders.[17] Whether or not he had offered these paintings to Delft upon their completion in 1615 is not known; however, the municipality accepted these glorifications of the city at a time when cities in Holland were asserting their importance within the political and social structure of the country.

Vroom's style of painting was by the 1630s rather old-fashioned. Most of the younger landscape artists of the day—Jan van Goyen (1596–1656), Salomon van Ruysdael

58. Profile view of Delft, detail from *Figurative Map of Delft*, 1675–78. Library, National Gallery of Art, Washington, D.C.

(1600/03–1670), and Aelbert Cuyp (1620–1691)—were less interested in careful topographical depictions than in situating city vistas into a broader pictorial context. In most of their city views of the 1630s and 1640s, the city sits well within the landscape rather than dominating it. In the late 1640s, however, at about the time of the Treaty of Münster and the renewed focus on the vitality of the city in maps and atlases by Visscher and Blaeu, the character of city views changed once again. Artists emphasized dramatic silhouettes of church spires, city walls, and windmills by bringing the point of view closer and by accenting structures in strong light.

During this period, Nijmegen, the city with the most dramatic skyline in the Netherlands because of the Valkhof fortress that had been built by Charlemagne, became a favorite subject for Van Goyen, Ruysdael, and Cuyp (fig. 59). Each artist suggested the massiveness of the stone walls with a variety of short strokes and dabs of paint, thus giving a solidity to the forms not seen in their earlier work. Artists may have chosen to paint the Valkhof at this time merely because its silhouette satisfied their compositional needs at this stage of their careers, but one wonders if the choice was not also political. Nijmegen had been the home of the Batavians, the ancient forefathers of the Dutch. The city had been the site of one of Prince Maurits' earliest major victories against the Spanish. At a time when the Dutch were finally freeing themselves of the Spanish yoke, these views of an old and distinguished city with a highly significant cultural and political heritage may have held special nationalistic meanings.

Comparable associations existed with Delft, both because it was founded in the thirteenth century and because of its close ties to the House of Orange. Vermeer's *View of Delft* can only be understood as a celebration of that long and distinguished history. The image of the city he created is almost reverential in character. From the viewpoint he chose, Delft remains distant and remote, the water obstructing one's direct approach to the city. The darkly weathered walls and fortified gates poignantly stress the city's ancient foundations and rich heritage. Beyond these shadowed walls and gates, light floods the city. It strikes in particular the Nieuwe Kerk, the focus of civic life in Delft and the site of the tomb of William the Silent. The light that streams down within the city acts as a powerful and positive force, symbolizing the city's strength and optimism, even in the aftermath of the disastrous explosion of the gunpowder warehouse in 1654.

That Vermeer may have consciously sought to give a special aura to his view of Delft seems plausible when one notes contemporary interest in glorifying Delft, its sovereignty, and its arts. In 1661, various artists, including Cornelis de Man and Leonaert Bramer, were

59. Aelbert Cuyp
(1620–1691), *View of
Nijmegen,* mid-1650s, oil
on panel. © 1994
Indianapolis Museum of
Art, anonymous gift in
commemoration of the
sixtieth anniversary of
the Indianapolis
Museum of Art

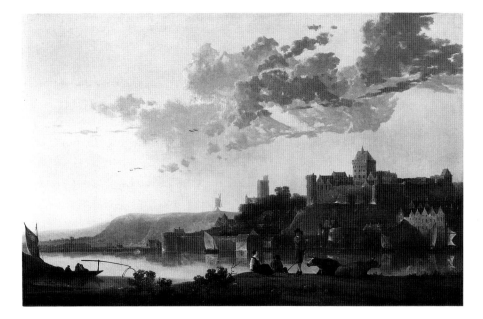

commissioned to execute allegorical works on the art of painting, architecture, and sculpture for the newly refurbished Saint Luke's Guildhouse.[18] Bramer also painted a series of the liberal arts for the guild, with painting explicitly added to the original seven. In 1667, upon the publication of Dirck van Bleyswijck's *Beschryvinge der Stadt Delft,* a description and history of the city, the author chose for his title page design an allegorical figure of Fame blowing her gilded trumpets. A few years later the town government commissioned the large *Figurative Map of Delft* for the burgemeester's room in the city hall. In this detailed view of the town, Delft was shown in its full glory, commanding the surrounding region. The symbolism of Delft's importance, however, lay not only in the impressive scale of the map, but also in the emblematic images contained in its frame.

These emblems, while different in kind from the more subjective devices used by Vermeer to glorify Delft and its heritage, have at their roots a common need to convey the importance of the image beyond its physical characteristics. This concept that art goes beyond description, that it contains references to essential truths fundamental to human experience, is found in all of Vermeer's paintings.

[83]

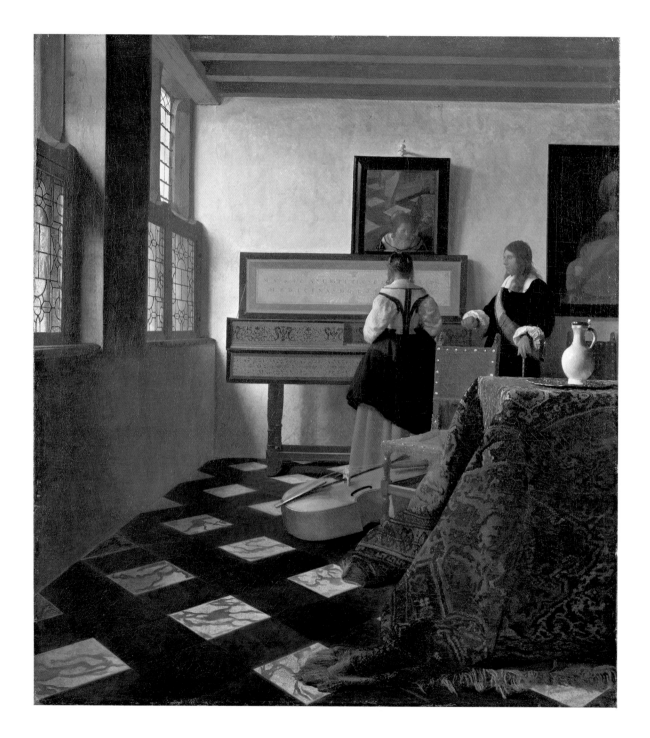

CHAPTER VIII

~

The Music Lesson

The virginal was an instrument greatly admired by the Dutch upper class during the mid-seventeenth century. The lyrical yet restrained tones that resonated from its keyboard underscored the refinement in taste that accompanied the increase of wealth and influence enjoyed by this society. The music written for the virginal, by (among others) Constantijn Huygens (1596–1687), was measured in its rhythms, and nuances of timing were carefully conceived and executed. The lyrics that often accompanied the music extolled love, both human and spiritual, and the solace that could be gained from it. The sentiments the music and lyrics expressed and the role they played within the upper echelons of Dutch society frequently were inscribed on the instruments themselves. The text on the lid of the virginal in *The Music Lesson* (fig. 60), reads: "Mvsica letitiae co[me]s medicina dolor[vm]" (Music: companion of joy, balm for sorrow).

Of the many paintings from the period that feature the virginal, none captures as well as Vermeer's the balance and harmony of its music or the elegance and refinement of the world to which it belonged. Every object in Vermeer's spacious interior is as carefully considered and identified as the notes in a song by Huygens, yet these independent entities are likewise carefully orchestrated to be brought together into a whole whose mood is based upon a firm mathematical and geometric foundation.

The instrument that is at the focus of Vermeer's painting can be identified as one made by the famed Antwerp instrument maker Andreas Ruckers (1579–1654).[1] Its large scale and the elaborately painted decorative elements covering its various surfaces mark it as one of Ruckers' finest productions. The painter clearly admired the craftsmanship with which it was made and recorded its exquisite detail with care.

That Vermeer gave such prominence to the virginal and that a family expended the vast sum that such an outstanding instrument would have required indicate the importance of this instrument in Dutch society. To judge from the number of depictions of maidens seated or standing at such instruments from the 1650s and 1660s by Frans van Mieris, Jan Steen, Gerard ter Borch, Gerard Dou, Gabriel Metsu, and Vermeer, a young woman's

61. Jan Steen (c.
1625–1679), *The Music
Master*, c. 1659, oil on
panel. Reproduced by
courtesy of the Trustees,
The National Gallery,
London

proficiency in this art was greatly esteemed.[2] A music master was often retained to instruct the young woman. Once having mastered the art she would perform solo or as part of a duet or trio, usually within a domestic setting. Indeed, aside from being an artistic form of expression suitable for a young woman, proficiency at the clavecin, virginal, or harpsichord also served a social function, for it facilitated polite contact between the sexes.

Artists were fascinated with the nature of that contact, and exploited the theme of the music lesson or concert as a vehicle for depicting the sensuality as well as the social acceptability of a woman playing such an instrument. Sometimes, as in Jan Steen's *Harpsichord Lesson* in the Wallace Collection, the music master's attentions to the attractive pupil are seen as lecherous, but usually a spirit of sensual harmony pervades the scene that is not out of keeping with the elevated ideals inscribed on the instruments. In Steen's *Music Master*, c. 1659 (fig. 61), for example, the man's attentive attitude conveys an ease and familiarity with the woman, yet nothing in his demeanor or in her upright posture suggests that they are disrespectful of the elevated sentiments plainly visible on the cover of the harpsichord: "Soli Deo Gloria." Indeed, rather than a music master, it seems more probable that the man is a suitor who, moved by the woman's beauty and that of her music, feels in perfect harmony with his beloved.

A comparable feeling of harmony pervades Vermeer's *Girl Interrupted at Her Music* from the early 1660s (see fig. A13), where an attentive gentleman assists a young woman with her sheet music. A painting of Cupid on the rear wall affirms that the contact between the two is amorous; the relationship of this image of Cupid to an emblem by Otto van

62. "Qvid Non Sentit
Amor," engraving from
Jacob Cats, *Proteus*.
Library, National Gallery
of Art, Washington,
D.C.

63. "Zy blinckt, en doet
al blincken," engraving
from P. C. Hoot,
Emblemata Amatoria.
Library, National Gallery
of Art, Washington,
D.C.

Veen, which stressses the importance of taking but one lover, establishes the moral tenor of the scene.³ Similarly, the man who is so transfixed by the music in *The Music Lesson* is almost certainly not a music master, and his presence must be otherwise explained. He is an aristocratic gentleman, perhaps a suitor, dressed in a conservative black costume that is accented by a white collar and elegant white cuffs. He stands resting a hand on his staff, while a gold-knobbed sword hangs from the white sash that crosses his chest.

Music was often used metaphorically to suggest the harmony of two souls in love. In one of his most familiar emblems, for example, Jacob Cats depicted a lute player in an interior before an open window (fig. 62).⁴ Beside him lies another lute, unused. As Cats explained in his text, the emblem "Qvid Non Sentit Amor" means that the resonances of one lute echo onto the other just as two hearts can exist in total harmony even if they are separated. Steen's painting probably incorporates a similar sentiment, for in the background of the scene a young servant brings the man at the clavecin a lute, an indication of the harmony shared by the pair. The presence of the bass viol on the floor in Vermeer's *Music Lesson* may serve a similar thematic function.

Even more directly related to Vermeer's painting is the emblem "Zy blinckt, en doet al blincken" (it shines and makes everything shine) in P. C. Hooft's *Emblemata Amatoria* (fig. 63).⁵ The emblem contains two vignettes, Cupid holding a mirror reflecting sunrays in the foreground, and a man standing near a woman playing a keyboard instrument in the background. The accompanying verses explain that just as a mirror reflects the sunlight it receives, so does love reflect its source in the beloved. What love one possesses comes not from oneself, but from the beloved. Although the image of Cupid with the mirror depicts quite literally the message of Hooft's verses, the figures in the background—the man looking with rapt attention at his beloved, whose music has so moved him—expand upon them metaphorically. The compositional relationships between the emblem and *The Music Lesson* suggest that Vermeer had a similar concept in mind when conceiving his work. Not only do the figures in the background of the emblem bear a striking resemblance to those in *The Music Lesson,* the emphasis on the mirror in the emblem parallels the prominence given to the woman's reflection in the mirror in Vermeer's painting.

Given the similarity in theme between Steen's and Vermeer's paintings, the differences in their artistic approaches are remarkable. Steen emphasized the narrative elements of the scene by allowing the viewer to look over the harpsichord player's shoulder and watch her hands playing the keys. The music book can be seen and the figures' expressions studied. The room around them is undefined so that primary attention is placed on their relation-

64. *The Music Lesson,* detail of woman and mirror

ship, although the angle at which Steen placed the harpsichord does lead the eye back to the doorway and to the servant bringing the lute down the stairs. Vermeer, in contrast, virtually eliminated the narrative. The woman is seen directly from behind. Her hands and music are obscured from the viewer; her face, partially turned toward the gentleman, is only dimly visible in the mirror hanging before her (fig. 64). Thus Vermeer emphasized less the specifics of the woman and her music than the abstract concepts her music embodies: joy, harmony in love, healing, and solace. Vermeer seems to have rethought the pictorial tradition within which Steen worked by transforming the allusions to love into something more universal and less moralizing.

Vermeer's message, delivered in measured cadences rather than in a compelling narrative, partakes of the total environment in which the figures exist rather than being focused on their attitudes and activities. For Vermeer, the room's geometric character, its furnishings, and the light that pervades it establish the essential framework for conveying the nature of the relationships of the figures at the clavecin. The theme of healing and solace,

for example, is reinforced through the painting partially visible on the rear wall. Just enough of its image is visible to identify it as a depiction of Cimon and Pero, a story taken from Valerius Maximus that is better known as *Roman Charity*.[6] Other elements in the room also reinforce the painting's thematic content, including the white pitcher on the tapestry-covered table in the immediate foreground of this deeply recessive interior space.

Brilliantly illuminated by the sun, this pure white, elegantly proportioned ceramic pitcher on a sparkling silver platter is an object whose meaning has never been explained. A similar pitcher occurs in both *The Glass of Wine* in the Gemäldegalerie, Berlin (see fig. A10) and *The Girl with the Wine Glass* in the Herzog Anton Ulrich-Museum, Brunswick (see fig. A11). In each instance Vermeer has depicted it as the vessel from which the wine has been poured, and thus as part of the sensual, and hence negatively intended, component of the composition. An even more explicit example of the sensual implications of the wine pitcher is evident in Frans van Mieris' *Oyster Meal* (fig. 65), where it is placed in conjunction with a platter of oysters, which were commonly viewed as an aphrodisiac. It could be argued that such associations exist here as well. Nevertheless, its context is essentially different from the ones seen in the Berlin and Brunswick paintings. Here it exists independent of a genre context. No glasses are visible, no figures are near. The beauty and purity of its starkly illuminated form gives it an almost sacramental character, reminiscent of the ewer and basin found in early Netherlandish scenes of the Annunciation. The pitcher reinforces the positive thematic message of the painting. Whether seen as a vessel containing the cleansing freshness of water or the nourishment of wine, its function parallels rather than contrasts with those symbolized by the *Roman Charity* and the woman at the virginal.[7]

A final component of Vermeer's composition that is difficult to explain fully is the mirror (see fig. 64). Vermeer carefully placed it directly above the keyboard of the virginal so that the bottom edge of its black frame is overlapped by the black painted border of the instrument's lid. He thus linked it compositionally with the virginal and created a visual vertical extension of the instrument's rectangular geometric form directly above the young woman. By this means, and by including her reflection in the mirror, he reinforced her compositional and thematic significance within the painting.

By tilting the mirror, Vermeer allows the viewer to look down on the woman and the carpeted table and floor tiles; this device also reveals the bottom portion of the artist's easel. The reasons he decided to include the easel are unknown. One possibility is that he was trying to depict the scene as he saw it with total accuracy. Indeed, the sensitivity with which he has rendered the reflection in the mirror is remarkable. He set the image back into the mir-

65. Frans van Mieris the Elder (1635–1681), *Oyster Meal,* 1661, oil on panel. Mauritshuis, The Hague

ror rather than as though it were painted on its surface by rendering forms softer and smaller and by depicting the distorted reflections along the mirror's beveled edge. He carefully recorded the perspective of the table and floor and rendered naturalistically the light falling on the woman from the window. Nevertheless, as with still-life painters like Abraham van Beyeren (1620/21–1690), who often included an image of the artist at work in the reflection in a silver pitcher, Vermeer probably intended the image of his easel in the mirror as an artistic conceit, as a reminder that he had orchestrated this scene and that he, with his remarkable technical virtuosity, was bringing it to life. A final possibility is that, in the tradition of Jan van Eyck in the *Arnolfini Marriage Portrait* (National Gallery, London), his presence in the mirror indicated that Vermeer was a witness to this private and yet transcendent moment in which art and nature, through the vehicle of music, become harmoniously united. These three explanations for the presence of the easel, far from being mutually exclusive, are totally interrelated and offer a clue to the complex workings of the artist's mind.

The illusionism of the image in the mirror works because it reflects a room that convinces the viewer of its reality. Vermeer has so carefully constructed the space, created the sense of texture in objects, and naturalistically rendered light effects that the viewer feels immediately drawn into that world. One accepts its existence as a matter of course. One's overriding sense is that if illusionism exists here, it is to be found in the mirror, not in the reality it reflects.

The basis of Vermeer's manipulation of spatial effects is his awareness of the expressive possibilities of linear perspective. By constructing a relatively short distance point, Vermeer used a sharply receding perspective to make the room look larger than it probably was in reality. The scale variation between foreground and background is abrupt and that contrast, as well as the pronounced orthogonals of the window frames along the left wall, directs the eye immediately to the background. Vermeer further compressed that space by filling the right side of the composition with the large tapestry-covered table. Because the table is placed perpendicular to the picture plane, the orthogonals of its receding edge also lead to the vanishing point situated on the sunlit left sleeve of the young woman at the virginal. The eye is drawn to that central figure by the perspective and held there by the vivid colors of her costume. The reflection of her face in the mirror, by which she becomes accessible to the viewer, reinforces her significance as does the clear geometry of the starkly silhouetted forms of the virginal and mirror that frame her.

Vermeer's perspective, however, is only one component of the powerfully evocative character of this interior. His asymmetrical arrangement, in which the left side of the room

66. *The Music Lesson,*
detail of pitcher and
tablecloth

67. *The Music Lesson,*
detail of tablecloth

is empty and the right side is filled with objects, creates a dynamic balance around the centrally placed vanishing point that is crucial to the emotional impact of the scene. The woman becomes the fulcrum around which the public and private worlds of this painting revolve. She is the one to whom the viewer has direct visual access and the one through whom the harmonious chords of the music are released. She is, however, turned from the viewer. From the direction of her gaze in the mirror one comes to realize that the privacy of her relationship with the gentleman is a secondary theme that Vermeer has included to enlarge upon the first. He preserves their privacy through the exclusiveness of their gazes, but also by creating for them an intimate space within this vast interior behind the compact arrangement of furniture on the right.

The artificial constructs of this dynamically charged space are convincing because of the realistic character of the light and textural effects that Vermeer created. An important component of the perspectival construction, for example, is the diagonal pattern of the black-and-white marble floor. To enhance its illusionistic effect, Vermeer not only reduced the amount of detail for rendering the veins of the marble as the floor recedes into depth, but also varied its color. In the foreground the black squares of marble are given a bluish cast, but this tone changes to a dark gray halfway into the room.

The most extraordinary textural effects in the foreground occur on the table in the tapestry, silver platter, and white pitcher (fig. 66). Each of these objects has a different sur-

face and Vermeer used all of the technical prowess he had available to capture the differences in their materials. Vermeer constructed the rich patterns of the tapestry so that they convincingly curve over the folds as it gracefully drapes to the floor. Its colors range from the deep reds, blues, and blacks in the shadows to the very light, almost pastel tones of the summarily indicated patterns on the sunlit and receding planes along the top and left edge. Although Vermeer created the illusion of the tapestry's nubby weave throughout, he only thoroughly developed this textural quality along the sunfilled front edge of the table (fig. 67).[8] Here, he built his form with a number of layers of paint. He first laid down a black layer over the light ocher ground and on this base applied a thin layer of natural ultramarine. He then created the yellow and red textile pattern over this deep blue foundation.[9] The circular form of their accents can still be seen underneath the thin layer of lead-tin yellow that he then applied over them to unite them into a broader pattern. Vermeer used a similar technique in the reds, although he probably created the thick dabs of red with a combination of a red lake and lead white since the red is not as dense a color as the lead-tin yellow. As in the yellows he covered these accents with a thin glaze. The accents on the blues are less dense than in the reds and yellows and appear to be a mixture of lead white and ultramarine that lie on the surface.

Vermeer used a different technique to indicate the specular reflections off the silver platter. On a base of light blue paint laid over a light ground color, the form and accents

68. *The Music Lesson,* detail of window

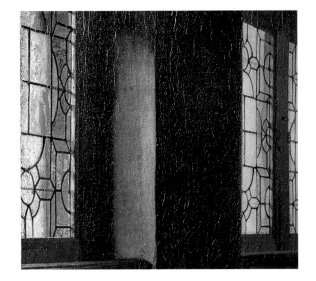

were developed with a sequence of short strokes of varying shades of olive green, some of which were applied wet in wet. White accents, applied in what appears to be a relatively random pattern, lie on top. Finally, Vermeer created the white pitcher's sheen with an application of lead-white paint so smooth that individual brushstrokes cannot be distinguished. Vermeer conveyed the translucency of the shaded side of the pitcher's base with a thin light blue glaze that lies over the light olive green of the silver platter. He then indicated the specular reflection of the platter on this darkened side of the pitcher with a few irregular strokes of white.

In each of these instances Vermeer accented the textural characteristics of these objects through the way he depicted light hitting their surfaces. Vermeer's interest in the interaction of light with such objects is but one aspect of his mastery in this painting. From the shadows of the leading in the glass on the window frames (fig. 68) to the multiple shadows on the sunlit wall behind the mirror or virginal top, he convinces the viewer of the flow of light into the room. Upon examining these light effects, however, one realizes not only how carefully Vermeer observed its various characteristics, but also how he used them selectively and creatively. Light falling at the back of the room, for example, is much brighter than it is in the foreground, probably because he had blocked the windows to the left of the picture plane with a shutter or curtain. In this way he helps draw the eye to the far side of the room. Given the reduced level of light entering through the foreground window, the brilliance of the light hitting the tabletop, platter, and pitcher is logically inconsistent even if compositionally effective.

Light effects around the virginal are far more artificially conceived than one would initially suspect. That direct sunlight enters the room is clear from the bright rear wall and pronounced diagonal shadow falling from the windowsill. Logically, however, sunlight that would create such a shadow would form similar ones at the juncture of the windows and the ceiling and behind the horizontal frame at the top of the lower window. Such shadows do not exist in this painting. The broad expanse of an evenly illuminated white wall was important as a backdrop for the subtle geometric harmonies Vermeer wanted to create with the silhouetted objects against it. By selectively eliminating shadows, moreover, he minimized the temporal quality of the light entering the room. The shadows create the semblance of reality while minimizing the transitory nature of the moment.

A comparable concern undoubtedly explains the character of the shadows in and around the virginal. A strongly accented diagonal shadow extends from the edge of the windowsill to the base of the instrument's feet. At the same time, another shadow, falling at

a completely different and quite illogical angle, connects the top of the lower window frame with the top corner of the virginal. These shadows, which together encompass the full height of the virginal, connect the instrument and the architecture of the room. Because these shadows fall at such discrete places and do not cut across forms, they appear to be locked in place, as though that moment will not change.

A final instance of Vermeer's careful manipulation of light to reinforce the feeling of permanence in the composition occurs beneath the virginal. Although the vertical shadows of the legs of the base are clearly visible, Vermeer gave them greater substance by placing them closer to each other than they would appear in reality in order to reiterate the strongly silhouetted shapes of the legs themselves. Furthermore, he eliminated the shadow of the instrument's body against the rear wall, probably because it would have obscured the vertical emphasis provided by the shadows from the legs of the instrument.

Such careful considerations of light effects parallel other means by which Vermeer sought to make relationships within his composition more enduring. For instance, it is remarkable that the virginal is so high. In most instances these instruments were designed to be played seated as well as standing. Vermeer may have explicitly raised the instrument to a level where the woman's head is tangentially related to its upper edge and to the bottom of the mirror, thus strengthening the visual bonds among these three crucial components of the composition. Indeed, her position at the virginal as well as that of the man were areas of great concern for the painter. Infrared reflectography reveals that Vermeer first painted the man further forward and leaning more attentively toward the woman (fig. 69). She, likewise, had a more active stance. At present she appears to stand directly facing the virginal, but originally her pose resembled more closely that seen in the mirror. Her body was slightly turned away from the man, but her head was twisted back in his direction.[11] These adjustments were subtle but crucial. In both instances Vermeer transformed the figures from active poses to restrained and statuesque ones, and as a consequence emphasized less their transitory interaction than the permanent character of their relationship. The effect is to draw them more fully into harmony with their carefully ordered environment and to convey the powerful lasting effects of music upon the soul. By retaining the original image of the woman in the reflection in the mirror, Vermeer extended that moment in yet another way. Her reflected image reinforces the sense of the figures' communion with each other and adds a dimension of warmth that infuses the entire painting.

69. Infrared reflectogram of man in *The Music Lesson*

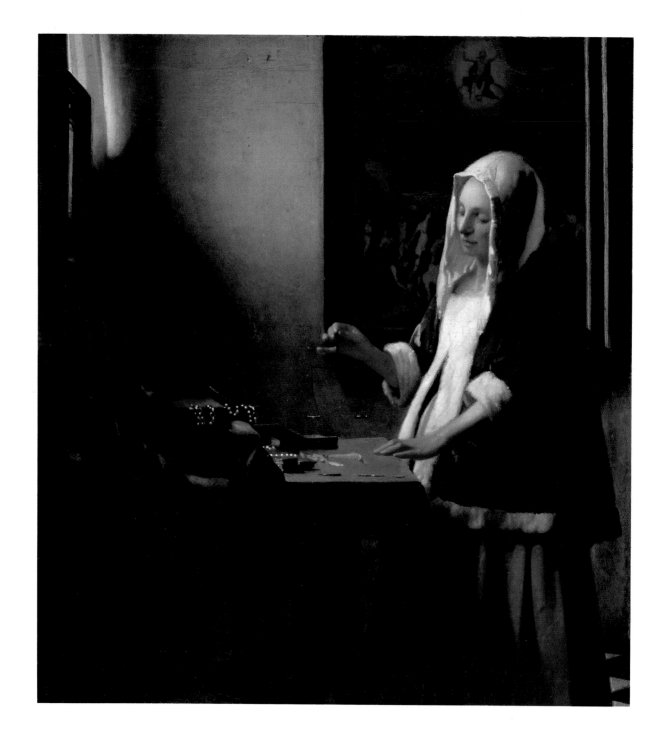

Woman Holding a Balance

70. *Woman Holding a Balance,* 1664, oil on canvas. National Gallery of Art, Washington, D.C. Widener Collection

The young woman standing before a table in a corner of a room in this painting gazes toward a balance held gently in her right hand (fig. 70). As though having waited for the delicate modulations of the balance to come to rest, she stands transfixed in a moment of equilibrium. She is dressed in a blue morning jacket bordered with white fur; seen through the parting of her jacket are vivid stripes of yellow and orange, perhaps ribbons or part of her bodice. Her white cap falls loosely to both sides of her neck, framing her pensive yet serene face. Diffused sunlight, entering through an open window before her, helps illuminate the scene. The light, warmed by the orange curtain in front of the window, flows across the gray wall and catches the fingers of her right hand and the balance she is holding. It then passes across the upper part of her body before resting on the parcel-gilt frame of a painting of the Last Judgment hanging behind her.[1]

Painted in mute blacks and ochers, it acts as a compositional and iconographic foil to the scene taking place before it. The *Last Judgment,* its proportions echoing those of the overall painting, consumes the entire upper-right quadrant of the composition. Its dark rectangular shape establishes a quiet and stable framework against which Vermeer juxtaposed the figure of the woman. The woman's white cap and blue morning jacket contrast with the dark painting. Her figure is aligned with the central axis of the *Last Judgment,* and her head lies at the middle of its composition, directly beneath the oval mandorla of the Christ in majesty. Her right hand, holding the balance, coincides with the lower corner of the frame. The position of her head and the central gesture of her hand are thus visually bound with the *Last Judgment,* and a seeming moment of quiet contemplation becomes endowed with symbolic associations.

The visual juxtaposition of the woman and the *Last Judgment* is reinforced by thematic parallels: to judge is to weigh. Christ sits in majesty on the day of judgment. His gesture, with both arms raised, mirrors the opposing direction of the woman's balance. His judgments are eternal; hers are temporal. Nevertheless, the woman's pensive response to the balance she holds suggests that her act of judgment, although different in consequence, is as

considered as that of the Christ behind her. Her mood is in sharp contrast to the violent scene of salvation and damnation in the *Last Judgment*. Her serene countenance belies no fear of the consequences of the final day of judgment. What then, if any, is the relationship between her act and the subject of the painting on the wall behind her?

Most interpretations of this painting have focused on the act of weighing and have assumed that the pans of the woman's balance contain certain precious objects, generally identified as gold or pearls. Consequently, throughout its history the painting has been alternately titled *Goldweigher* or *Girl Weighing Pearls*.[2] Behind these diverse interpretations of the painting lies considerable confusion as to whether the woman is weighing pearls, gold, weights, pearls versus gold, jewels, or whether she is merely balancing the scales. Questions concerning the nature of her action are closely intertwined with the broader question of the symbolic intent of the juxtaposition of the woman and the painting of the Last Judgment.

It is admittedly difficult to see with the naked eye what, if anything, rests in the pans of the woman's balance. Microscopic examination, however, reveals that what seem to be objects in the scales are painted quite differently from the representation of gold and pearls found elsewhere in this painting. The highlights in the scale certainly do not represent gold since they are not painted with lead-tin yellow, as is the gold chain draped over the jewelry casket. The pale, creamy color is more comparable to that found on the pearls, but if the point of light in the center of the left pan of the balance initially looks like a pearl (fig. 71), Vermeer's technique of rendering pearls is different than the technique used here. As may be seen in the strand of pearls lying on the table (fig. 72) and in those draped over the jewelry box, Vermeer painted pearls in two layers: a thin grayish underlayer and a superimposed highlight. This technique permitted him to depict specular highlights on the objects and at the same time to suggest their translucent and three-dimensional qualities. In the band of pearls draped over the box, the size of the pearl (the thin, diffused layer) remains relatively constant, although the highlights on the pearls (the thick top layer) vary considerably in size according to the amount of light hitting them. The highlight in the center of the left pan is composed of only one layer—the bright highlight. Lacking the underlayer, the spot is not only smaller than the other pearls, but also does not possess their soft luminescence. The more diffused highlight in the center of the right pan is larger, but it is not round and has no specular highlight. These points thus appear to be reflections of light from the window rather than separate objects. Reinforcing the sense that the scales are empty is the fact that the pearls and gold on the boxes and table are bound together in

71. *Woman Holding a Balance,* detail of balance

72. *Woman Holding a Balance,* detail of pearls on jewelry box

strands and none lie on the table as separate entities as though waiting to be weighed and measured against one another.

Even if specific interpretations of the scene remain tenuous, the mood that Vermeer transmitted helps interpret his basic intent. Vermeer has portrayed the woman standing before a table with various jewelry boxes, strands of pearls, and a gold chain. These elements belong to, and are valued within, the temporal world. They are, in a sense, temptations toward material splendor. One should be hesitant to identify the woman, however, as the personification of Vanitas. Pearls have many symbolic meanings ranging from the purity of the Virgin Mary to the vices of pride and arrogance.[3] The woman, moreover, does not appear tempted by the jewels. She concentrates on the balance in her hand. Her attitude is one of inner peace and serenity. There is no psychological tension that would suggest a conflict between her action and the implications of the *Last Judgment.*

Although many elements of a vanitas theme exist, the dominant mood of the painting argues against such an interpretation. The balance, the emblem of justice and eventually of the final judgment, denotes the woman's responsibility to weigh and balance her own actions, a duty reinforced by the placement of her head over the traditional position of Saint Michael in the Last Judgment scene.[4] Correspondingly, the mirror, placed near the light source and directly opposite the woman's face, refers not so much to the transitoriness of life as to the mirror as a means of self-knowledge.[5] As Otto van Veen wrote in an emblem book Vermeer certainly knew, "a perfect glasse doth represent the face, / Iust as it is in deed, not flattring it at all."[6] In her search for self-knowledge and in her acceptance of the responsibility of maintaining the equilibrium of life, the woman is aware, although not in fear, of the final judgment that awaits her. Indeed, in that pensive moment of decision, the mirror also suggests the evocative imagery of 1 Corinthians 13: "For now we see through a glass, darkly; but then face to face; now I know in part; but then shall I know even as also I am known." Vermeer's is a positive statement, an expression of the essential tranquility of one who understands the implications of the Last Judgment and who seeks to moderate her life in order to warrant her salvation.

The character of the scene conforms amazingly closely to Saint Ignatius of Loyola's recommendations for meditation in his *Spiritual Exercises,* a devotional service with which Vermeer was undoubtedly familiar through his contacts with the Jesuits. Before meditating, Saint Ignatius urged that the meditator first examine his conscience and weigh his sins as though he were at Judgment Day standing before his judge.[7] Ignatius then urged that one "weigh" one's choices and choose a path of life that will allow one to be judged favorably in

a "balanced" manner: "I must rather be like the equalized scales of a balance ready to follow the course which I feel is more for the glory and praise of God, our Lord, and the salvation of my soul."[8]

Given that the theme relates so closely to Jesuit sensibilities, one may also ask if there is any significance to the fact that a beautiful young woman holds the scales as opposed to a man. Is she, as some have suggested, a secularized image of the Virgin Mary, who, standing before the Last Judgment, would assume her role as intercessor and compassionate mother?[9] Is she pregnant, and, if so, does her pregnancy have consequence for the interpretation of the painting?[10] Cunnar has argued, for example, that one image of a pregnant Virgin Mary contemplating balanced scales would have been understood by a Catholic viewer as referring to her anticipation of Christ's life, his sacrifice, and the eventual foundation of the Church.[11] Such theological associations were made in the seventeenth century and may have played a part in Vermeer's allegorical concept.[12]

The many different interpretations of this painting that have appeared over the years, however, are a reminder of how cautious one must be in assessing the evidence, whether visual or contextual. For example, it will never be certain whether the woman is pregnant, or whether her costume reflects a style of dress that was current in these years.[13] It will probably never be known whether the painting was commissioned or whether Vermeer or a patron helped devise the iconographic program. Nevertheless, to judge from the pictorial evidence, Vermeer is almost certainly conveying a message that one should lead a life of temperance and balanced judgment. This message, with or without its explicit religious context, is one frequently found in Vermeer's paintings and probably represents his profound beliefs about the proper conduct of human life.

Stylistically this painting offers one of the most glorious examples of Vermeer's exquisite sense of balance and rhythm. The woman, her right hand gently poised holding the scale, extends her small finger to give a horizontal accent to the gesture. The left arm, gracefully resting on the edge of the table, closes the space around the balance and establishes an echo to the gentle arch of boxes, blue cloth, and sunlight sweeping down from the other side. The scales themselves, perfectly balanced but not symmetrical, hang poised against the steel gray wall in a small space seemingly created especially for them. As is evident in an infrared reflectogram of this area (fig. 73), where a smaller scale is visible, Vermeer gave greater prominence to the balance by enlarging it. Vermeer also adjusted the shape of the picture frame by raising its bottom edge before the woman to allow sufficient space for the balance. Throughout, Vermeer's interplay of verticals and horizontals, and of both against diagonals,

73. Infrared reflectogram of balance in *Woman Holding a Balance*

74. Pieter de Hooch (1629–1684), *A Woman Weighing Gold,* c. 1665, oil on canvas. Staatliche Museen Preussischer Kulturbesitz, Gemäldegalerie, Berlin

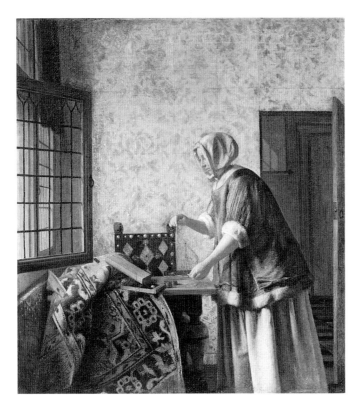

of mass against void, and of light against dark, create a subtly harmonized but never static composition.

The degree of Vermeer's sensitivity can best be illustrated by comparing this scene with a close counterpart by Pieter de Hooch, *A Woman Weighing Gold* (fig. 74).[14] Although De Hooch painted this scene in the mid-1660s after he had left Delft for Amsterdam, it is so similar to Vermeer's that it is difficult to imagine that the two images were painted without knowledge of the other or of a common source.[15] Nevertheless, the refinements and mood of the Vermeer are lacking in the De Hooch. The woman in De Hooch's painting is not serenely gazing at her scales; she is placing a gold coin or weight into one of the pans. By her active gesture she separates herself from the geometric structure of the room. She is an adjunct of that space; it and the forms within it would be complete without her participation.

Vermeer's pictorial space, however, is reinforced by the woman's presence. The perspective lines of the mirror, for example, converge to a vanishing point at the woman's right hand. This coincidence, combined with the supporting structural element of the frame of

the *Last Judgment,* heightens the importance of the gesture. As has also been noted, Vermeer further emphasized the importance of the gesture by adjusting the position of the frame to create a spatial environment for the balance. De Hooch failed to isolate this important thematic element. In his painting, the woman's hand and the balance intersect and compete visually with the edges of a chair placed behind the table.[16]

The care with which Vermeer composed *Woman Holding a Balance* is also evident in the buildup of the paint. He initially covered the support, a lightweight linen, with a light brown (ocher) ground layer composed primarily of lead white. In selected areas of the painting, as for example under parts of the blue jacket of the woman where a deeper brown tone is visible, he applied a second thin priming layer.[17] The existence of selectively toned grounds indicates that Vermeer had a thorough understanding of the optical effects of various colors. He also understood that shadows need not or should not be black or simply darker shades of the same hue. He probably chose a light brown ground to give an underlying warmth to the scene. The reddish brown tone under the blue, visible in the shaded folds of the jacket, enriches and lends an inner warmth to the coolness of the blue that helps relate it to the dominant color scheme of the painting. Vermeer's use of selected ground colors strongly implies that very early in the process of painting he knew precisely where compositional elements would be placed and what color harmonies they would have.

One further aspect of Vermeer's concern for compositional refinements can be deduced from the character of the edges of the composition of *Woman Holding a Balance* as they appeared before the conservation of the painting in 1994. Overpaint existed along each edge of the painting that measured about three-eighths to one-half inch wide on each side. Simulated crackle patterns similar to those in the original paint had been deftly added by an earlier restorer to disguise the added paint. During the 1994 restoration the overpaint, which had covered the original ground layer extending beyond the design area to the edges of the canvas, was removed.[18] Along the outer limits of Vermeer's design are losses that resulted from bending the fabric over a smaller stretcher. The scallop pattern of the stretch marks in the canvas, however, indicates that Vermeer painted his image when the canvas was stretched to its present, larger dimensions. After the painting had dried he restretched it in the smaller format. Subsequently, perhaps when the painting was relined at a much later date, the format was reenlarged and the edges overpainted.

Similar patterns in the history of alterations in the dimensions of Vermeer's paintings can be observed in x-radiographs of other paintings from the mid-1660s, including *Woman in Blue Reading a Letter* (see fig. 2), *Woman with a Pearl Necklace* (see fig. A17), and *The*

Girl with a Pearl Earring (see fig. A20).[19] The consistent pattern found here of an image being reduced and then enlarged suggests that Vermeer may have worked in the following manner. He could very well have painted on a "trampoline" stretcher, similar to those seen in numerous depictions of Dutch artists in their studios. This type of stretcher is larger than the canvas, which is then stretched tautly with cords sewn through the fabric. With the image completed, the canvas would be stretched on a conventional, "Dutch strainer" stretcher, a process that would allow Vermeer to crop the composition in a precise manner. Sometimes, as in *Woman Holding a Balance,* it would be cropped uniformly on all sides; sometimes, as in *Woman in Blue Reading a Letter,* it would be cropped more in one direction than in another (in this instance, more along the bottom edge). The paintings apparently were later expanded again when restorers restretched the canvases on larger stretchers.

Woman Holding a Balance is one of the few Dutch paintings whose provenance can be traced in an almost unbroken line back to the seventeenth century. Perhaps the most fascinating early reference to this work is that of the first sale in which it appeared, the Dissius sale in Amsterdam of 1696. The first painting listed in a sale that included 21 paintings by Vermeer, it was described in the following terms: "A young lady weighing gold, in a box by J. van der Meer of Delft, extraordinarily artful and vigorously painted."[20] That the painting was listed first in the sale and contained in a protective box indicates the extraordinary value placed on this work, an appreciation that has never diminished.[21]

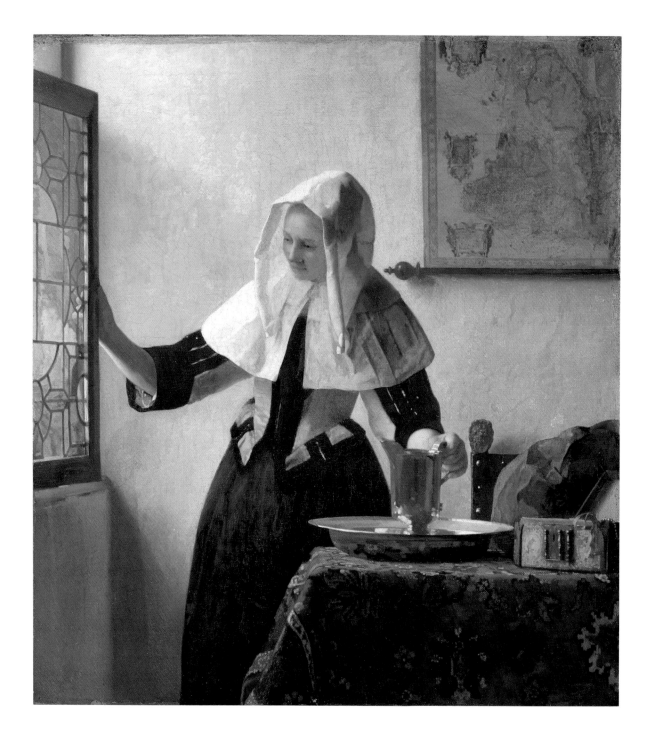

Young Woman with a Water Pitcher

75. *Young Woman with a Water Pitcher*, c. 1664–65, oil on canvas. The Metropolitan Museum of Art, New York. Gift of Henry G. Marquand, 1889. Marquand Collection (89.15.21)

It is always revealing to try to place Vermeer's paintings within the context of his contemporaries. Vermeer's early history paintings, his genre scenes from the mid-1660s, his cityscapes, and even works with an allegorical character, like *Woman Holding a Balance,* can, to a certain degree, be related in style and approach to other artists' works. By the mid-1660s, however, Vermeer's genre scenes no longer seem to exist within such a framework. At a time when Van Mieris, Metsu, and Steen had perfected means for portraying social vignettes that focus upon relationships between individuals (see fig. 65), Vermeer almost completely removed narrative from his paintings. Even Ter Borch, the artist whose manner seems closest to Vermeer's during the 1660s, and with whom Vermeer had cosigned a document in 1653, painted his few representations of single genre figures with a different emphasis. As in *Woman Writing a Letter* from the mid-1650s (see fig. 97), his figures are invariably engaged in a specific activity. Vermeer, on the other hand, depicted figures at a moment of repose, when quiet contemplation, if only briefly, weighs more than the activity itself.

The purest of these paintings are *Young Woman with a Water Pitcher* (fig. 75) and *Woman with a Pearl Necklace* (see fig. A17). In the first, a woman stares absently toward a window as she grasps a pitcher with one hand and rests the other lightly on the window frame; in the second, a woman stands transfixed before a mirror tying her necklace. In neither painting has Vermeer explained the woman's thoughtful countenance by alluding to her prior activities or subsequent movement. In each instance the focus is upon the sitter's reflective mood, allowing the viewer to experience a bond between her quiet demeanor and his or her own thoughts and feelings.

Vermeer created this effect in *Young Woman with a Water Pitcher* through the way in which the woman interacts with her environment. Particularly important are the flowing rhythms of her arms as they extend from the window frame to the jug. The encompassing nature of that gesture is underscored by the parallel arrangement of both objects she holds. Although her gesture is poised and at rest, the slight turn of her body as she stands back from the window suggests an intensity to her gaze even as she stares absentmindedly toward

the light filtering into the room. Her alertness is reinforced by the crisp modeling and bright colors that characterize this work: the reds of the intricately patterned tablecloth, the gold color of the ornate jewel box, the yellow and black jacket with its clearly articulated design, and the folds of her white cap and collar.

Although Vermeer's approach to color and composition in the work is different from *Woman in Blue Reading a Letter,* where he used muted tones and a strong centralized focus, perhaps even more revealing are the differences that exist in the character of the forms, or negative shapes, between objects. Whereas these patterns in *Woman in Blue Reading a Letter* are essentially rectangular in shape, those in *Young Woman with a Water Pitcher* have a more fluid character. The flow of the woman's gesture from window to water pitcher is reinforced by the pattern of wall surrounding her form. For instance, Vermeer placed the map in this painting just far enough to the right of the woman's figure to allow the white of the wall to continue unobstructed behind her. Comparably fluid shapes are found under the arms. On the right Vermeer established a tangential relationship between the woman's sleeve and the water pitcher; to the left he created the suggestion of a triangular shape that reinforces the directional flow of light entering the room.

76. Infrared reflectograms of
Young Woman with a Water Pitcher

The position of the map and the rod that weighs it down is interesting for its effect on the spatial reading of the scene. Because the map edge is quite distinct and the rod has a strong profile, one tends to read these elements as being in close spatial proximity to the woman. To judge from the structure of such a room, however, she must be standing at some distance from the back wall. The window frame she is holding hinges to the left, which means that there is a second window behind it, leading to the back wall. The situation can be visualized by scanning *The Music Lesson* (see fig. 60), where both lower windows, and the upper window through which light enters, are visible. Thus, as with *Woman in Blue Reading a Letter,* Vermeer consciously orchestrated his composition so that the visual bonds between pictorial elements take precedence over the logic of spatial organization.

The importance such compositional concerns held for Vermeer can be postulated in this instance through two major compositional changes that he made. Although both of these, a chair with lion head finials, which once occupied the lower left foreground, and the position of the map, which once extended just to the left of the woman's head, can be vaguely discerned with the naked eye, they can be observed best in infrared reflectograms (fig. 76). Blocking in may well exist in other areas, but its extent cannot be determined with present examination techniques.

The chair was almost complete when Vermeer decided to eliminate it. In the reflectogram one can see how carefully Vermeer anticipated how he would model it. The right finial, which would have been seen in silhouette, was totally blocked in in gray. Vermeer blocked in those areas of the left finial that would be in shade with gray paint, and left the ground layer as a reserve for the uppermost portion that would be lit by the sun. He defined the upper edge of the seat back in a similar manner.[1]

The map shape, which is more difficult to read, can be distinguished by a vertical shift in tone that falls just to the left of the woman's head. In the upper right of the reflectogram a diagonal curve is also slightly visible under the wall map in its present position. This line appears to be an indication of the Dutch coastline as it would have appeared when the map was positioned behind the woman. The change in the position of the map was probably made so that its shape would not interrupt the visual flow between the woman and the window, but iconographic considerations may also have played a role.[2] The map, which was published by Huyck Allart (active c. 1650–75), depicts *The Seventeen Provinces,* with the south oriented to the left.[3] By shifting the map to the right Vermeer included in his painting only the southern provinces, which he may have done purposely if a thematic connection exists between the woman and the map. If her pensiveness has to do with an absent

loved one, a map depicting only the southern provinces conveys that sense more than would be the case if all seventeen provinces were visible.[4]

From the scanty evidence derived from reflectograms taken of this and other paintings from the mid-1660s, it seems apparent that Vermeer, from the early stages of the creative process, was thinking of patterns of light and shade as well as of the arrangement of form. The way he used the dark tones in the underlying layers in conjunction with surface glazes, moreover, indicates that he also was able to anticipate how he would achieve the final modeling of the various compositional elements. Observations of surface modeling reinforce that hypothesis: shaded areas are generally painted with at least two layers, a thin glaze reflecting the local color over a dark underlying tone. This technique occurs in this painting, for example, in the shaded portion of the woman's headdress (fig. 77), in the shaded portion of the yellow jacket, in the blue cloth draped over the chair, and in the dark blues of her dress (fig. 78). In each of these instances, an underlying tone much darker than the light ocher ground of the painting establishes the base color. Shadows, thus, are not surface phenomena, but reach into the very body of the material.

77. *Young Woman with a Water Pitcher,* detail of woman's headdress

78. *Young Woman with a Water Pitcher,* detail of blue dress

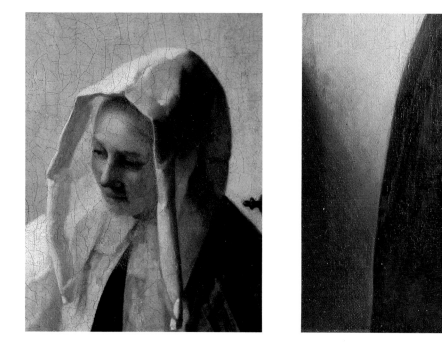

79. *Young Woman with a Water Pitcher,* detail of basin

The actual color of these underlying tones is difficult to establish with the naked eye. Some appear darker than others: some appear to be primarily grays, some a mixture of light brown and gray, some dark reddish brown and gray. The latter color can often be found under deep blues, perhaps to give an added warmth to that cool color. One can assume, however, that the base color was important, for it was part of the overall optical effect that Vermeer sought to achieve.

In one instance in this painting the color of such a selective ground, an imprimatura layer, can be clearly distinguished, and its optical characteristics for the final composition understood. Before Vermeer painted the basin on the red tablecloth he blocked in its shape with a reddish tone. The color can clearly be seen with close examination, in particular along the upper rim of the basin on the left (fig. 79). A microscopic examination confirms this tone beyond the left of the basin, and its full shape can be seen in a reflectogram of the area (see fig. 76). It seems likely that Vermeer originally intended the basin to extend a few centimeters more to the left than it presently does. As is evident in the reflectogram, the basin also had a slightly different shape: it did not have such a broad lip. Its earlier form can still be seen where the lip curves around on the right.

This reddish color was probably intended to give the sunlit portions of the tablecloth an underlying tone that would serve as the base for rich design patterns. The reddish tone under the basin was important for the reflections coming from the tablecloth. The reflections in the lower part of the basin are painted with broad, free brushstrokes that suggest the multicolored patterns of the tablecloth. Surprisingly, the reflections do not conform to the actual tablecloth patterns, but the effect is so realistic that the discrepancies have never been noticed. Along the upper surface of the basin, Vermeer has alternated sunlit highlights painted with lead-white paint and shaded areas where he has allowed the reddish underlayer to show through the grayish green metallic color. The same basic techniques were used for the vertical reflections on the water pitcher, although here the orange-red reflection of the inside of the jewelry box is painted on the surface rather than on an underlayer of paint.

Much of the beauty of this painting stems from the subtle ways light falls upon objects, is refracted through them, or is reflected off them. As in so many of Vermeer's works, light is the unifying element that binds the composition together and establishes the overall mood. Here, a muted light, which passes through a semitransparent leaded window, creates soft shadows across the painting as it illuminates the woman, the back wall, the tabletop, and, in particular, the basin and pitcher. As with *Woman in Blue Reading a Letter*, the back wall is not a simple white color; rather, its tones of white, ocher, and blue are gently modulated and seem to vary in response to the figure's proximity. Where the woman's shoulder is highlighted by the sun, the wall—as a foil—is slightly toned with an ocher color. Where the woman's shoulder is in shadow, the wall is appropriately lighter, even though logically it should be darker because it is farther from the light source.

Focus also varies. Bright sunlight, as along her left arm or on the headdress, creates sharply articulated accents of light and shade. In other areas, light creates a soft haze where contours are diffused. Vermeer employed, for example, the same device for softening the edge of the blue skirt here as he did in *Woman in Blue Reading a Letter*. The white wall color to the left of the woman follows the edge of the skirt down to the shadow, where it turns into a light blue stroke diffusing the contour (see fig. 78). The same effect occurs on the other side of the skirt, where a soft white contour line articulating the shape between her arm, the jug, and her body is painted slightly over her clothing.

The most diffused form in the painting is the jewel box. This beautifully elaborate box, which helps counterbalance the strong compositional focus of the painting to the left, is

painted in a free and suggestive manner. Tones of ochers and browns and specular highlights of yellow indicate but do not precisely delineate the design of the face of the box.

One constant feature of Vermeer's attitude toward realism is his willingness to depart in so many ways from an accurate record of light, color, and shape of objects in his paintings. This selectivity of focus is another aspect of his willingness to modify reality to enhance the unity and content of his work. When confronted with objects of great complexity he almost invariably suggested their forms with abstracted notations of color, often quite thinly painted, although given accents with specular highlights. Maps, for example, appear accurate in the broadest sense, yet the specifics of the cartographers' work are never recreated.

This selective reality is also apparent in Vermeer's handling of the glass in the window. The abstract patterns of ocher, blue, and white that convey the various facets of light that pass through the glass are, in fact, surprisingly opaque. The only transparency occurs over the woman's fingers. As in *Woman Holding a Balance* and *The Concert,* other paintings from this period, Vermeer also altered shapes of objects in what may seem arbitrary ways. The basin, upon which he exerted so much care in the layering of paint and character of reflections, is not continuous where it passes behind the base of the water pitcher. The contours of the rim differ on each side of the pitcher (see fig. 79). This discontinuity was probably intended to disrupt the form of the basin slightly so that it would not remain an entity unto itself.

The moving character of *Young Woman with a Water Pitcher* cannot be pinpointed to any one of these technical or compositional aspects, for they all fuse together to reinforce the sense of purity that pervades this image. That Vermeer's compositional emphasis reinforces a thematic one is evident in the fact that the woman holds a water pitcher as she stands quietly before the window. The pitcher and basin are objects imbued with the notion of cleansing and purification. A hanging pitcher and basin, for example, occupy a niche in the background of the Annunciation from Jan van Eyck's Ghent altarpiece. Jan Lievens, in his *Pilate Washing His Hands,* c. 1625, depicted a youth pouring water over Pilate's hands with a pitcher almost identical to that in Vermeer's painting, while catching the water in a comparable basin.[5] Although no reinforcing imagery in *Young Woman with a Water Pitcher* indicates that a specific religious interpretation should be given this painting, the associations with cleansing and purity brought by the pitcher and basin give the image a broader message than at first evident in this depiction of seemingly everyday reality.

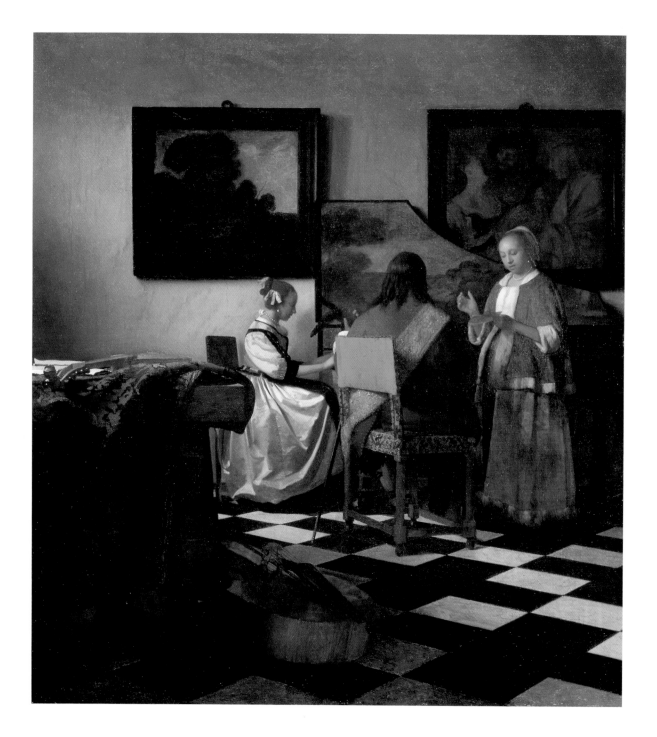

CHAPTER XI

∿

The Concert

The chronology of Vermeer's paintings is notoriously hard to establish, for only three are dated: *Saint Praxedis,* 1655 (see fig. 8), *The Procuress,* 1656 (see fig. A4), and *The Astronomer,* 1668 (see fig. A27).[1] From this meager framework art historians have had to construct a logical sequence for his work. Among the many components that enter into the consideration of Vermeer's chronology are subject matter, style, technique, costume, the form of Vermeer's signature, and the character of the interiors and objects he included in his paintings. Unfortunately, specific chronological relationships seem impossible to establish since too many unknowns and inconsistencies in Vermeer's working procedure exist. Dating by costume, for example, is difficult because Vermeer used identical costumes in paintings that appear to come from different points in his career. Variations in the appearance of the rooms he depicted may reflect different settings, but they also are the result of artistic license. Finally, his painterly techniques did not always evolve in a predictable pattern. He was able to vary his painting methods dramatically in accord with his subject matter. As in *The Music Lesson* (see fig. 60), even within one painting he could vary his techniques considerably.

These issues are particularly intriguing in trying to determine the relationship between *The Music Lesson* and *The Concert* (fig. 80), two paintings that are often thought to be pendants because of their virtually identical size and their similarity in composition and subject matter. Both paintings focus on musical subjects that take place at the far side of an expansive room where figures, intent upon their music, convey no awareness of the presence of a spectator. In both works a large tapestry-covered table in the foreground is dramatically juxtaposed with the figures. The refined and elegant tenor of each scene is in part established by a prominent black-and-white patterned marble floor. Finally, in *The Concert,* just as in *The Music Lesson,* the young woman intently playing a stringed instrument wears a yellow jacket with black bands. Seen in profile and set against a plain white wall, she is as visually integrated with the starkly silhouetted harpsichord and painting as is the woman in *The Music Lesson* with the virginal and mirror. By thus bonding the young woman at the

harpsichord with her surroundings, as in *The Music Lesson,* Vermeer created a quality of timelessness within the scene. Her position appears immutable, her stark profile image forever caught in a moment of intense concentration.

Although Vermeer almost certainly painted *The Music Lesson* and *The Concert* in close chronological proximity, an analysis of their compositions, their underlying themes, and their painting techniques reveals that their similarities are more superficial than substantive and that there is little reason to believe that he conceived them as pendants. Because no sources specifically discuss the question of pendant relationships in Dutch painting, however, assessments of pendants are necessarily based on information derived from those few instances when such connections can be firmly made. Pendants exist in all types of Dutch painting: portraits, landscapes, still lifes, allegorical paintings, and genre scenes. Although pendant relationships can occasionally be substantiated by identical provenances, as, for example, Vermeer's *Geographer* (see fig. A28) and *Astronomer* (see fig. A27), many works that must have been conceived as pendants have become separated over time.[2] Thus one searches for the constants that exist among all pendants: identical size and shape, compositions that relate but do not necessarily mirror one another, similar painting techniques, and thematic connections. The themes, in genre painting in particular, can be complementary or contrasting. Gabriel Metsu painted pendants of both types. In his pendants *Lady Reading a Letter* and *Man Reading a Letter* from the Beit collection (National Gallery of Ireland), for example, the subjects are complementary, whereas in other paintings the images establish contrasts like virtuous and immoral behavior.[3]

In *The Concert* and *The Music Lesson,* some but not all of the conditions that establish a pendant relationship appear to be met. The primary reason for arguing that the works are not pendants is the difference in the conceptions of the interior space, despite the fact that Vermeer apparently painted both scenes in the same room and from approximately the same location. In *The Concert* Vermeer chose a long rather than a short distance point for his perspective system and thus the space recedes more gradually, and the room appears to be less deep and to rise less steeply than in *The Music Lesson.* Vermeer also reduced the strong diagonal emphasis that is so marked in *The Music Lesson* by constructing a more complex floor tile pattern, a clear example of artistic license. To further minimize the strong thrust of the perspective he omitted the receding side wall. Finally, he made the room appear less deep by placing large paintings behind the figures rather than the comparatively small shapes of the mirror and fragment of a painting seen in *The Music Lesson.*

Another difference in his use of perspective was to change the placement and function

of the vanishing point. Instead of reinforcing the compositional and thematic center of the painting, as it does in *The Music Lesson,* the vanishing point in *The Concert* falls on the bare wall at the left. It is located above the instrument lying on the table at the eye level of the seated young woman at the harpsichord.

This placement affects the way one looks at this painting. To judge from the compositional arrangements in other of Vermeer's paintings, the artist was acutely aware that the eye normally views a painting from the left, scanning across it as a Western reader scans a text. It was on this basis that Vermeer designed the pronounced orthogonals of the left wall of *The Music Lesson.* In this painting, however, he blocked immediate access to that vanishing point and hence to the interior of the room by placing a large table in the foreground, which he draped with a vivid red and blue tapestry. The eye is eventually led to the vanishing point by following the left-to-right orthogonal suggested by the receding right edge of the table. That Vermeer intended this effect is evident from the way he folded back the drapery to reveal the sunlit corner of the table. The large bass viol he placed at the foot of the table also directs the eye back to the vanishing point. This compositional organization, which counteracts one's subconscious inclination to progress immediately into such an open, illusionistically conceived space, creates a psychological as well as a physical barrier for the viewer. It is almost as though, having barged into a room without knocking and discovering that a concert is taking place, one hesitates behind the table so as not to disturb that moment of communion that exists among the performers.

The location of the vanishing point behind the large table in *The Concert* has the additional function of minimizing the forcefulness of the perspective system. Unlike in *The Music Lesson,* here it is difficult to judge how far away the back wall really is. Even the structure of the room displays inconsistencies: the floor seems to extend farther back behind the woman at the harpsichord than it does on the far right side of the painting. Other perspectival relationships of objects in the room, moreover, seem purposefully vague. The man's chair, for example, recedes to a horizon line slightly below that of the room itself. The horizon line of the seated young woman's chair cannot be precisely determined, but to judge from the angle of its upper edge it must be even lower, approximately at the level of her right elbow. Vermeer thus appears to have created a more intuitively than geometrically determined space in this painting, where relationships between figures and their environment are not precisely defined. In practice, this shift allowed him to paint the figures smaller than they would have appeared had they been constructed within the same perspective system as the room.

Beyond the differences in spatial conception, these paintings should be seen as separate entities and not as pendants because the themes are parallel rather than complementary or contrasting. In *The Music Lesson* the *Roman Charity* on the wall and the objects in the room reinforce the theme of the love, solace, and joy provided by music. A comparable celebration of music as a metaphor for harmony in love underlies *The Concert*. The three figures in this musical ensemble are joined together in complete concord as they play their instruments, keep time to the music, and sing. The unused instruments on the table and floor, which relate to Jacob Cats's emblem "Quid Non Sentit Amor" (see fig. 62), reinforce the theme of shared feelings just as does the bass viol in *The Music Lesson*. In this respect the subject of *The Concert* is complete within itself. It no more needs a pendant to add another dimension to its meaning than does *The Music Lesson*.

Although some seventeenth-century chamber music was sacred in character, most was devoted to the delights and tribulations of love relationships. As seen in numerous seventeenth-century Dutch paintings, as well as on the title page of Jan Harmensz Krul's 1634 collection of love songs (fig. 81), men and women enjoyed coming together to share in the sentiments expressed by this type of music.[4] From the refined setting and proper decorum of the figures in *The Concert,* it is not entirely clear whether the music being played and sung is sacred or profane. However, the presence on the rear wall of Dirck van Baburen's *Procuress,* one of the paintings owned by Vermeer's mother-in-law, Maria Thins, suggests that Vermeer thought of the group as singing love songs. It would seem that he included

81. Title page engraving from Jan Hermansz. Krul, *Minnelycke sangh-rympies.* Library, National Gallery of Art, Washington, D.C.

the painting of the *Procuress* to establish a thematic contrast between music associated with illicit love and music associated with harmony and moderation. The contrast is reinforced by the arrangement of Vermeer's figures, which mirror those in Baburen's painting. While the embrace of the solider and woman in the *Procuress* indicates unrestrained passion for sensual pleasure, the woman keeping time with the measured chords of music must be understood as a statement of temperance, or of a life of moderation. The further juxtaposition of the painting of a rugged landscape (with a dead tree) with the arcadian landscape on the lid of the harpischord reinforces the sense that Vermeer intended these paintings within a painting to function as thematic contrasts to the activities of the figures rather than as thematic parallels, as is the case in *The Music Lesson.*

Vermeer's thematic emphasis on harmony is reinforced by the harmonious relationship of compositional elements. The dark frames of the comparably scaled paintings flanking the harpsichord, for example, establish a quiet framework for the measured cadence of the musicians. How different the effect would have been if Vermeer had enframed Baburen's *Procuress* in gold as he did in *A Lady Seated at a Virginal* (see fig. A35). In the latter painting, moreover, Vermeer substantially enlarged Baburen's image and compressed the figures so that the *Procuress* seems vertical, further indication that the artist altered the appearance of objects in his paintings for compositional reasons.

The quiet, reflective mood of *The Concert* comes from many sources, but an important component is the softness of the light. Its gentle flow against the background and across the figures has a serenity quite different from the brighter tonalities of *The Music Lesson.* Vermeer has not represented the arrangement of the windows through which light enters the room, but to judge from the muted light that gently illuminates the figures and forms the shadows against the wall, he has blocked the lower portion of the back windows and allowed light to enter only through the upper registers. The brightly illuminated objects on the table must have received light from a lower as well as upper window, yet the immediate foreground is in total shadow. One result of this arrangement is that light-dark contrasts enhance the prominence of the foreground table. The brightly illuminated music sheets at the far left are set against the shaded wall, while on the right of the table the dark form of the tapestry is silhouetted against the white satin of the woman's dress. More important, the light falling on the wall, on the back of the man's chair, and on the white tiles helps encompass the figures and draw them together into a visual whole.

The harmonious character of this group would have appeared more pronounced when Vermeer first executed this work than it does now.[6] This painting has suffered much surface

abrasion, in particular in this section, and the balance of light and color has been affected. The most pronounced area of abrasion is the standing woman's blue jacket and dress. The blue, which was a thinly painted layer of natural ultramarine, is largely gone, and what remains is the black that lay beneath it and formed its base. These blues would have worked together with those in the landscape painted on the cover of the harpsichord, which have also become abraded. This connection would have helped place the woman farther back in space so that the three figures would have formed a more convincing triangular relationship than they now do. With more emphasis on her figure, she would also have counterbalanced the strong light and bright colors of the young woman playing the harpsichord.

The general abrasions mentioned here result from the fragile nature of the glazes Vermeer used extensively during this period to achieve subtle nuances of light and color, in particular in the shadows. A beautiful example here is Vermeer's technique for conveying indirect light on the shaded face of the seated young woman (fig. 82). He first blocked in her face with an opaque flesh tone, then laid a thin gray glaze over it. In the cheeks, forehead, and along the nose he allowed this undertone to penetrate through the glaze to help model the form. Finally, he carefully extended the glaze slightly over the contours of the face to further soften its form.

82. *The Concert,* detail of seated woman

83. *The Concert,* detail of table covering and musical instrument

This technique for capturing the translucency of the flesh tones in these halftones was an extension of techniques Vermeer used in the first half of the 1660s, but it differs in that he here applied it over the whole face. In and of itself that difference is understandable because the face is in shadow, but in the context of the rest of the painting it becomes apparent that Vermeer's techniques here are less varied and complex than in earlier works. He is less concerned with reproducing textures of materials than with the effect of light upon them. In comparison to *The Music Lesson,* for example, where Vermeer created a three-dimensional paint surface to reproduce textural effects on the tapestry covering the table (see fig. 67), the tapestry in *The Concert* is relatively flat (fig. 83). He painted the various colors of its pattern with quick, fluid strokes of blues, reds, and yellows that he then accented with small, similarly colored highlights. The woven texture of the material is suggested by the irregularity of the contours of the patterns of color, not by the three-dimensionality of the paint. Painted black lines on the surface of the tapestry reinforce the definition of the design.

Although Vermeer employed a smaller range of techniques in this painting than in *The Music Lesson* and their intent is somewhat different, he continued to use specular highlights to accent smooth shiny objects that reflect direct sunlight, for example the woman's pearls, earrings, and necklace. Vermeer carefully highlighted the keys of the lute lying on the table to suggest their luminosity by placing a small opaque dot of white over a somewhat larger semitransparent circular shape. He also used light blue accents in the open portion of the neck of the lute, colored highlights that call to mind those found in the features of *Girl with the Red Hat* (see fig. 84).

In this painting Vermeer also developed for the first time a technique for rendering folds to which he would return frequently. The bright light striking the young woman sitting at the harpsichord models the yellow jacket and white satin dress with pronounced shadows along sharp and crisp folds. Strikingly effective from a distance, the technique Vermeer used to paint this area is relatively simple. He laid down a base tone that was thinner and less intense than the final sun-filled color. He then modeled the folds with highlights and painted a darker, neutral tone for the shadows. Finally, he extended this tone over the edges of the lights to suggest the modulations of light along their curved edges. Thus, with great surety and remarkable economy of means, Vermeer was able to convey both the luminosity and translucency of the satin. Indeed, the delicate balance Vermeer created in this painting between the play of light and the representation of texture is probably unmatched anywhere else in his oeuvre.

~

Girl with the Red Hat

84. *Girl with the Red Hat,* c. 1666–67, oil on panel. National Gallery of Art, Washington, D.C. Andrew W. Mellon Collection

Girl with the Red Hat (fig. 84) is a painting that is widely loved and admired, both for its intimacy and its immediacy. As the girl turns outward, with her mouth half opened, her eyes seem bright with expectancy. The lushness of her blue robes, the almost passionate flame red of her hat, and the subtle interplay of green and rose tones in her face give her a vibrancy unique among Vermeer's paintings. Unlike most figures in Vermeer paintings, she does not exist in a cerebral, abstract world. She communicates directly with us, both staring out and drawing us in.

Perhaps the most striking characteristic of this painting is the artist's exquisite use of color, both in its compositional and psychological effects. Vermeer has concentrated his two major color accents, red and blue, into distinct areas, the hat and the robe, but he has also remained sensitive to their interrelationships. Red, in particular the flame red that borders the girl's broad feathery hat, is an intensely warm and active color. It heightens the immediacy of the girl's gaze, an effect Vermeer accentuated by subtly casting its orange-red reflection across her face. Blue, a cool and recessive color, is an appropriate counterbalance to the red. The large, stable form of the girl's blue robe creates an effective compositional support for the activity engendered by the flourish of red in the hat. Vermeer painted the shadowed area of the underside of the hat in a deep purple hue and accented the cheeks with the orange-red reflections of the hat. The shaded portions of the girl's face—her forehead, eyes, nose, and right cheek—are indicated with a greenish glaze, the complement of red.[1]

At the center of the composition, the vivid white of the girl's cravat cradles the face and focuses attention on her expression. The intensity of the white, however, is also important as a unifying element in the painting. Part of the painting's vibrancy is derived from the manner in which materials are animated by light reflecting off their surfaces. Highlights flicker off the hat, the blue robe, and the lion-head finials of the chair. The white of the cravat helps subordinate these point reflections, which might otherwise distract from the broader tonal harmonies of the painting.

Girl with the Red Hat is a small work, even by Vermeer's standards, and it is painted on panel, an unusual support for the artist, the only other panel painting attributed to him being the problematic *Girl with a Flute* (see fig. A36).[2] The painting techniques used in this work, however, are comparable to those found in other of Vermeer's paintings, as, for example, in *Woman Holding a Balance* (see fig. 70). In both paintings Vermeer imbued the blue robes with an inner warmth by painting them over a reddish brown ground.[3] He also used yellow highlights to accent the blue garment, a juxtaposition of primary colors that enlivens the visual effect of the garment.[4] By accenting highlights with bright yellow strokes rather than with white or light blue ones, he imbued the cool blue robe with a certain warmth without reducing its level of color saturation. The main difference in the use of these accents is that more of them enliven the surface of the robe in *Girl with a Red Hat,* which gives a flickering quality to the garment. He also gave the fabric a shimmering quality by painting some highlights thinly enough to allow the underlying blue color to be visible through them. In a similar fashion he achieved the feathery appearance of the girl's hat by painting a succession of semitransparent strokes of light red and orange over an opaque layer of deeper orange-red paint.

The manner in which Vermeer achieved the light reflections on the lion-head finials (fig. 85) is a somewhat freer example of the technique he used to paint the pearls on the table in *Woman Holding a Balance*. In both instances he applied opaque white highlights over a less intense, thinly painted white underlayer. The smooth transition of these highlights into the underlying paint indicates that Vermeer painted them wet in wet. The only difference between the techniques in these paintings is that in *Girl with the Red Hat* Vermeer used the underlying layer more extensively as a modeling device. With rapid yet sure strokes, he suggested the basic contours and structure of the head and then accented the point reflections with his highlights.

Vermeer exploited other techniques in this painting to enhance optical effects. He modeled the white cravat by stroking away parts of the thick impasto with a blunt instrument rather than by drawing a thin glaze over it. This technique not only creates a texture for the cravat, it also introduces a transparency to the otherwise opaque white paint. Perhaps even more striking are the colored highlights Vermeer placed in the mouth and left eye. Vermeer accented the lower lip of the shadowed portion of the girl's face with a small pink highlight. He similarly enlivened the pupil of her left eye with a light green highlight. These accents lend to the figure a marvelous sense of animation and vitality. Vermeer used this technique in at least two other paintings: in the keys of

85. *Girl with the Red Hat,* detail of finial

86. Frans Hals (c. 1580–1666), *Portrait of a Young Man,* c. 1646, oil on canvas. National Gallery of Art, Washington, D.C. Andrew W. Mellon Collection

the musical instrument lying on the table in *The Concert* (see fig. 80), and in the colored yarn of the *Lacemaker* (see fig. A29).

The pose of a girl looking over her shoulder at the viewer is found elsewhere in Vermeer's oeuvre, as, for example, in *Girl with a Pearl Earring* (see fig. A20) and *Portrait of a Young Woman* (see fig. A25), although in no other instance does a figure lean an arm on the back of a chair. Similar poses, however, are found in the works of other Dutch painters. Frans Hals, in his *Portrait of a Young Man,* c. 1646 (fig. 86), used the pose to capture an informal, momentary impression of the sitter. He draped his figure's arm over the chair, suppressing the horizontal shape of the chair to create a more active diagonal emphasis. Vermeer, on the other hand, sought a somewhat less robust image and minimized the diagonal thrust of the girl's arm by obscuring it partially behind the lion-head finials of the chair.

Throughout his career, even in his early history paintings, Vermeer's compositions are the product of intense control and refinement. Figures and their environment are subtly interlocked through perspective, proportion, and color. He also felt free to modify and adjust the shapes and sizes of objects for compositional reasons. This same approach is apparent even in a seemingly spontaneous small image such as this. Here, the position of the lion-head finials, which so eloquently define the foreground plane, have been subtly adjusted to allow them to place the figure in space. The finials, as Vermeer has painted them, are closer together than they would have been in reality and are not correctly aligned. The left finial is much larger than the right one and is angled too far to the right. The top of the chair, if extended to the left finial, would intersect it above the bottom of the ring that loops through the lion's mouth.

The relationship of the girl to the finials has bothered some scholars to the extent that they have questioned the attribution of this small panel painting to Vermeer.[5] Their assessment is based on an underlying assumption that Vermeer painted exactly what he saw, not recognizing the extensive modifications of reality that he incorporated into his paintings throughout his career. Those disputing the attribution have also based their objections on the assumption that the girl is seated in the chair to which the finials belong.[6] The argument follows that the chair is inaccurately represented because the finials should face toward the seat, not toward the rear of the chair. According to this line of reasoning the back rather than the front of the finials should be visible, as they are in Hals' *Portrait of a Young Man.* There is no basis for this assumption, however, for the girl is almost certainly seated in a different chair and is posed with her arm resting on the chair facing the viewer. In any event, Vermeer was imaginatively using the finials as a foreground foil for his com-

87. Experimental photograph through a camera obscura. Photograph by Henry Beville. National Gallery of Art, Washington, D.C.

position. Visually, the spatial organization succeeds in integrating his figure with the chair and at the same time in using the chair to help establish the informal mood he sought.

Despite similarities in technique with *Woman Holding a Balance* (see fig. 70)—a sophisticated composition, imbued with complex forms and symbolism—*Girl with the Red Hat* is no more than a bust, portrayed with unusual spontaneity and informality. The painting may well be one of the *tronyen* (bust-length figure studies) listed in the 1683 inventory of Jacob Dissius' possessions.[7] It may also have been one of the paintings listed as "a tronie in antique dress, uncommonly artful" in the Amsterdam auction of Vermeer's paintings of 16 May 1696.[8] One could well imagine that the rather fanciful costume, which helps give the painting its exotic air, could have been termed "antique," a generic term used for any image that suggested something old or out-of-date.[9] The tapestry background, so unusual for Vermeer, also enhances the exotic quality of the image, in large part through the ill-defined patterns that play across the surface.[10] Just why Vermeer, in this tronie and in *Girl with a Pearl Earring,* chose to depict his sitter in an exotic or antique costume cannot be answered with certainty, although it may have been because he wanted to remove his figure from any reference to a specific time or place. He may have done so to fuse that sense of spontaneity, so forcefully evident in this work, with something more lasting and universal, an impulse that is fundamental to the character of his larger, more involved compositions.

Despite the painting's refined technique, the fluidity of his brushwork in this painting is remarkable. To a large extent this fluidity can be attributed to the difference in touch between the smooth, hard surface of the panel support and the canvas he used in his other works. His brushstrokes here seem to have glided easily over the surface, creating quicker rhythms than usually found. As panel paintings are an anomaly in Vermeer's oeuvre, it is interesting to speculate on the rationale behind Vermeer's decision to paint on such a surface in this particular instance. The explanation may simply be that for such a small study panel was a more appropriate support than canvas. Vermeer's choice of support, however, may also relate to his experimental use of the camera obscura, although he probably did not project an image from a camera obscura directly onto the panel. Nevertheless, his conscious attempt to exploit optical phenomena visible in a camera obscura—intense colors, accentuated contrasts of light and dark, and halation of highlights—suggests that Vermeer sought to re-create the impression of such an image. He may have decided to paint on a hard, smooth surface to lend to his small study the sheen of an image seen in a camera obscura as it is projected onto a ground glass or tautly stretched oiled paper, as was done in the mid-seventeenth century.

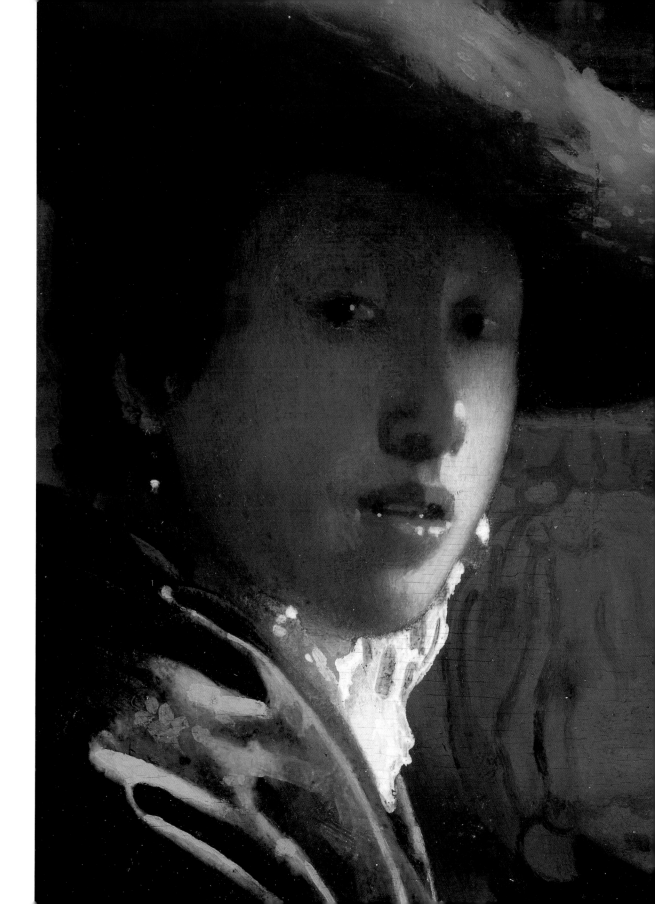

88. *Girl with the Red Hat*, detail of girl

The hypothesis that Vermeer might have used a camera obscura while painting *Girl with the Red Hat* is based on his method of painting light reflections, in particular those on the right lion-head finial, which have the diffused characteristic of unfocused points of light in a photograph, called halation of highlights. Seymour was the first to argue that it is highly unlikely that Vermeer could have achieved this effect without having witnessed it in a camera obscura. He demonstrated, with the aid of excellent experimental photographs, the similarity of Vermeer's painterly treatment of the lion-head finial (see fig. 85) and an unfocused image seen in a camera obscura (fig. 87). As Seymour argued, Vermeer undoubtedly exploited this effect both to animate his surface and to distinguish different depths of field.[11]

One of the many misconceptions about Vermeer's painting style that has affected theories of his use of the camera obscura is that Vermeer was a realist in the strictest sense, that his paintings faithfully record models, rooms, and furnishings he saw before him.[12] His willingness to adapt reality, however, must have dictated Vermeer's artistic procedure whether he viewed his scene directly or through an optical device like a camera obscura. Even in this small panel painting, which perhaps most closely resembles the effects of a camera obscura of any of his images, Vermeer intuitively shifted and adjusted forms to maintain compositional balance. Thus, even though he must have referred to an image from a camera obscura when painting *Girl with the Red Hat* and sought to exploit some of its optical effects, it is most unlikely that he traced its image directly on the panel.[13] The possibilities that he traced his more complex compositions are even more remote.

Vermeer's handling of diffused highlights in his paintings, including *View of Delft* (see fig. 55), suggests that he used them creatively as well, and not completely in accordance with their actual appearance in a camera obscura. In *Girl with the Red Hat* he has accentuated the diffuse yellow highlights on the girl's blue robes, whereas in a camera obscura reflections off unfocused cloth create blurred images as in *The Art of Painting* (see fig. 95). He even painted some of his diffused highlights in the shadows where they would not appear under any circumstance (fig. 88).

Surprisingly, Vermeer chose for his painting a panel that had already been used, perhaps because he did not have a readily accessible panel in his workshop. The bust-length portrait of a man with a wide-brimmed hat lies directly under *Girl with the Red Hat,* with no intermediate paint layer separating them. This underlying layer is partially visible in x-radiographs of the panel (fig. 89a) and more so in infrared reflectography (fig. 89b). Because

89a. X-radiograph of *Girl with the Red Hat* (upside-down). National Gallery of Art, Washington, D.C.

89b. Infrared reflectogram of *Girl with the Red Hat* (upside-down). National Gallery of Art, Washington, D.C.

Vermeer turned the panel upside down to paint the girl, it is possible to examine the man's face in the x-radiograph without too much interference from the surface image. The painting style of this face, which is modeled with a number of bold rapid strokes that have not been blended together, is very different from that of Vermeer. The reflectogram reveals a great flourish of strokes to the right of the face that represent the man's long, curly hair.

Although it is impossible to attribute a painting to an artist on the basis of an x-radiograph and reflectogram, certain characteristics of the handling of the paint in the underlying image are remarkably similar to those seen in paintings by Carel Fabritius. The small scale of the panel, the subject matter of a male bust, and the rough bold strokes and impasto with which the head is painted are all features found in studies by Fabritius from the late 1640s, such as *Man with a Helmet*.[14] At his death Vermeer owned two *tronijn* by Fabritius.[15] Because Vermeer was an art dealer and may have studied under Fabritius, he could well have owned others during his lifetime.

The close relationship between *Girl with the Red Hat* and the appearance of a camera obscura image would appear to provide some welcome evidence about one of the fundamental questions in Vermeer scholarship: the impact of this optical device on Vermeer's style and technique. In this instance, to judge from the fluidity of paint, the diffused highlights, and the heightened contrasts of colors, its influence was substantial. The pictorial effects are so similar that one can almost imagine that Vermeer sought here to emulate the appearance of a camera obscura image. Nevertheless, to determine the extent of the camera obscura's impact is virtually impossible. Most of Vermeer's paintings, even those that include optical effects similar to those found in a camera obscura, are far more complex than is this relatively simple image of a girl looking over her shoulder, which means that Vermeer had to design them with careful attention to perspective and compositional balance. In the end, it seems, the differences between Vermeer's stylistic approach in *Girl with the Red Hat* and in his other paintings, in particular those of the mid- to late 1660s, are merely ones of degree and not of kind.

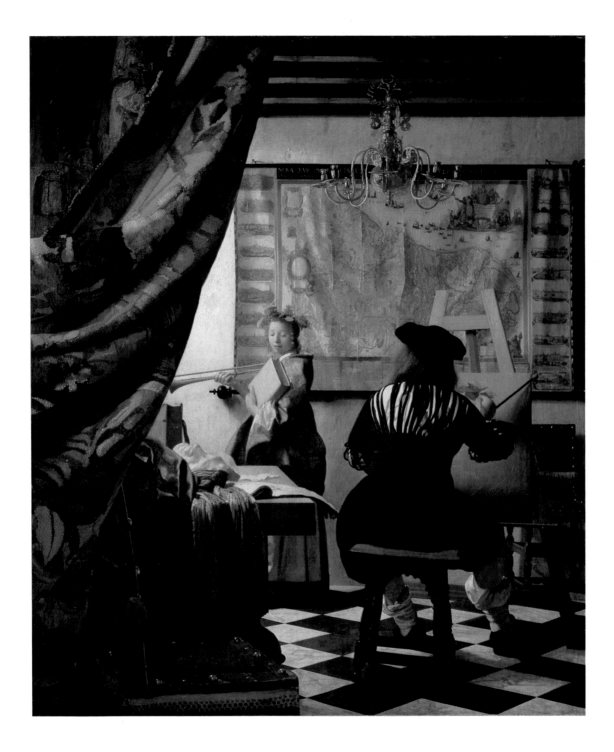

CHAPTER XIII

~

The Art of Painting

90. *The Art of Painting,* c. 1666–67, oil on canvas. Kunsthistorisches Museum, Vienna

Certain paintings stand apart as reaching the essence of an artist's creative personality. *The Art of Painting,* c. 1666–67 (fig. 90), is one such work. For an artist so well known for his scenes of daily life, it seems strange that an allegorical painting should take on such significance, yet its unique character and large scale tell us that Vermeer attached great importance to this work. Whatever the circumstances that induced him to conceive of this allegory, his personal associations with it were apparently strong, as it remained in his estate. Even after his death, when the family was in dire financial straits, the painting was not sold. On 24 February 1676, Vermeer's widow, Catharina Bolnes, transferred ownership of it to her mother, Maria Thins, to keep it out of the hands of creditors.[1]

Clear proof that the painting is an allegory is provided by the title given in the document of 1676: *De Schilderkunst,* or *The Art of Painting.* Instead of a descriptive title, as one normally finds in seventeenth-century documents, this one focuses on the painting's meaning. It confirms that the image represents far more than an artist at an easel depicting a woman dressed as Clio, the muse of history. It also suggests that the other significant compositional components—map, tapestry, and chandelier—were probably incorporated to help convey Vermeer's conviction about the meaning and significance of the art of painting.

The issues Vermeer dealt with here were not new ones. Ever since antiquity artists and theorists had struggled to define those qualities that paintings should contain, the ideals they should convey, and the significance these images held for human beliefs and understanding. Concurrent with these concerns were questions about the artist's place in society, an issue that focused on the duality of the artist's perceived role as craftsman and as creative genius. Finally, commentaries on the visual arts always conveyed an awareness of the enormous fame brought to a city or a nation by its artists.

Although the intellectual ideas underlying Vermeer's painting belong to a deeply ingrained tradition, Vermeer's interpretation is unique. Instead of depicting a single allegorical figure to convey his theme, as does the painter at his easel with the figure of Clio, Vermeer elicited abstract concepts from the specific realities that his art had come to rely

[129]

upon for its inspiration. The allegory transpires in a recognizable room filled with objects drawn from daily experience. The event that Vermeer has depicted is an artist painting an image of his model, who, following the prescriptions of Ripa, has been dressed as Clio, the muse of history.[2] She wears a crown of laurel on her head to denote honor, glory, and eternal life. In one hand she holds the trumpet of fame, and in the other she clasps a thick tome, perhaps a volume of Thucydides, symbolizing history. The artist, having posed her in the guise of this allegorical figure, carefully and accurately records her image on his canvas. Thus, he is not so much inspired to create by the muse of history as he is the agent through which the muse takes on life and significance. The painter's image of Clio will then convey meanings that result from a fusion of his artistic vision and the intellectual and emotional associations of history, fame, and honor traditionally brought to her.

The depiction of Clio, though central to the meaning of the allegory, is only one aspect of Vermeer's work. For Vermeer, the art of painting meant more than conveying abstract principles in realistic form; its very essence was built upon a conviction that a thorough understanding of the laws of nature was crucial for a convincing representation of his image. The illusionism of *The Art of Painting* is the framework around which the thematic interplay between the model as Clio and the artist transpires. Their existence and their relationship are convincing only within the context of an elaborately conceived interior, constructed according to the dictates of linear perspective. This realm is given life through Vermeer's masterful observations of light illuminating the figures and the rest of the room. Finally, the extraordinary techniques Vermeer devised to depict the glints of light off the chandelier, the unfocused appearance of the drapery hanging over the edge of the table, and the aged surface of the map of the United Netherlands on the back wall insist that the allegory be grounded in close observation of natural effects and in a matching painterly virtuosity.

That these concerns were uppermost in Vermeer's mind while conceiving *The Art of Painting* is understandable, given the philosophical framework for "Pittura," or "Schilderkonst," provided by Ripa in his *Iconologia*.[3] Although the allegorical figure of Schilderkonst described by Ripa does not figure in Vermeer's painting, the mask described as hanging from her neck on a gold chain can be seen lying on the table directly in front of the model for Clio.[4] The mask stands for imitation, and Ripa's text discusses at length the importance of the imitation of nature for the artist. Ripa emphasized, however, that the artist needs to rely upon art as well as nature, making judgments, using his imagination, and observing the rules of perspective.[5] Just as with poetry, painting draws from nature but also,

91. *The Art of Painting,*
detail of painter

through its art, brings a deeper understanding of external appearances. The foundation for the art of painting, or *Schilderkonst*, derives from drawing, which the artist then covers and hides in his completed work, just like the artist in Vermeer's painting. As with a rhetorician, the artist should achieve his effects without allowing the artifice to become apparent.[6] Finally, the fame and praise received by a deserving artist comes from virtue, a quality alluded to by Vermeer through the laurel wreath the artist has begun to paint (fig. 91).[7]

Central to the allegory is the close bond between art and history. The artist immortalizes the muse of history because she is and always has been the muse that guided an artist's aspirations to record the higher reaches of the human mind. According to seventeenth-century art theory, painting only reached its highest level of accomplishment when it strove to convey the abstract ideas of human behavior traditionally associated with allegories and representations drawn from the Bible and mythology.[8] Although this ideal, at first glance, may seem somewhat removed from the emphasis of Vermeer's genre scenes or landscapes, the essence of his art had always been to reach below the superficial level of reality to probe those essential truths of human existence. In this respect, the ideals expressed in this painting visually express the philosophical concerns at the foundation of his approach to the art of painting.

The new and different component to this painting is the explicitness of its allegorical character. Aside from his early mythological and religious paintings, Vermeer had until this moment always given priority to the apparent reality of his image. The moralizing implications or historical allusions they contained worked through that reality and were subordinate to it. The artist himself receded to the background, to be seen only fleetingly and partially in the mirror reflection on the back wall of *The Music Lesson* (see fig. 64).

In this allegory, Vermeer proclaimed his presence and his control. As in a theater, the large tapestry pulled back on the left announces that in this tableau vivant Vermeer has constructed an artifice whose meaning is to be carefully considered.[9] The artist, at work on his canvas, sits with his back to the viewer to reveal the creative process by which the art of painting is realized. His elegant costume, with a distinctive doublet with slits across the back and on the sleeves, elevates him beyond the social level of anonymous craftsman. He is almost certainly not, as has often been written, dressed in an outmoded Burgundian costume, for his slit doublet was of a type occasionally worn for special occasions in the mid-seventeenth century.[10] He is dressed as an artist worthy of depicting this elevated subject matter, someone whose social stature reinforces the concept that painting belongs to the liberal arts.[11]

The bond between art and history, made explicit by Clio, is also implicitly stressed in the large wall map. This map, representing the seventeen provinces of the Netherlands and its major cities, was also the creation of a distinguished artist, Claes Jansz. Visscher (1587–1652), whose Latinized name, Nicolaum Piscatorem, was clearly inscribed by Vermeer along the map's upper right edge. As is evident in a comparison with the only extant example of the map, Vermeer depicted it with veneration.[12] In addition to faithfully recording the features of the land, the cartouches, and the text, he took care to represent the patina of the map and the folds and creases that had formed over time, for by the mid-to-late 1660s (when Vermeer painted this work) Visscher's map was not new. By the 1660s reclamation of land had changed the physical character of the countryside. The political realities were also different. The Netherlands no longer consisted of seventeen provinces as described by Visscher in the title of his map. At the signing of the Treaty of Münster in 1648 the northern seven provinces had officially separated into an independent political reality, the Dutch Republic, while the southern provinces remained under Spanish control.

The map is not the only object in the painting that alludes to recent past Dutch history. Hanging directly in front of it, symbolically crowning its image of the Netherlands, is a glittering chandelier (fig. 92). In its elegant craftsmanship, the chandelier, like the map, stands out as a masterpiece of design. Surmounting it is an abstracted image of a double-headed eagle, the imperial symbol of the Hapsburg dynasty that had had jurisdiction over the seventeen provinces.

The relation of Visscher's map and the chandelier to an allegory on the art of painting has been a matter of conjecture. The painting has been interpreted as a yearning for a return to a united Netherlands and, by implication, to the fame and glory associated with that past era.[13] The distinctive crease in the middle of the map through the city of Breda has also suggested to some that Vermeer meant to allude to the political history that had divided the land into two distinct segments, the Northern and Southern Provinces.[14]

Whatever the specific iconographic roles the map and chandelier might have played, however, Vermeer included each of these elements to give a framework to the essential core of the painting, the act of creation transpiring on the easel. Ripa stressed that the art of painting begins with a firm foundation of drawing, and must proceed so that the artifice is disguised by paint. Here, after laying in the composition with a white chalk underdrawing, the artist has begun his painting by depicting Clio's laurel wreath, her symbol of glory. The artist draws strength from this reverence for history and, as is evident in the map and the chandelier, from an understanding of his nation's past and its traditions. He is, however,

92. *The Art of Painting,*
detail of chandelier

not merely the beneficiary, for his painting becomes a vehicle through which his country's glory and fame is transmitted.

Artists' role in enhancing the fame of their homeland and of their native city was profoundly appreciated in the Netherlands at this time. This concept, one of the subthemes of Giorgio Vasari's influential *Lives of the Artists,* was given a northern flavor by Karel van Mander in his *Het Schilderboeck* of 1604. It then figured into the individual histories of Dutch cities published during the seventeenth century, including Dirck van Bleyswijck's *Beschryvinge der Stadt Delft.*[15] Vermeer almost certainly had this concept in mind when he decided to include Visscher's large wall map, flanked by city views, as a background foil to his image. Clio, moreover, is situated precisely at the juncture between the map of the Netherlands and these city views. Located directly in front of her is, appropriately, a view of the Hof in The Hague, the seat of government.

When Bleyswijck commented that artists bring glory and distinction to their respective cities, he also lamented that fame due to them comes only after their deaths. Bound by convention to limit his praise to artists already deceased, Bleyswijck only listed Vermeer as one of the artists active in Delft; he included not one word about Vermeer's work. To the reader of this history of Delft, Vermeer remains as indistinguishable from his contemporaries as the artist in this painting. Indeed, one wonders whether Vermeer depicted his artist from the rear primarily to assert the universality of his allegory or to emphasize the anonymity experienced by the artist during his lifetime even as he brings fame and glory to his homeland.

Among the theoretical concepts that underlie this work, none is so pervasive as the insistence on the illusionistic character of the image, an illusionism based on a firm foundation of perspective and awareness of optical laws. The importance of the mimetic aspect of painting was firmly rooted in art theory. The story of the competition between the ancient artists Parrhasius and Zeuxis to see who could paint the most realistic painting, for example, was continually cited as an example of the ideal toward which an artist should strive.[16] Parrhasius won this contest by painting a curtain that was so real in appearance that Zeuxis tried to lift it to see the image beneath; to a certain extent, the large tapestry in *The Art of Painting* that has been pulled aside to reveal this allegorical scene also recalls Parrhasius' triumph. Its colors, folds, and textures convince us of its existence. Because it overlaps the corner of the map, Clio's trumpet, and the large book on the table, the viewer feels an urge to push it back to reveal more of the room behind it.

For Vermeer, who always strove to convey the appearance of reality in his landscapes and genre scenes, this illusionistic impulse was so essential to his art that one hardly recognizes its theoretical underpinnings. It becomes clear what a guiding principle this ideal was for him, however, when one discovers how thoroughly he understood the principles of perspective, how he adapted his painting techniques to capture the appearances of light and texture, and how these elements combine to create the illusion of reality.

As with the curtain of Parrhasius, the painting techniques that Vermeer used to create the illusion were not ends unto themselves: they reinforced viewers' expectations and enhanced their appreciation of the painting's subject. In *The Art of Painting* the thematic culmination exists not on the surface, as in Parrhasius' trompe l'oeil, but behind the curtain. Once he had introduced his painting with the tapestry, Vermeer then had to draw the viewer into the image in a way that would encourage contemplation of the meaning of the allegory. To achieve this effect Vermeer adapted a number of devices from his previous works. As in *The Concert* (see fig. 80), he juxtaposed the darkened foreground with a brightly illuminated back wall. He then gave further emphasis to this area through the perspective. He constructed the vanishing point just in front of the figure of Clio to give her light-filled form added significance.[17] The viewer is drawn to her as is the painter.

Clio stands motionless; her young face, with eyelids lowered and mouth slightly open, is serene and peaceful. To give her further visual stability and to enhance her visual importance, Vermeer carefully positioned her in relation to the lower left corner of the wall map. He placed her head at the juncture of the vertical and horizontal borders of the map proper. The outer edge of the wall map coincides exactly with the knob on her trumpet, and the round finial at the end of the rod weighting the map echoes the shape of her right hand. Finally, the blues of her dress and the flesh tones of her face harmonize with the soft tonalities of the map's variegated colors.

In contrast to the close bonds Vermeer established between Clio and her surroundings, the artist stands apart. To begin with, he is disproportionately large. As with the officer in *Officer and Laughing Girl* (see fig. 36), Vermeer situated this figure within a different perspective schema to enhance the dramatic intensity of his composition. If the painter stood up he would tower over his model. His eyes would be level with the top of his easel, the approximate horizon line for the stool on which he is sitting. Although the artist's importance is stressed by his central position and his large proportions, he is also given added prominence through the stark and irregular silhouettes of his black beret, hair, jacket, and

pantaloons against the regular geometric shapes of easel, painting, map, and wall. Even though his face is not visible, the viewer senses both the forcefulness of his personality and the intensity of his gaze as he begins to record the image he sees before him.

Vermeer painted the artist at a large scale for specific compositional and thematic reasons, but he also designed the image so that the discrepancies in size would not disrupt the realistic foundation of the allegory. Thus he was particularly careful in establishing points of contact between the artist and objects in the room that have a certain spatial ambiguity. The artist's primary connection to his surroundings, for example, is with his painting and easel, but these objects are difficult for the viewer to orient spatially because they are essentially parallel to the picture plane. His left shoe is partially hidden by the cross bar of the stool; his right shoe is difficult to define because its black color blends into one of the black squares of the marble floor.

The most significant visual contact Vermeer established between the artist and his surroundings is the pamphlet that reaches over the edge of the table and barely overlaps his black pantaloons. Through this device Vermeer created a fascinating visual and spatial tension for the scene. The pamphlet provides a visual bond that links the artist's form and the foreground table as well as helping to define the distinctive negative space that is formed by the contours of the artist, the model, and the bottom edge of the map. This shape, as well as the area between the pamphlet and the floor, has the contrary effect of flattening the space between the model and the artist. The spatial tensions that result heighten the dynamic relationship between the two figures and activate the entire composition.

To reinforce the drama of his allegory, Vermeer painted the foreground of this composition in a quite summary fashion, giving much greater textural emphasis to the middle ground and background. The difference in his approach can be seen by comparing his treatment of the foreground tapestry and chair with comparable elements in *The Music Lesson* (see fig. 66). Although Vermeer has depicted light hitting the nubs of the weave on the tapestry with multicolored highlights and has accented the brass nails of the chair, in neither instance did he try to re-create the essence of their material structure. The green and yellow cloth hanging over the edge of the table, which essentially defines the foreground plane of the allegory itself, is less precisely defined than these other introductory elements. It is as though Vermeer depicted it as an unfocused compositional element to be passed over by the eye as it continues into the further reaches of the painting.

The artist at his easel is executed with broad strokes that match the boldness of his

93. *The Art of Painting,*
detail of Clio

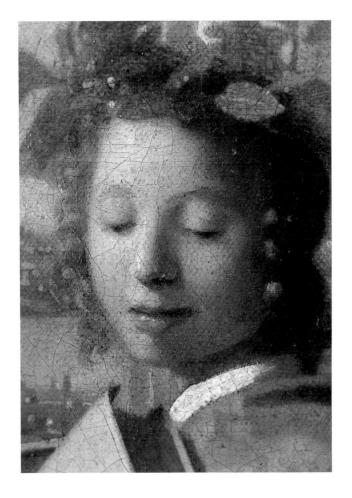

image. The patterns of the black jacket, red leggings, and white socks are almost abstract in their crisp renderings of light and shadow. At the rear of the room, however, Vermeer has described forms with more attention to light and textural effects. He depicted the nuances of light falling across Clio's hands, face, and robe (fig. 93). Vermeer has effectively conveyed the softness of her skin, the smoothness of the leatherbound folio she holds, and the sheen of the blue fabric as light reflects off the varied folds of its irregular surface. Vermeer similarly recorded the worn surface of the wall map as light models its form and reflects its aged appearance (fig. 94). Short strokes of varying shades of white, blue, red, and green convey both the design and these nuances of light. Finally, in one of the most striking passages in

94. *The Art of Painting,* detail of map

95. *The Art of Painting,* detail of material on table

any of his works, Vermeer captured the brilliance of sunlight reflecting off the polished surface of the brass chandelier (see fig. 92). With sure strokes that range from thick impastos of lead-tin yellow in the highlights to darker and thinner strokes of ocher in the shadows, Vermeer created the illusion of an object that seems almost tangible.

By thus reserving his most careful descriptions of light and textural effects for the model, Visscher's map, and the chandelier, Vermeer reinforced his compositional structure. The viewer quickly passes by the dark foreground elements, executed in a broad manner, and is drawn to the carefully rendered forms in the light-filled background. At the same time, by asserting the physical reality of the map, the chandelier, and model dressed as Clio through his painting techniques, he emphasized those elements for his allegory on the art of painting.

Though Vermeer carefully crafted this image through his control of light, perspective, and painting techniques, he almost certainly also conceived his composition with the aid of a camera obscura. The most conspicuous indication that Vermeer utilized this instrument is the explicitly unfocused drapery hanging over the front edge of the table (fig. 95). Vermeer used this effect to indicate that the true focus of the painting was farther in the distance. This optical phenomenon, known today as depth of field, is not evident in normal vision, but is dramatically visible through a camera obscura lens. The distinctively diffused charac-

ter of the drapery in this painting records exactly the type of image seen in a camera obscu-
ra when soft materials, such as cloth, are not in focus. If one can deduce from this conspic-
uous clue that Vermeer utilized a camera obscura, then its use may also explain how he
came to conceive of the idea to create such a pronounced contrast in scale between the
artist and Clio. Because the camera obscura is constructed along principles of monocular
rather than binocular vision, there are extreme contrasts in scale between near and far
objects in the images it creates.[18] Finally, the camera obscura works most effectively when
bright light reflects off an opposing surface. The image then tends to exaggerate the con-
trasts of light and dark much as it does differences in scale. The character of the light in
this painting is thus consistent with that in this optical device.

As in *The Milkmaid* (see fig. 42), *View of Delft* (see fig. 51), or *Girl with the Red Hat* (see
fig. 84), however, Vermeer would have used the camera obscura as a tool to help him visual-
ize the scene and guide him in conceiving it, rather than as a device to create an image he
would transfer directly to the canvas. The subtle relationships Vermeer established among
his compositional elements are unlike those that occur in nature. Whatever the role of the
camera obscura in his actual artistic process, Vermeer probably emphasized visual effects
related to its use because of the high estimation accorded the images it created. Constantijn
Huygens, Samuel van Hoogstraten, and other contemporaries marveled at the sense of real-
ity conveyed by the "truly natural painting," as the camera obscura image was often
called.[19] Vermeer would also have been aware of the parallel that writers had drawn
between the creation of an image in a camera obscura and an image in the eye, an argu-
ment that emphasized that the camera obscura's image was a true and accurate record of the
visual world. Given the visual evidence of its use in this allegory, thus, Vermeer affirms that
the camera obscura was a tool that the artist could use to help create the illusionism that
Ripa had asserted was at the core of the visual arts. Its use reaffirmed that the artist's por-
trayal was as valid as the camera obscura's image in revealing the underlying truths of
nature.

≈

Mistress and Maid

The images of domestic life that Vermeer created during the mid-1660s project an aura of tranquility. In his well-ordered interiors, carefully dressed and seemingly self-assured women are quietly occupied with their thoughts or participate in intimate concerts with gentlemen. Light fills their worlds, reinforcing the sense of well-being and security. Against this background *Mistress and Maid* (fig. 96) comes as a surprise. The moment of concentration is here interrupted, and the expression on the mistress' face, as well as her involuntary gesture, is one of concern and anxiety.

Perhaps because this theme was at such variance with those he had been developing in his other works, Vermeer radically revised the compositional ideas he had previously used. The painting is large, and the mistress and maid are life-size and fill the foreground plane. Behind them is a dark brown curtain, so vaguely defined that it is barely noticeable. In this reduced setting the viewer's concentration is focused on the psychological interchange between the two figures.

Within the tightly constricted circles of Dutch genre painting, iconographic traditions for specific subjects seem to have been well understood and shared by artists working in different geographical centers. For example, most paintings by Vermeer and his contemporaries that focus on the theme of letter writing depict love letters being either written or read (fig. 97). Occasionally an attendant waits for a letter to be finished, or a confidant listens to the content of a letter. Vermeer's interpretation of the theme in this painting is exceptional, for it attempts to capture the anticipation that occurs at the moment a letter arrives. The mistress' expectation is tinged with anxiety, however, because the letter appears to have come unexpectedly. Her own letter, still half-written, lies under her hand.

Departing from the traditional iconography of the letter writer, Vermeer nevertheless relied upon its underlying thematic content to give poignance to his scene. The mistress' expression reveals the uncertainties of love that disrupt the serenity of ordered existence. The mistress' controlled demeanor and fashionable wardrobe seem to suggest that such fleeting doubts affect even those who are most secure and content in their lives. The maid,

97. Gerard ter Borch,
Woman Writing a Letter,
c. 1655, oil on canvas.
Mauritshuis, The Hague

while offering the letter, responds to her mistress' gaze with a caring yet concerned look. With her slightly opened mouth and lowered eyelids, her expression is as restrained as her mistress', yet Vermeer created a visual dialogue between them that conveys the intense psychological impact of the letter's arrival.

Vermeer may well have decided to paint his figures life-size in order to give greater immediacy to this interchange. One of his remarkable achievements in this work, however, was to realize that he could convey these feelings without precisely delineating the image. He purposely softened forms and generalized shapes. An area that reveals his techniques is the mistress' head (fig. 98). Her face, which is so expressive in its concern, is defined only through gentle modulation of the flesh tones. Her eye is suggested with little more than a wisp of ocher; yet it seems to both peer intently at the maid and pose questions as well. The soft curls of the stylish coiffure that frames her forehead are formed with broad strokes of thinly applied ocher paint that are then accented with equally fluid strokes of light ocher. The somewhat diffused form that Vermeer has created imparts a classical purity at the same time that it suggests the slight movement of her face as she looks up at her maid.

The broad technique has suggested to some that this painting is unfinished.[1] Quite to the contrary, Vermeer achieved his effects by creatively adapting the techniques he had used in the mid-1660s for depicting figures at a smaller scale. In much the same way that was evident in the modeling of the woman's head in *Woman in Blue Reading a Letter* (see fig. 1), Vermeer carefully integrated the paint layers, in particular along the mistress' contours, to suggest the roundness of her form. After applying a white ground layer, which consists of mixture of chalk and lead-white paint, Vermeer laid down a thin brown-black layer of paint that apparently covers the entire surface.[2] He may have applied this overall dark layer, which is quite unusual in his work, to enhance the richness of the color harmonies used for the large-scale figures. Above this dark layer he blocked in the mistress' head and neck with a warm ocher color. This layer, which is visible through the ringlets of curls on her forehead, then served as the base layer for the woman's hair. It also served as the base layer for the light impastos Vermeer used to model the face. He did not, however, entirely cover this base flesh layer along the mistress' profile. By allowing a thin sliver of tone to remain visible, in particular along her forehead and under her nose, he used it to help soften the contour of her face. Vermeer also utilized the dark reddish browns of the background to help modulate her contours. He used this background color to cover the underlying flesh tone along the profile of the woman's nose to help sharpen its image. Under her chin, he suggested the roundness of her form by drawing a thin layer of the background color over the flesh tones.

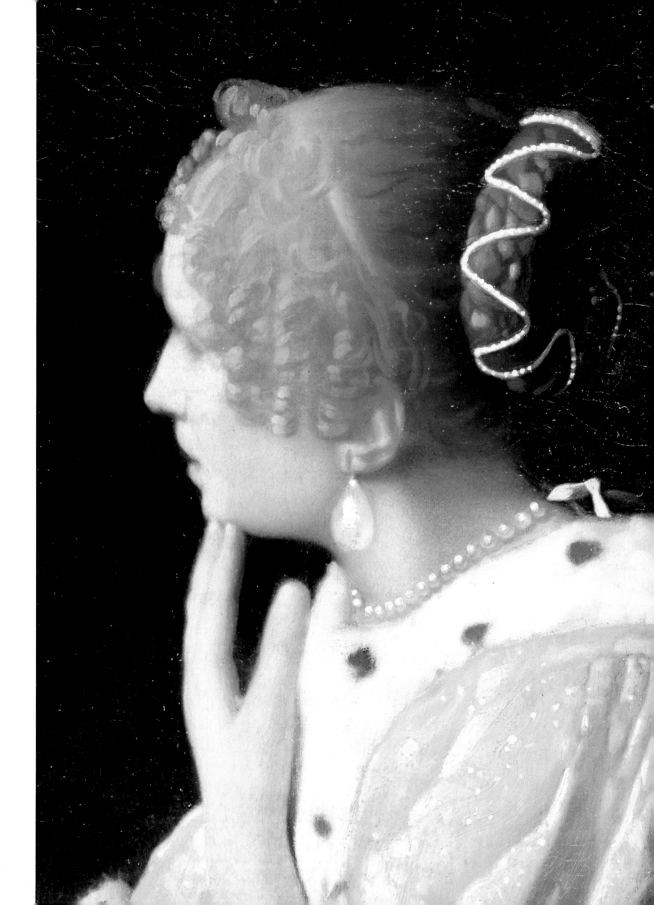

98. *Mistress and Maid,*
detail of mistress' head

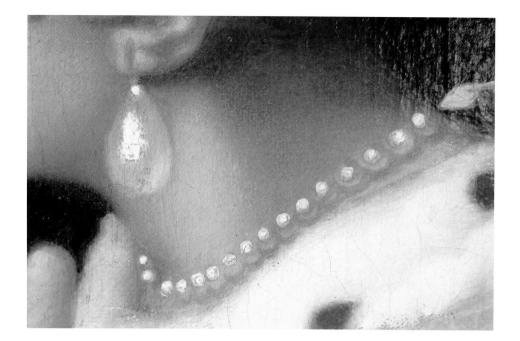

99. Mistress and Maid,
detail of necklace

The confidence with which Vermeer controlled his medium is evident in the economical technique he devised to define the string of pearls around the woman's neck. To suggest the translucency of the jewels he followed his normal procedure of highlighting each pearl with a small dot of white paint (fig. 99). In this instance, however, he suggested their translucency by using the mistress' pale flesh as a base tone rather than through the application of a separate color. He then defined the round shape of the pearls by allowing darker underlying flesh tones to suggest the shadows of their form against her neck.

The broadness of Vermeer's techniques extend throughout the painting. The maid's face is subtly modeled with feathered strokes of the brush and with paints of various densities (fig. 100). Her costume, discreetly colored olive brown, draws her slightly into the background. It, too, has softly modulated folds. The hand that holds the letter is relatively undefined, modeled with a play of light across its form rather than with crisp contours.

Perhaps the most remarkable painterly effects are the abstracted highlights Vermeer used to depict light reflecting off the glass inkwells. With a minimum of modeling he suggested both their weight and their form with these bold, controlled strokes. The daring

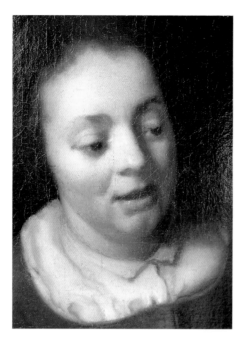

100. *Mistress and Maid,*
detail of maid's face

quality of these accents is evident when one compares them to the more restrained tech-
nique Vermeer used to define these objects in *A Lady Writing,* executed only a year or two
earlier (see fig. A22). A similar comparison can be made with the execution of the jewelry
box, another object that appears in both paintings. In *A Lady Writing* each of the decorative
pearls on the case is carefully articulated, and its three-dimensional quality emphasized,
even though the side of the box is in shadow. In *Mistress and Maid,* where Vermeer is less
concerned with carefully defining individual objects than with conveying an impression of
their form, the pearls are only cursorily suggested.

Although it is difficult to determine fully the derivation of this work, Vermeer may
have conceived it in response to a tendency among contemporary genre painters to depict
scenes that focus on the arrival of a guest or an unexpected intruder to a woman's dwelling.
Gerard ter Borch and Gabriel Metsu (fig. 101) had exploited this device during the 1650s
and 1660s to introduce a narrative element into paintings of amorous genre subjects.
Vermeer differs from Ter Borch and Metsu, however, in that he shifted the scene from the
specific to the abstract by leaving the room undefined. The intruder, moreover, is not an

101. Gabriel Metsu, *The Intruder,* c. 1660, oil on canvas. National Gallery of Art, Washington, D.C. Andrew W. Mellon Collection

identifiable man, whose character and relationship to the mistress can be assessed by the viewer, but a letter whose contents remain undisclosed. Vermeer's emphasis, thus, is not on the activity surrounding the interruption, but on the psychological response it triggers.

Even though the painting represents a departure for Vermeer, he drew upon his previous work to formulate his conception. Of great importance for the mood he wanted to establish is the delicate equilibrium between the transitoriness of the moment and the restrained and self-contained image. Vermeer had previously established equilibrium through his use of light, color, and the careful juxtaposition of figures with a framework provided by the room and objects contained within it. In this painting the geometric framework is minimal but significant. Vermeer helped establish the quiet mood with the pronounced horizontal of the table edge in the immediate foreground of his painting. Light falling on the table accentuates its shape as well as the simple vertical folds of the blue cloth that covers it. Although less obviously than in other paintings of his from the 1660s, Vermeer also used perspective effects to reinforce his thematic conception. Because he minimized the number of receding orthogonals in his composition, the precise location of the vanishing point is difficult to determine. Nevertheless, to judge from the angle of recession

of the side edge of the table and from the position of the horizon line just above the top of the jewel box, it must fall at a point on the maid's forearm.

Although the position of the vanishing point necessarily strengthens the significance of the maid's gesture, Vermeer also provided other visual incentives to draw the viewer's attention in this direction. The blue of her dress, against which the white letter is partially silhouetted, is related in hue to the cloth covering the table, but is deeper and richer in color. The brilliant reflections off the inkwells bring added visual interest to that area of the painting. Most significant, the maid's arm and that of the mistress resting on her letter are virtual mirror images. The two gestures reinforce one another at the same time that their juxtaposition, the one hand holding a pen and the other the letter, underscores the source of the mistress' apprehension.

One of the most subtle means by which Vermeer achieved this balance between a transient and extended moment in this painting is through his treatment of the mistress' raised left hand. This gesture, while indicative of momentary surprise, is inwardly directed. As the mistress' extended fingers press ever so slightly against her chin, her hand becomes linked to her face and visually becomes an extension of her concern. However, while the hand has come to rest, the mistress' gesture does not appear static. The broad modeling of the hand, which Vermeer created by softening its contours, has given it a relatively diffused character, not unlike the unfocused appearance of a hand in movement.[3]

As in *Officer and Laughing Girl* (see fig. 36) and *The Art of Painting* (see fig. 90), Vermeer occasionally intensified the relationships between figures in his works by shifting their spatial orientation through an alteration in his perspective system, the same device used in *Mistress and Maid*. The mistress, whose eye level is considerably above the horizon line, is disproportionately large. Her figure and her emotional reactions thus take on primary significance in this work, an importance enhanced by the stark contrast of her illuminated face and lemon-yellow satin jacket against the dark background.

Finally, the forcefulness of Vermeer's characterization of the figures' gazes is a brilliant culmination of one of the leitmotifs of his work. In most instances his figures stare quietly ahead, lost in their own thoughts. Through their gazes, however, whether the figure is reading a letter, peering toward a window, or looking into a mirror, Vermeer established a contemplative mood that pervades the composition. This effect is even more pronounced in *Mistress and Maid* because the interchange between these two individuals establishes an active rather than passive mood. The forcefulness of this exchange helps unify the painting and bridge the discrepancies of color and scale that separate the two women.

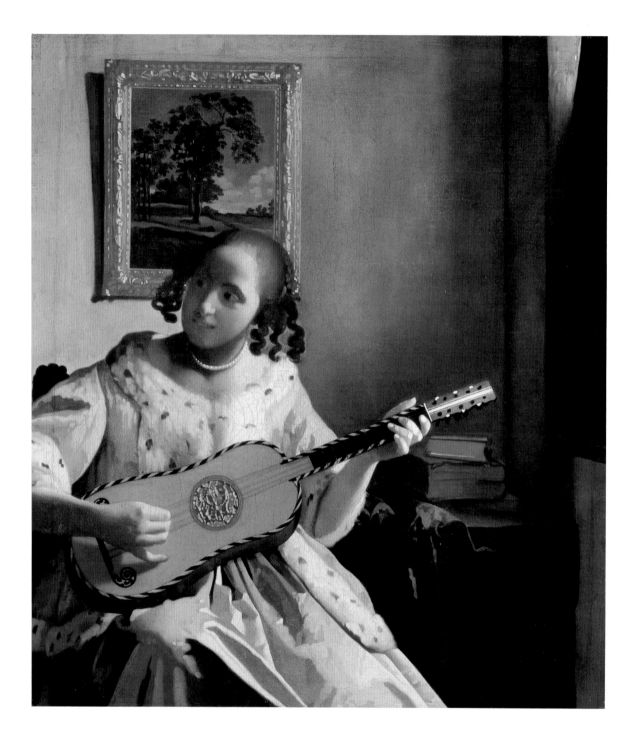

The Guitar Player

One of the unexpected delights of studying Vermeer as an artist is discovering the enormous variation in mood and atmosphere he created in his images. Although he worked in a relatively narrow range of subjects, he continually challenged himself with new compositional problems that resulted in an oeuvre that remained rich and varied until the very last. Because so little is known about his artistic contacts during his life or his own aspirations as an artist, it is virtually impossible to understand fully the origins of his compositional ideas, his motivations for portraying any particular subject, or his reasons for varying his style and painting technique. This realization is particularly acute when it comes to Vermeer's paintings of the 1670s, which are among the most misunderstood of his works as they are frequently judged in terms applicable to his paintings of the mid-1660s. One of the most striking of these works, and one which demonstrates the remarkable energy of Vermeer's late style better than any other, is *The Guitar Player* (fig. 102), painted about 1670.[1]

In this light-filled painting a young girl strums a guitar held comfortably in her lap while she sits near a window in a corner of a room. She is dressed in an ermine-bordered yellow jacket that is familiar from a number of Vermeer's paintings. Despite broad similarities to his other genre scenes, including *Woman with a Lute* (see fig. A18), *The Guitar Player* strikes an unusual note in Vermeer's oeuvre. Except for his early *Officer and Laughing Girl* (see fig. 36), no other painting seems as radiant in mood. From the wholesome features and open expression of the girl's face to the pastoral landscape with its glistening gold frame hanging on the wall behind her, the painting exudes a joyous energy. Instead of the quiet, self-contained world so often represented in Vermeer's paintings of the 1660s, this image virtually bursts out of its confines. The young girl, who sits dramatically off-center and in the very front of the picture plane, looks to her left as though communicating with an unseen viewer. Her form, boldly painted with summary brushstrokes, pulsates with life and vitality.

In suggesting such joy in the guitar player's demeanor, Vermeer was responding to a well-established tradition, most notably expressed in Frans Hals' *Buffoon Playing a Lute,* c.

103. Frans Hals, *Buffoon Playing a Lute*, c. 1623, oil on canvas. Musée du Louvre, Paris

1623 (fig. 103). Hals' rapid brushstrokes bring the lute player to life as does the ease of his pose, where he looks over his right shoulder and impishly smiles at an unseen viewer. Although it is unlikely that Vermeer had Hals' specific painting in mind when he conceived *The Guitar Player,* the comparison of these two works highlights an important characteristic of *The Guitar Player*: the remarkable tension created by the asymmetrical placement of the girl in this interior space. The viewer, who intuitively enters a painting from the left, is immediately confronted by the guitar player's presence and is visually riveted there by the rich brushwork of her costume and instrument. To pass beyond her and explore the rest of the space is virtually impossible. The eye continually returns to her, held to her form by her engaging expression, the vivid colors of her jacket, and the reinforcing compositional anchor of the rectangular landscape painting situated directly behind her. The eye focuses on her brightly illuminated right hand as it strums the strings of the guitar. The strings, painted with diffused strokes to indicate their vibration, bring to life the radiant music that her expression, suggestively rendered in halftones, and the luminous interior otherwise so vividly convey. Vermeer generally included paintings within paintings to amplify the thematic content of his works. Goodman-Soellner has rightly emphasized that such is also the case in *The Guitar Player*.[2] Seventeenth-century songs and poems frequently compared female beauty to nature, and Vermeer may have included the pleasant, sun-filled pastoral landscape as an allusion to the woman's beauty. The woman's wide gaze and rather flirtatious expression, however, also suggest an implied presence of a male listener. Pastoral songs were often written as amorous dialogues between shepherd and shepherdess, and here, played before this pastoral landscape painting, the woman's song may well be understood in a similar vein.[3]

104. *The Guitar Player,* detail of guitar

The dynamic pose of Vermeer's guitar player represents a new direction for his art. The compositional balance and harmony that he had developed to perfection during the 1660s had allowed him to explore moments in which an individual was lost in quiet contemplation. In *Woman with a Lute,* c. 1664, the woman, seated behind a table that separates her from the viewer, is not playing her instrument for the viewer's pleasure. Rather, she is quietly tuning her lute as she gazes absentmindedly out of the window to her right, facing the light that illuminates her form and the room around her. In *The Guitar Player* Vermeer rejected this compositional balance for a dynamic arrangement that confronts the viewer with an arrangement to which he or she is unaccustomed in Vermeer's work.

Vermeer's compositional organization may be linked to his decision to depict a guitar player rather than a lute player. The guitar was just coming into vogue in the late seven-

105. *The Guitar Player,*
detail of hair

teenth century as a popular instrument for solo accompaniment. The music it created was bolder than that of the lute, in large part because its chords produced a resonance not possible on the earlier instrument. Indeed, by this time the lute had begun to take on associations with an idealized past, a sophisticated era where music had been enjoyed and contemplated for the purity of its sounds.4 The bright and direct character of *The Guitar Player,* thus, spoke more to the modern world of music represented by the guitar than to the conservative and contemplative traditions of the lute.

The asymmetrical arrangement was one device to force the viewer to become actively engaged in the work; another was the illumination of the figure from the right rather than from the left. The light, from an unseen source on the right, counters the natural direction of the eye as it passes through the painting. As the light strikes the left side of the girl's face and body, it prevents the viewer from visually passing beyond the figure to the background right. The direction of the light thus reinforces Vermeer's compositional arrangement by holding the viewer's attention on the figure of the guitar player so that the full impact of her presence is felt.

The shimmering textures of materials—the ivory-colored satin dress, yellow jacket, gilded picture frame, and guitar—further bring this image to life. As light plays off their forms, the specific shapes of these objects seem to dissolve before our eyes. Perhaps the most remarkable of these areas is the finely tooled gold rose covering the sound hole of the guitar, where Vermeer has indicated form with an abstract arrangement of ocher strokes of paint that are highlighted with diffused accents of lead-tin yellow (fig. 104). The ermine fur and yellow jacket are likewise abstractly rendered with bold touches of the brush. To modulate the surface of the jacket, Vermeer laid broad strokes of bright lead-tin yellow over a slightly darker layer (fig. 105).5 The deep shadows on the right arm and shoulder are painted in a brownish color that is laid directly on the ground, another indication that Vermeer conceived his paintings in planes of light and shade. The remarkable freedom of this brushwork is evident upon comparing this jacket with that of the mistress in the *Mistress and Maid* painted only a few years before (see fig. 96). In *Mistress and Maid* the modulations are carefully blended to suggest the roundness of form; in *The Guitar Player* form is secondary to the visual excitement of the unblended strokes on the surface. Similar effects are found on the skirt and picture frame. Finally, instead of continuing his technique for subtly blending contours to assure that a figure relates to its surrounding environment, Vermeer defined his forms with crisp and unmodulated contours. In a few instances, as, for exam-

ple, along the right shoulder and along the ringlets of hair, he has further differentiated the figure from the ground with a light gray stroke.

Consistent with this bold concept is the general simplification of both composition and form. The space beyond the figure has little of interest to draw the viewer's attention. The window is covered by a dark, undifferentiated curtain that allows only a small area of light to enter into the upper-right corner of the pictorial space. Three books and a dark blue cloth on a table fill the space in the lower right, and although the books introduce a learned character to the scene, they are minor elements that primarily provide a counterbalance to the overriding compositional emphasis on the left. The simplification of form is evident throughout. Perhaps the most striking example is the oval shape of the girl's head and the abstract patterns of the ringlets of hair that fall to each side of her face. A comparison of the girl's features with those of the maid in *Mistress and Maid* is particularly revealing, for it demonstrates how differently Vermeer had rendered the nose and eyes of the maid just a

106. *The Guitar Player,* detail of necklace

few years previously (see fig. 105). In *The Guitar Player* these features are suggested in a generalized fashion with broad accents of unmodulated color.

This tendency toward abstraction of form is nowhere more evident than in the remarkable technique Vermeer devised here for rendering the pearl necklace (fig. 106). With his customary awareness of the effectiveness of figure-ground relationships, he painted a curved light gray stroke of paint over the deep greenish gray shadow of the neck to serve as the basis for the strand of pearls. Over this stroke he applied a sequence of white highlights that continue onto the sunlit portion of her neck. This simplified, though effective, means of depicting pearls, which is so different from the complex layering of individual pearls Vermeer had devised during the mid-1660s, epitomizes the transformation in approach to the representation of reality that characterizes Vermeer's late style. His earlier efforts to recreate the textural and optical qualities of objects and light as a basis for his images have been supplanted here by an interest in exploring the expressive possibilities of light, color, and texture as a means for creating an abstracted image of that reality.

The shift in Vermeer's pictorial emphasis is in many ways a natural outgrowth of his own stylistic evolution. He had utilized a number of innovative painting techniques to suggest the abstraction of form throughout his career. In particular, he had always been fascinated by the diffused appearance of objects when they were illuminated by strong sunlight and had devised means to represent these effects in his paintings. Such inclinations had clearly been reinforced in the 1660s through his observations of unfocused images in a camera obscura. They are most evident in the diffused highlights on the boat in *View of Delft* (see fig. 55), on the lion-head finial in *Girl with the Red Hat* (see fig. 85), or in the abstract patterns of red and white threads falling out of the sewing cushion in *The Lacemaker* (see fig. A29).[6] The character of these abstractions is, in fact, not essentially different from the diffused technique Vermeer employs on the gold sound hole of the guitar in *The Guitar Player* (see fig. 104). In *The Guitar Player,* however, Vermeer did not utilize this effect to suggest an unfocused foreground element, but made it an integral part of his image through the broader abstraction of form that occurs throughout. If this increased freedom of expression can be associated with his experiments with the camera obscura, so also might be his remarkably asymmetrical composition. Unusual cropping effects are found by viewing through this optical device, and it is not impossible that this most unusual compositional organization was suggested to him in such a way.

Vermeer's own artistic inclinations, and not the demands of a patron, seem to have led him in this stylistic direction, given the fact that this work remained in his possession until his death. Shortly thereafter, however, his widow, Catharina Bolnes, was forced to sell two works, a painting representing "a person playing a guitar [*cyter*]" and another depicting "two persons one of whom is writing a letter," to the baker Van Buyten to settle a debt.[7] As the latter painting was probably *Lady Writing a Letter with Her Maid* (see fig. 107), it is evident that Vermeer's late style was highly valued by his contemporaries. That its daring originality should have been so overlooked by later admirers of the artist is one of the fascinating aspects of Vermeer connoisseurship.

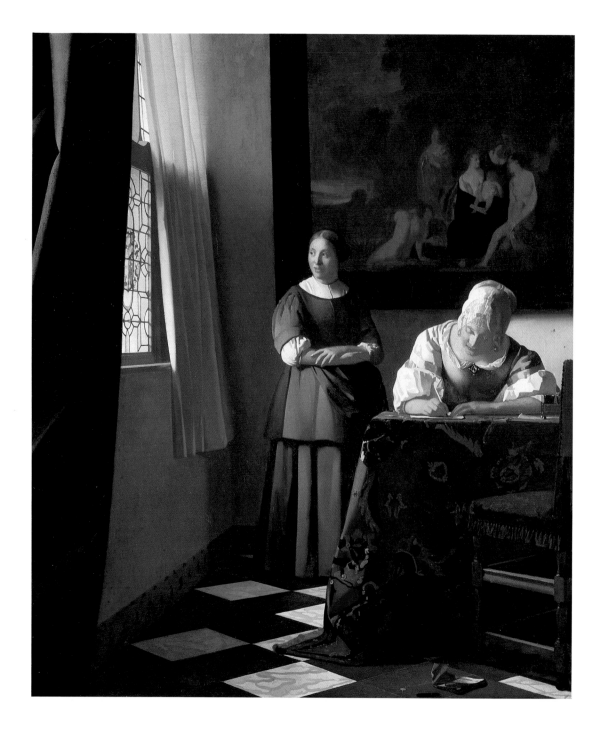

~

Lady Writing a Letter with Her Maid

107. *Lady Writing a Letter with Her Maid,* c. 1670–72, oil on canvas. National Gallery of Ireland, Dublin

The remarkable synthesis of illusionism and abstraction that Vermeer achieved in his paintings from the mid-1660s, as in *Woman in Blue Reading a Letter* (see fig. 1), was not maintained during the 1670s. In his later work the challenge of emulating reality became less compelling than that of abstracting the same textures and light effects that he had so effectively re-created in his earlier works. This evolution in approach was in many ways a natural culmination of his style, for it was built upon his understanding of the fundamental characteristics of light, color, and texture that had been at the basis of his artistic concerns. In his late works he began to suppress the incidentals of nature and presented instead a purified vision of the world as he saw and understood it. The transformation of his style was thus premised on the idea that the image he created was ordered and conceived in the artist's mind and through his intuition rather than through the dictates of nature. It is a different concept of classicism than that which had guided his previous work, one tinged with the ideas of Neoplatonism.

The shift in Vermeer's attitude toward the representation of reality, found to a certain extent in *A Lady Standing at a Virginal,* c. 1670–72 (see fig. A33) and *A Lady Seated at a Virginal,* c. 1673–75 (see fig. A35), is nowhere better seen than in his magnificent *Lady Writing a Letter with Her Maid,* c. 1670–72 (fig. 107). Here, in this relatively large-scale genre scene, Vermeer presented a carefully conceived composition of a letter writer and her maid that fused his ideals of restraint and balance with his fascination with the tensions inherent in a theme devoted to the expectations of love. A deep green curtain hangs along the left edge of the painting, as though it has been pulled back to reveal a quiet and personal moment in the lives of these two women. The mistress of the house writes intently at the table while her maid, in somber dress, stands patiently behind her with arms crossed, staring toward the window. It is a quiet scene, with the only hint of an unregulated existence being a slightly crumpled letter, with its detached wax seal, that lies on the floor in front of the mistress' writing table. Although the letter on the floor raises questions about its contents, Vermeer does not dwell on the issue nor on the connection between this letter and

the one being written. It is a subplot that, nevertheless, adds poignance to the larger image.

Essential to establishing the restrained mood of *Lady Writing a Letter with Her Maid* are the emphatic vertical and horizontal forms of the massive black frame that surrounds the large painting *Finding of Moses* hanging on the back wall. Vermeer's conscious placement of the maid over the corner of the frame and the mistress' brightly illuminated white lace cap over the frame's bottom edge emphasizes its role as an important visual ingredient of the composition. Other objects in the painting reinforce this sense of an ordered existence. The dark green curtain is simple in shape and relatively uniform in color. The edge of the red and black patterned rug that covers the table likewise falls to the black-and-white tiled floor in an uncomplicated fashion, with its bold black border echoing the angles of both the floor tiles and the chair on the right. The diffused light transmitted through the upper portion of the simple, white curtain hanging over the window the crystalline light passing through the exposed lower leaded-glass window only adds to the cool, calculated mood of the painting.

This mood is reinforced by the abstractions of form Vermeer created with his painting techniques. The most remarkable of these occur in the folds and creases of the white sleeves

108. *Lady Writing a Letter with Her Maid,* detail of lady's head and blouse

of the mistress, which are defined with knife-edge precision (fig. 108). Comparable alternating areas of light and shadow exist on the shoulder of the greenish ocher dress.[1] In similar areas of earlier paintings, such as *Mistress and Maid* (see fig. 96), Vermeer created softly nuanced folds through complex layerings of opaque paints and glazes. In *Lady Writing a Letter with Her Maid,* highlights and shadows do not overlap but are laid down in adjacent, predetermined areas.

Vermeer used comparatively simplified techniques throughout this work. The tablecloth is executed in broad, flat areas of color rather than in the dense pattern of superimposed highlights he used on the tablecloth in *The Music Lesson* (see fig. 68). The window glass seems frosted rather than transparent, and the leading between the panes of glass is executed in broad strokes of paint with none of the nuances seen in *Young Woman with a Water Pitcher* (see fig. 75). The gray veins of the white marble floor tiles are so schematically rendered that they have lost all relationship to the carefully depicted veins in *The Art of Painting* (see fig. 90). Most remarkable of all, however, is the geometric simplicity of the form and features of the maid. It takes a certain degree of imagination to realize that her abstracted facial characteristics (fig. 109) are those of the maid in the *Mistress and Maid* (see fig. 100). In the earlier painting her features are executed in softly modulated tones of color, conducive to a sense of movement and psychological presence; in this work Vermeer's flat planes of color subordinated her individual personality to accord with her statuesque pose.

Vermeer's shift in painting techniques signals a change in his attitude toward pictorial representation. Instead of using paint to convey the essence of a material's form and texture as revealed through light and shade, he now freed himself from such restraints. The abstraction that always underlay his compositional and thematic ideas now extended to the representation of the visual world. Although Vermeer's art remained grounded in reality, his images no longer gave the appearance of being mirrors of reality but took on their own independent existence.

This evolution in Vermeer's approach is most fully realized in this work, but it was not an entirely new phenomenon in his art. It draws upon abstractions he occasionally introduced in his earlier paintings: in particular diffused highlights on the boat in *View of Delft* (see fig. 55) and on the lion-head finial in *Girl with the Red Hat* (see fig. 85), and the softly modulated folds of the drapery on the table in *The Art of Painting* (see fig. 95). In each of these instances Vermeer seems to have sought to emulate effects found in a camera obscura, yet the realization that abstractions of light effects and form could be more powerful visual images than realistic ones was inherent in his artistic decisions. These earlier abstractions,

109. *Lady Writing a Letter with Her Maid*, detail of maid's head

however, were accepted within the framework of realism, insofar as the camera obscura was understood as a device that depicted objects according to the fundamental laws of nature. The abstractions in *The Guitar Player* (see fig. 102) and in *Lady Writing a Letter with Her Maid* are different in that Vermeer subordinated paint neither to natural forms nor to their textures. Paint, however expressively applied, remained first and foremost paint.

As is always the case with Vermeer, the compositional organization and painting technique of *Lady Writing a Letter with Her Maid* reinforced his thematic concerns. In this serene and quiet interior the mistress concentrates on the letter she is writing, while her maid, standing behind her and staring out of the window, patiently awaits its completion. The two figures, existing within their separate spaces and turned away from each other, are each occupied with their own thoughts. No movement and no sound breaks their concentration. One can almost imagine only the scratching of the mistress' pen interrupting the stillness of the room. The mood is remarkably different from *Mistress and Maid,* executed only a few years previously, where Vermeer was primarily interested in depicting the psychological reaction of the mistress to the unexpected arrival of a letter. By bringing the mistress and the maid to the frontal plane, positioning them against an undefined background, and painting their forms with softly nuanced brushstrokes, he focused on the emotional

interaction of the two figures. In *Lady Writing a Letter with Her Maid* he set the figures back into the interior space, away from the spectator. The abstract painting technique keeps the viewer at a distance, unseduced by the illusion of reality. In this serene world, where figures are occupied with their own thoughts, the viewer is encouraged to reflect on the balance, harmony, and essential meaning of the scene.

Vermeer's control of perspective in this painting is masterful. He situated the vanishing point of the orthogonals near the left eye of the mistress to emphasize her significance. More subtle are the ways he united the two main figures through perspective as well as through the black picture frame behind them. Orthogonals from the frame of the window toward which the maid stares pass her head and clasped arms as they proceed to the vanishing point, thus encompassing the essential characteristics of her being along their trajectory. Although each figure is lost in her own thoughts and momentarily oblivious to the other's presence, they are bound to one another through shapes in the room, perspective, and light.

Light effects in this painting are as abstract as the representations of textures of materials. Although both the maid and the mistress are similarly illuminated, as though from the visible window on the left, this could not be the case. The maid, whose face, neck, and shoulder are strongly lit, stands behind the white curtain in an area that should rightfully be in shadow.[2] Vermeer also manipulated light effects on the back wall for compositional reasons. To the left of the mistress the wall is dark, so that her illuminated shoulder and arm stand out; to her right the wall is strongly illuminated to contrast with her shaded contour. As with other examples of Vermeer's manipulation of light, the effect is to remove the scene from the realm of the transient. In this instance, the abstraction is more consistent and more obvious than in earlier examples. It thus reinforces the classicistic character of the image by stressing, as do the spatial organization and painting technique, the artist's control over the incidentals of natural phenomena.

The sense of permanence that is such an essential component of Vermeer's classicism is closely bound with a search for essential truths of human existence. These were to be found not only in the idealization of natural forms, but also in the moral lessons that such images might convey. That Vermeer conceived his work with this underlying concept in mind is clear from the prominence he has given the painting on the rear wall, *Finding of Moses*. The importance of this image to the scene is evident by comparing its enormous scale to that of its appearance some years previously in *The Astronomer*, 1668 (see fig. A27). Because history paintings were generally understood allegorically in the seventeenth century to provide

insights into human nature and God's divine plan, Vermeer must have included this Old Testament scene to reinforce the underlying meaning of his painting.[3]

Traditionally, the life of Moses was thought to prefigure that of Christ: the close correspondence of the events of their lives was seen as testament to the unity of God's design throughout history. The finding of Moses and his welcome reception prefigured the eventual reception of Christ's ministry by the community of the faithful. Moses' finding also came to be associated with the guidance of divine providence.[4] The broad connection between this Biblical episode and the letter being written may well be the expectation that the absent loved one will be protected by God.

Given the presence of the discarded letter on the floor, the thematic connections may well be as related to love as to divine providence. Letter-writing scenes are traditionally related to love rather than theology in the seventeenth century. Artists generally sought to convey an insight into the writer's state of mind, either through the figure's pose and expression or, by extension, through images seen in paintings hanging in the room. In Gerard ter Borch's *Woman Writing a Letter* (see fig. 97), for example, the young woman writes in a darkened chamber in front of her bed. In Vermeer's *Love Letter* (fig. A31) the mistress holds a letter inquiringly while the maid who has delivered it stands in front of a quiet seascape hanging on the rear wall. The seascape would have been understood as an allegory (found in contemporary emblem books) of love as a sea, and a lover as a ship searching for a safe harbor.[5] In Vermeer's quiet and reflective *Lady Writing a Letter with Her Maid* the thematic connections to love are more subtly conveyed. Whereas the importance of faith in divine providence is stressed through the *Finding of Moses* on the back wall, the discarded letter, which is easily overlooked, is crucial for understanding the full implications of this painting. Letters were highly valued and not lightly crumpled and discarded: the implication, thus, is that the letter had been cast aside in haste and in anger. Given the calmness of the scene, it appears that that moment has passed. The mistress' quiet demeanor implies that her response has been measured, buttressed by her faith that divine providence will control her destiny. With faith, Vermeer seems to assert, comes inner peace and serenity, even in matters of the heart.

VERMEER AND THE CREATING OF REALITY

~

Vermeer's early history paintings, which in many respects seem so hard to reconcile with his later works, provided him with a broadness of vision and of execution that no other genre painter of the period possessed. Whereas, for example, Gerard ter Borch started his career as a portrait painter who worked in a refined manner on a small scale, Vermeer's initial impulse to paint large history scenes meant that from the beginning of his career his concerns were less with the careful recording of individual textures and materials than with the overall impact of his image. His painting techniques, thus, were relatively free and bold, appropriate to the large compass of his works. When he later evolved into a genre and landscape painter, his techniques became more refined and complex, but they always maintained the capacity to suggest rather than describe form and texture.

His foundation as a history painter also profoundly affected the thematic focus of his subsequent works. His history paintings tended to depict quiet, brooding moments that emphasized the meditative side of life. This thematic concern, explicit in *Christ in the House of Mary and Martha*, is implicit in both *Saint Praxedis*, where the kneeling saint gazes pensively at the crucifix, and *Diana and Her Companions*, where one of the maidens, with almost sacramental gravity, tenderly bathes the foot of the goddess in a manner not unlike representations of the apostle cleansing the foot of Christ. Vermeer's genre paintings and landscapes have a comparable seriousness of purpose that has virtually no parallel in Dutch painting despite their ostensible resemblance to works by his contemporaries. His religious concerns, his deep pride in his city and his country, and his commitment to the role of the artist in society gives to his apparently quotidian works an unexpected resonance.

The delicate equilibrium between illusionism and abstraction that is the hallmark of Vermeer's masterpieces during his mature period is but one facet of the essential classicism that underlies the entirety of his work. The challenge that he seems to have set for himself in the late 1650s was to translate the classicizing tendencies of his early religious and mythological paintings into a contemporary idiom, a transition facilitated by his inherent sensitivity to human psychology. He sought not only to incorporate truths of nature into his paintings by recording the variety and beauty of the visible world, but also, by carefully arranging natural effects, to convey a sense of both the transience and permanence of human existence.

Vermeer's approach to the depiction of reality was surprisingly consistent with ideas expressed by writers in contemporary Dutch art theory, particularly Cornelis de Bie and Samuel van Hoogstraten. Both writers stressed the importance of creating paintings that mirror nature so faithfully that they deceive the eye into believing that they are real. The reality theorists urged for the visual arts, however, was not a slavish imitation of life itself, but rather a selective reality, controlled and ordered by the artist's intuition and his knowledge of the laws of perspective. This illusionism was important not only as an artistic conceit, but also because close observation of nature and the careful depiction of reality brought one closer to God's creation and to timeless truths of nature.

The care with which Vermeer considered every facet of his compositions is perhaps less surprising than the extent to which he abstracted reality by controlling and adjusting light, color, texture, and space in his paintings. He frequently altered the scale and color of objects for compositional reasons. Although he utilized perspective to structure and give focus to his compositions, he also understood its ability to affect the character of the viewer's perceptions. Vermeer effectively used the flow of light to enliven the surface of objects, but he also occasionally adjusted natural light conditions to create compositional emphasis and to reinforce the mood of his paintings. The artist also made numerous changes as he sought a satisfactory image: he eliminated figures, altered costumes, adjusted the shapes of buildings in his cityscape, and reconsidered the placement and scale of objects in his interiors.

Vermeer highly valued the craft of painting. Whether he began his creative process with preliminary drawings (individual figure studies or overall compositional drawings) is not known, but he does seem to have blocked in portions of some of his compositions in gray paint. He may have also prepared his compositions through other means, for example, using white chalk underdrawings as seen in *The Art of Painting*, but evidence of such work cannot be revealed with existing examination techniques. He seems to have worked with high quality paints: gold, for example, for *A Woman Asleep*, and natural ultramarine, one of his favorite pigments.

Extremely important to Vermeer throughout his career was the manner in which he applied his paints. He understood the optical qualities of paints, and built up his paintings carefully. Although he preferred a light ground, he would selectively apply intermediate toned layers to work in conjunction with thin glazes on the surface. From the early stages of his career (as, for example, in *Diana and Her Companions*), he developed an awareness of how to establish a figure's form with dense impastos and how to add a richness and depth to shadows by applying glazes over the ground or a selected imprimatura layer. As he devel-

oped a greater interest in creating textural effects in the later 1650s, he used small specular highlights to suggest sunlight flickering against a form, as in the chair back in *Officer and Laughing Girl*. He was not averse to using purely artificial devices to accent his forms, as in the white contour lines found in *The Milkmaid* and *View of Delft*.

By the mid-1660s, his treatment of contours had become subtler, as he sought to bind ever more completely the figural elements within their spatial framework. In such paintings as *Woman in Blue Reading a Letter*, the white contour has become a soft diffused stroke, a blend of the blues of the woman's dress and the white of the wall behind her. During this period Vermeer often applied glazes over impastos as well as over imprimatura layers as he sought to soften forms and create diffused contours of hands and faces. In the 1670s the abstractions of Vermeer's painting techniques take on greater importance within his images. Whereas they had previously served an important albeit subordinate function, whether to accent compositional elements or enhance naturalistic effects, during the 1670s these abstractions took on an independent existence. The accents of color Vermeer used to indicate the folds on the woman's dress or the exquisite decorative rose of the guitar in *The Guitar Player*, for example, are seen first and foremost as paint, and only secondarily as descriptive of material texture.

Although Vermeer's painting techniques evolved in a recognizable way over the course of his career, enough variables exist to preclude establishing a precise chronological sequence for his work on this basis alone. Vermeer seems to have consciously adjusted his style of painting in accordance with his subject matter. *The Little Street*, for example, is painted quite delicately, with relatively little impasto, whereas *The Milkmaid*, which he probably executed shortly thereafter, is vigorous in execution, as appropriate to the forceful impression he wanted to convey. Vermeer would also vary his techniques within a single work for compositional effect. The foreground table covering in *The Music Lesson* is quite densely painted, with many small brushstrokes, whereas the forms in the background are softly rendered. The most extreme of these instances when he varied his techniques in one work is *The Art of Painting*, where the cloth on the table before the model is softly diffused whereas the chandelier hanging above is painted in thick impastos.

In this latter instance the camera obscura certainly had an impact on Vermeer's manner of painting the tablecloth. As with his use of perspective and light effects, however, Vermeer adapted optical qualities of the camera obscura image only to the extent that they enhanced the compositional or emotional effect he sought in his work. Because the artist's use of the camera obscura was so selective, it is difficult to determine the full range of its influence on

his style. Its impact was almost certainly not limited to those works in which visual evidence—diffused forms, halation of highlights, exaggerated perspective, and intensified color—is found.

Vermeer's range of genre subjects, though not large, provided a reservoir of images that permitted him to reach deep and universal human emotions. He occasionally indicated the nature of his thematic concerns through emblems, in the form of maps or paintings hanging on the rear walls of his interior settings or in leaded-glass windows. Yet he was always discreet about their use, unwilling, perhaps, to define too precisely a specific message for any particular image. That Vermeer consciously sought such a result can also be deduced from x-radiography and infrared reflectography: during the process of painting the artist often eliminated compositional elements, a number of which had specific emblematic or symbolic associations.

The range of interpretations possible for Vermeer's paintings is part of the poetic quality associated with his work. An even more fundamental aspect of that poetry is his ability to suggest the universal within the realm of the everyday. He conveyed this quality by avoiding the purely incidental and the anecdotal, where actions and gestures become tied to specific events or situations. The emotions of longing and expectation that he so often incorporated into his work provided a thematic means for suggesting the extension of time, a quality he enhanced with purity of composition, purposefulness of human gaze and gesture, and evocative treatment of light. Through these means Vermeer not only succeeded in transforming a momentary activity into a timeless vision, but also created images whose moods and concerns continue to speak directly to viewers far removed from the world in which he lived.

Catalogue of Vermeer's Paintings

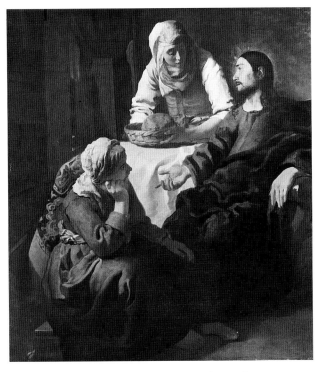

A1. *Christ in the House of Mary and Martha,*
c. 1654–55, oil on canvas, 63 × 55⅞ in (160 × 142 cm).
National Gallery of Scotland, Edinburgh

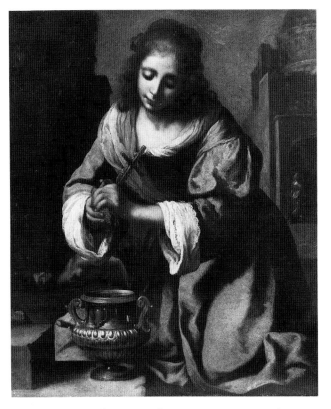

A2. *Saint Praxedis,* 1655, oil on canvas, 40 × 32½ in
(101.6 × 82.6 cm). The Barbara Piasecka Johnson
Collection Foundation

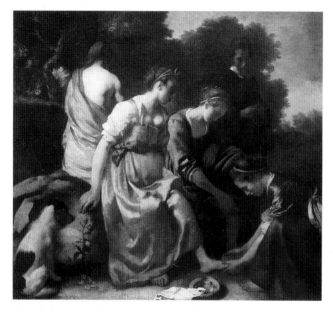

A3. *Diana and Her Companions,* c. 1655–56, oil on
canvas, 38¾ × 41⅛ in (98.5 × 105 cm). Mauritshuis,
The Hague

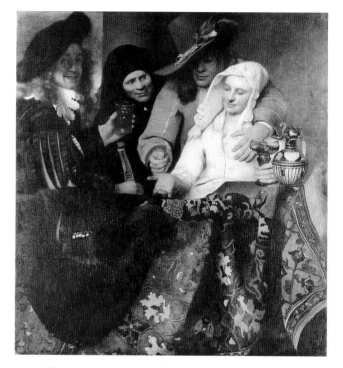

A4. *The Procuress,* 1656, oil on canvas, 56⅛ × 51⅛ in
(143 × 130 cm). Staatliche Kunstsammlungen,
Gemäldegalerie, Dresden

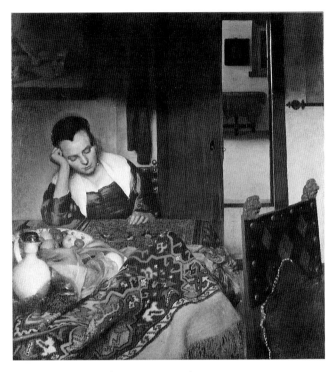

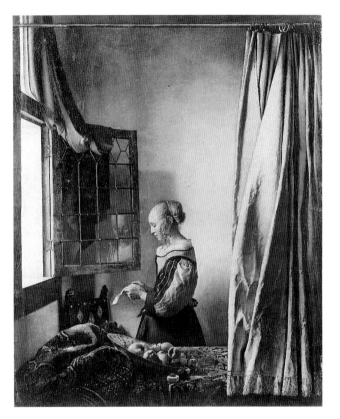

A5. *A Woman Asleep,* c. 1657, oil on canvas, 34½ × 30⅛ in (87.6 × 76.5 cm). The Metropolitan Museum of Art, New York. Bequest of Benjamin Altman, 1913. (14.40.611)

A6. *Girl Reading a Letter at an Open Window,* c. 1657, oil on canvas, 32¾ × 25⅛ in (83 × 64.5 cm). Staatliche Kunstsammlungen, Gemäldegalerie, Dresden

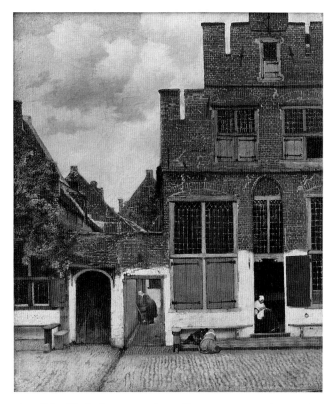

A7. *The Little Street*, c. 1658, oil on canvas, 21⅜ × 17⅜ in (54.3 × 44 cm). Rijksmuseum, Amsterdam

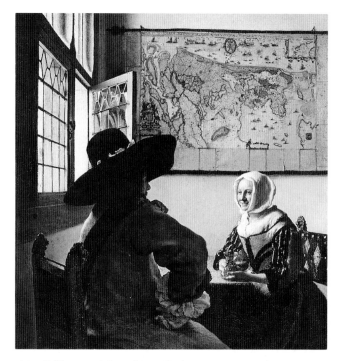

A8. *Officer and Laughing Girl*, c. 1658–60, oil on canvas, 19⅞ × 18⅛ in (50.5 × 46 cm). Copyright The Frick Collection, New York

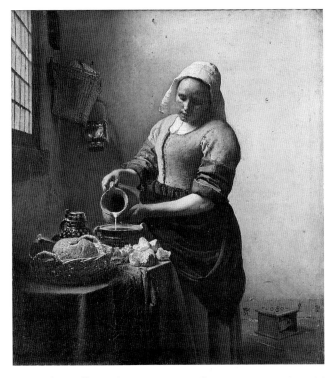

A10. *The Glass of Wine,* c. 1658–60, oil on canvas, 25⅝ × 30¼ in (65 × 77 cm). Staatliche Museen Preussischer Kulturbesitz, Gemäldegalerie, Berlin

A9. *The Milkmaid,* c. 1658–60, oil on canvas, 17⅞ × 16⅛ in (45.5. × 41 cm). Rijksmuseum, Amsterdam

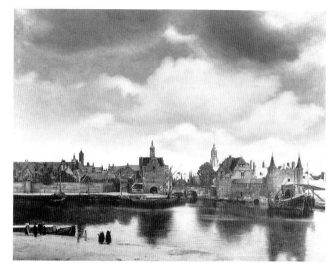

A12. *View of Delft,* c. 1660–61, oil on canvas, 38¾ × 46¼ in (98.5 × 117.5 cm). Mauritshuis, The Hague

A11. *The Girl with the Wine Glass,* c. 1659–60, oil on canvas, 30¾ × 26⅜ in (78 × 67 cm). Herzog Anton Ulrich-Museum, Brunswick

A13. *Girl Interrupted at Her Music,* c. 1660–61, oil on canvas, 15½ × 17½ in (39.3 × 44.4 cm). Copyright The Frick Collection, New York

A14. *The Music Lesson,* c. 1662–64, oil on canvas, 28⅞ × 25⅜ in (73.3 × 64.5 cm). The Royal Collection © 1994. H. M. Queen Elizabeth II

A15. *Woman in Blue Reading a Letter,* c. 1662–64, oil on canvas, 18¼ × 15⅜ in (46.5 × 39 cm). Rijksmuseum, Amsterdam

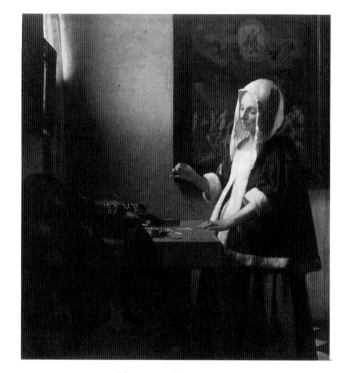

A16. *Woman Holding a Balance,* 1664, oil on canvas, 16¾ × 15 in (42.5 × 38 cm). National Gallery of Art, Washington, D.C. Widener Collection

A17. *Woman with a Pearl Necklace,* c. 1664, oil on canvas, 21⅛ × 17¾ in (55 × 45 cm). Staatliche Museen Preussischer Kulturbesitz, Gemäldegalerie, Berlin

A18. *Woman with a Lute,* c. 1664, oil on canvas, 20¼ × 18 in (51.4 × 45.7 cm). The Metropolitan Museum of Art, New York. Bequest of Collis P. Huntington, 1900. (25.110.24)

A19. *Young Woman with a Water Pitcher,* c. 1664–65, oil on canvas, 18 × 16 in (45.7 × 40.6 cm). The Metropolitan Museum of Art, New York. Gift of Henry G. Marquand, 1889. Marquand Collection (89.15.21)

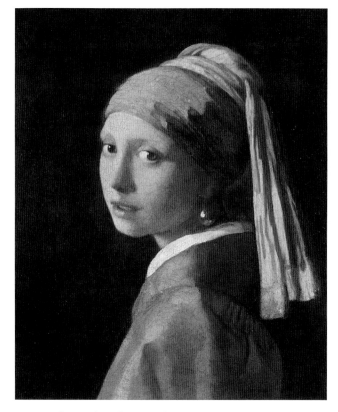

A20. *The Girl with a Pearl Earring,* c. 1665, oil on canvas, 18¼ × 15¼ in (46.5 × 40 cm). Mauritshuis, The Hague

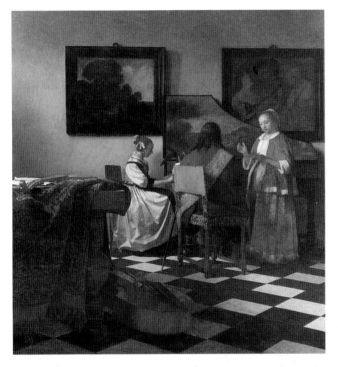

A21. *The Concert,* c. 1665–66, oil on canvas, 28½ × 25½ in (72.5 × 64.7 cm). Isabella Stewart Gardner Museum, Boston

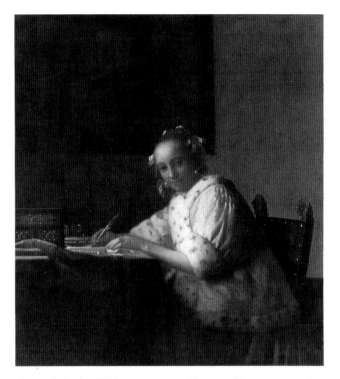

A22. *A Lady Writing,* c. 1666, oil on canvas, 17¾ × 15¾ in (45 × 39.9 cm). National Gallery of Art, Washington, D.C. Gift of Harry Waldron Havemeyer and Horace Havemeyer, Jr., in memory of their father, Horace Havemeyer

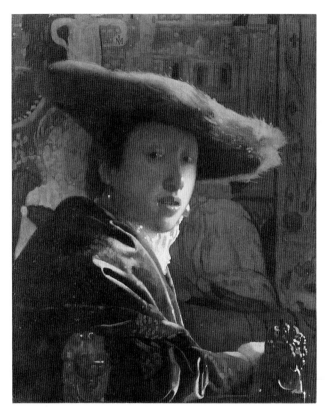

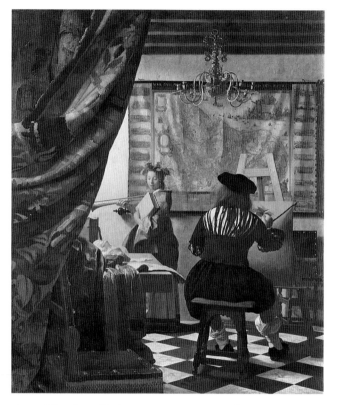

A23. *Girl with the Red Hat,* c. 1666–67, oil on panel, 9⅛ × 7⅛ in (23.2 × 18.1 cm). National Gallery of Art, Washington, D.C. Andrew W. Mellon Collection

A24. *The Art of Painting,* c. 1666–67, oil on canvas, 47¼ × 39⅜ in (120 × 100 cm). Kunsthistorisches Museum, Vienna

A25. *Portrait of a Young Woman,* c. 1666–67, oil on canvas, 17½ × 15¾ in (44.5 × 40 cm). The Metropolitan Museum of Art, New York. Gift of Mr. and Mrs. Charles Wrightsman, in memory of Theodore Rousseau, Jr., 1979. (1979.396.1)

A26. *Mistress and Maid,* c. 1667–68, oil on canvas, 35½ × 31 in (90.2 × 78.7 cm). Copyright The Frick Collection, New York

A27. *The Astronomer,* 1668, oil on canvas, 19⅞ × 17¾ in (50 × 45 cm). Musée du Louvre, Paris

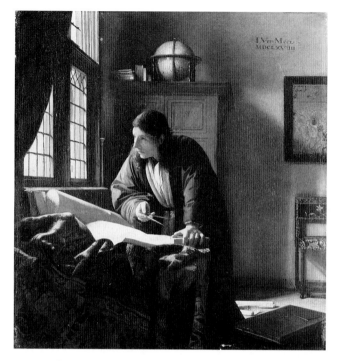

A28. *The Geographer,* c. 1668–69, oil on canvas, 20⅞ × 18¼ in (53 × 46.6 cm). Städelsches Kunstinstitut, Frankfurt am Main

A29. *The Lacemaker,* c. 1669–70, oil on canvas (attached to panel), 9⅝ × 8¼ in (24.5 × 21 cm). Musée du Louvre, Paris

A30. *The Guitar Player,* c. 1670, oil on canvas, 20⅞ × 18¼ in (53 × 46.3 cm). Kenwood, English Heritage as Trustees of the Iveagh Bequest

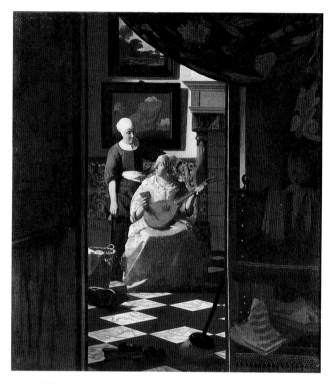

A31. *The Love Letter,* c. 1670–72, oil on canvas,
17⅜ × 15⅛ in (44 × 38.5 cm). Rijksmuseum, Amsterdam

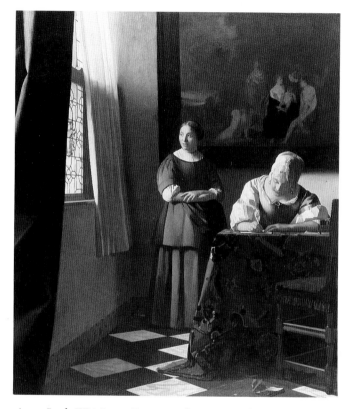

A32. *Lady Writing a Letter with Her Maid,* c. 1670–72,
oil on canvas, 28 × 23 in (71.1 × 58.4 cm). National
Gallery of Ireland, Dublin

A33. *A Lady Standing at a Virginal,* c. 1670–72, oil on canvas, 20⅜ × 17¾ in (51.7 × 45.2 cm). Reproduced by courtesy of the Trustees, National Gallery, London

A34. *Allegory of Faith,* c. 1671–74, oil on canvas, 45 × 35 in (114.3 × 88.9 cm). The Metropolitan Museum of Art, New York. Bequest of Michael Friedsam, 1931. The Friedsam Collection. (32.100.18)

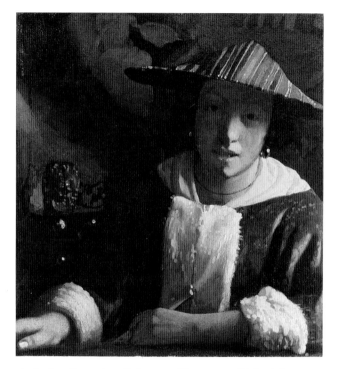

A35. *A Lady Seated at a Virginal,* c. 1673–75, oil on canvas, 20¼ × 17⅞ in (51.5 × 45.5 cm). Reproduced by courtesy of the Trustees, National Gallery, London

A36. Attributed to Johannes Vermeer, *Girl with a Flute,* probably 1665/1670, oil on panel, 7⅞ × 7 in (20 × 17.8 cm). National Gallery of Art, Washington, D.C. Widener Collection

NOTES

AN APPROACH TO VIEWING VERMEER

1. All of Vermeer's paintings are illustrated in the catalogue at the end of the volume.

2. William Crowne visited Delft in December 1636 at the end of his trip through Germany and the Netherlands with the duke of Arundel. Quoted in Francis C. Springell, *Connoisseur and Diplomat* (London: Maggs Bros., 1963), 94.

3. Edward Browne, *An account of several travels through a great part of Germany* (London: Benjamin Tooke, 1677), 3. See also John Ray, *Observations Topographical, Moral, and Physiological Made in a Journey through part of the Low-Countries, Germany, Italy, and France,* (London: Jay Martyn, 1673), 25.

4. Much valuable work in this area has been done by John Michael Montias. See, in particular: John Michael Montias, *Vermeer and His Milieu: A Web of Social History,* (Princeton: Princeton University Press, 1989); John Michael Montias, "A Postscript on Vermeer and His Milieu," *Hoogsteder Mercury* 12 (1991): 42–50. I am greatly indebted to Montias for his enormous contribution to Vermeer studies. Earlier publications of many of these documents, however, are also extremely useful. See, in particular, Albert Blankert, with contributions by Rob Ruurs and Willem L. van de Watering, *Johannes Vermeer van Delft 1632–1675* (Utrecht and Antwerp: Het Spectrum, 1975), revised and translated into English as *Vermeer of Delft: Complete Edition of the Paintings* (Oxford: Phaidon,

1978). This edition is important because the original Dutch is included with the translation of the documents.

5. Montias, *Vermeer and His Milieu,* 310, doc. 256. Vermeer registered in the guild on 29 December 1653.

6. Montias, *Vermeer and His Milieu,* 285, doc. 133.

7. Montias, *Vermeer and His Milieu,* 344–345, doc. 367.

8. Montias, *Vermeer and His Milieu,* 308, doc. 249; Blankert, *Vermeer of Delft,* 146. For an extended discussion of the implications of this document for the relationship of Vermeer and Maria Thins, see Arthur K. Wheelock, Jr., "Vermeer and Bramer: A New Look at Old Documents," in *Leonaert Bramer 1596–1674: A Painter of the Night,* exh. (Milwaukee: Patrick and Beatrice Haggerty Museum of Art, 1992), 19–22.

9. Montias, *Vermeer and His Milieu,* 308, doc. 251.

10. The most extensive account of Fabritius' life is that found in Dirck van Bleyswijck, *Beschryvinge der Stadt Delft,* 2 vols. (Delft: Arnold Bon, 1667), 2: 852. For a full transcription, see Christopher Brown, *Carel Fabritius* (Oxford: Phaidon, 1981), 159. The idea that Fabritius was Vermeer's teacher is suggested to many by a commemorative poem by Arnold Bon appended to Bleyswijck's text, in which Vermeer is lauded as the true successor of Fabritius' approach. See Bleyswijck, *Beschryvinge der Stadt Delft,* 2: 853–854.

11. Montias, *Vermeer and His Milieu,* 122.

12. Montias, *Vermeer and His Milieu,* 122. The English translation of the titles recorded in the document are given by Montias as "A painting wherein a procuress points to the hand" and "A painting of one who sucks the breast."

13. Montias, *Vermeer and His Milieu,* 110.

14. Montias, *Vermeer and His Milieu,* docs. 362, 363, 377, 379, 380. The documents concerning Vermeer's estate are extremely confusing. When Vermeer died he left his family with large debts, including one for 442 guilders owed to Jannetje Stevens, a spinster living in Haarlem. To pay off the debts Catharina Bolnes "sold" to Jan Colombier of Haarlem 26 unspecified paintings for which she received 500 guilders. A year later a suit brought by Jannetje Stevens makes it clear that the debt of 442 guilders was still outstanding. As a result, Colombier agreed to hand over to Anthony van Leeuwenhoek, the curator of Vermeer's estate, the 26 paintings for public auction. The agreement reached on that occasion was that Colombier would receive the first 500 guilders from the auction and the rest would go to the estate (doc. 377). It seems that among the paintings held by Columbier was *The Art of Painting.* The idea that this work would be sold at public auction, presumably at a low price because of the poor economic climate, induced Maria Thins to try to block its sale by claiming that the painting belonged to her (doc. 379). She asserted that the rights of ownership had been transferred to her by her daughter on 24 February 1676 (doc.

363). Leeuwenhoek, recognizing that this act of transferral had occurred illegally, since it happened only after the painting had been "sold" by Colombier, denied Maria Thins' petition. It thus seems that this painting was among those auctioned on 15 March 1677. If so, then it seems quite plausible that other of Vermeer's works were auctioned as well.

15. Montias, *Vermeer and His Milieu*, 246ff., doc. 417. The inventory records the joint possessions of Jacobus Abrahamsz Dissius and his deceased wife, Magdalena van Ruijven.

16. Montias, *Vermeer and His Milieu*, 180. Although De Monconys noted that the painting depicted a single figure, he did not identify the subject.

17. See Montias, *Vermeer and His Milieu*, 258–260. A proposal for the identification of the Van Asch painting Vermeer used as a model for this landscape has been made by J.M. Weber, "Johannes Vermeer, Pieter Jansz. van Asch und das Problem der Abbildungstreue," *Oud Holland*, 108 (1994): 98–106.

18. Hermann Kühn, "A Study of the Pigments and the Grounds Used by Jan Vermeer," *National Gallery of Art: Reports and Studies in the History of Art* 2 (Washington, 1968): 155–202.

19. The examination results at the Metropolitan Museum of Art were published in Maryan Wynn Ainsworth et al., *Art and Autoradiography: Insights into the Genesis of Paintings by Rembrandt, Van Dyck, and Vermeer,* (New York: Metropolitan Museum of Art, 1982). I would like to thank Jan Kelch for informing me about the results of the examinations on Vermeer undertaken in Berlin.

20. The technical analyses I have primarily utilized in this study, beyond microscopic examinations, are existent pigment samples, x-radiographs, infrared reflectograms, and neutron autoradiographs. Although Kühn, "A Study of the Pigments and the Grounds," is an extremely useful and thorough study, he had to limit the samples taken to the edges of the paintings, so information about paint layers is often lacking from other areas of the paintings he examined. X-radiographs exist for most of Vermeer's paintings, but they vary widely in quality. Some are quite old, made perhaps in the 1940s, and only show a portion of the image, whereas others have been made in the 1990s and include the entire image. Infrared reflectograms have been made for about half of Vermeer's paintings, and examinations with neutron autoradiography for only three works. It is hoped that further technical information will be forthcoming as a result of research connected with the exhibition of Vermeer's paintings to be held in 1995–1996 at the National Gallery of Art in Washington, D.C., and the Mauritshuis in The Hague.

Some of the material discussed in this book is based on earlier publications: Arthur K. Wheelock, Jr., *Jan Vermeer* (New York: Harry N. Abrams, 1981), and Arthur K. Wheelock, Jr., "Pentimenti in Vermeer's Paintings: Changes in Style and Meaning," *Holländische Genremalerei im 17. Jahrhundert: Symposium Berlin 1984, Jahrbuch Preussischer Kulturbesitz* 4 (1987): 385–412.

21. The only extant copy of this wall map, which depicts Holland and West Friesland, is in the Westfries Museum, Hoorn. It measures 116 × 172 cm. The map was designed by Balthasar Florisz. van Berckenrode in 1620 and published shortly thereafter by Willem Jansz. Blaeu.

22. The most extensive analysis of Vermeer's pigments was undertaken by Kühn, "A Study of the Pigments and the Grounds," 155–202.

23. This conviction that Vermeer accurately recorded what he saw before him underlies most assessments of his art. See, in particular, P. T. A. Swillens, *Johannes Vermeer: Painter of Delft 1632–1675* (Utrecht and Brussels: Spectrum, 1950), for the diagrams he made reconstructing the rooms in Vermeer's house, which he constructed on the basis of the artist's paintings. The assumption that Vermeer accurately depicted the world about him also underlies the writings of Albert Blankert (see Blankert, *Johannes Vermeer*, 48). Blankert, in *Vermeer of Delft*, 32, contrasts Vermeer's exactitude and "faithfulness to nature" with the "arbitrarily arranged elements" in paintings by Pieter de Hooch. On a more general level, Svetlana Alpers, in *The Art of Describing: Dutch Art in the Seventeenth Century* (Chicago: University of Chicago Press, 1983), noting the importance of lenses, the camera obscura, and the "mapping impulse" in Dutch society, argues that Dutch art is essentially descriptive in character. She stresses that it "was a particular assumption of the seventeenth century that finding and making, our discovery of the world and our crafting of it, are presumed to be as one" (27). Her arguments, thus, do not take into account the changes and modifications of reality so frequently made by Vermeer, who enters prominently into her discourse. The misconception that Vermeer adhered to perceived reality also underlies a number of assessments of his use of the camera obscura. See, in particular, A. Fink, "Vermeer's

Use of the Camera Obscura—A Comparative Study," *Art Bulletin* 53 (1971): 493–505.

24. For a fuller discussion of these issues see: Arthur K. Wheelock, Jr., "*Trompe-l'oeil* Painting: Visual Deceptions or Natural Truths?" in *The Age of the Marvelous,* ed. Joy Kenseth, exh. (Hanover, N.H.: Hood Museum of Art, Dartmouth College, 1991), 179–191.

25. Samuel van Hoogstraten, *Inleyding tot de Hooge Schoole der Schilderkonst: Anders de Zichtbaere Werelt* (Rotterdam: Frans van Hoogstraeten, 1678), 274: "Maer ik zegge dat een Schilder, diens werk het is, het gezigt to bedriegen, ook zoo veel kennis van de natuur der dingen moet hebben, dat hy grondig verstaet, waer door het oog bedroogen wort."

26. J. J. Orlers, *Beschrijvinge der Stadt Leyden* (Leiden: Abraham Commelijn, 1641), 377.

27. Philips Angel, *Lof der Schilder-konst* (Leiden: Willem Christiaens, 1642), 53–54.

28. Angel, *Lof der Schilder-konst,* 54–55. For an excellent discussion of Dutch art theory as it relates to the Leiden *fijnschilders,* see Eric J. Sluijter, "Schilders van 'cleyne, subtile ende curieuse dingen': Leidse 'fijnschilders' in contemporaine bronnen," in *Leidse Fijnschilders* (Zwolle: Waanders, 1988), 14–55.

29. Cornelis de Bie, *Het Gulden Cabinet vande edel vry Schilderconst,* (Antwerp: Ian Meysens, 1661), 215: "dat door Freer Zeghers Const het leven in haer woont." For an excellent assessment of De Bie's treatise, see E. S. de Villiers, "Flemish Art Theory in the Second Half of the 17th Century—an Investigation on an Unexplored Source," *South African Journal of Art History* 2 (1987): 1–11.

30. Hoogstraten, *Inleyding,* 25: "Want een volmackte Schildery is als een spiegel van de Natuer, die de dingen, die niet en zijn, doet schijnen te zijn, en op een geoorlofde vermakelijke en prijslijke wijze bedriegt."

31. *Memoirs of John Evelyn, Esq., F.R.S.,* ed. William Bray (London: H. Coburn, 1827), 246.

32. The identity of the *Girl Leaning on a Stone Pedestal* in the Dulwich Picture Gallery with that described by De Piles is not certain, but probable. See *Collection for a King: Old Master Paintings from the Dulwich Picture Gallery,* exh. (Washington, D.C.: National Gallery of Art, 1985), 100–101, cat. no. 26.

33. Roger de Piles, *Abregé de la Vie des Peintres: avec des reflexions sur leurs ouvrages revue et corrigé par l'auteur, avec une abregé de sa Vie, et plusieurs autres additions,* 2d ed. (Paris: J. Estienne, 1715), 423, cited in Seymour Slive, *Rembrandt and His Critics 1630–1730* (The Hague: Martinus Nijhoff, 1953), 129.

34. Hoogstraten, *Inleyding,* 79: "Den hoogsten en voornaemsten trap in de Schilderkonst, die alles onder zich heeft, geport en gedreven, welk is het uitbeelden der gedenkwaerdichste Historien."

35. See Albert Blankert, general introduction, *Gods, Saints & Heroes: Dutch Painting in the Age of Rembrandt,* exh. (Washington: National Gallery of Art, 1980), 16. Karel van Mander, *Het Schilder-Boeck* (Haarlem: Paschier van Wesbvsch, 1604).

36. Johannes Kepler, for example, used a tent camera obscura when drawing landscapes. See the text of a letter by Sir Henry Wotton published by Georges Potonniée, *The History of the Discovery of Photography,* trans. Edward Epstein (New York: 1936), 25.

37. The literature on Vermeer and the camera obscura is extensive. See, in particular: Charles Seymour, "Dark Chamber and Light-filled Room: Vermeer and the Camera Obscura," *Art Bulletin* 46 (1964): 323–331; Heinrich Schwarz, "Vermeer and the Camera Obscura," *Pantheon* 24 (1966): 170–180; Fink, "Vermeer's Use of the Camera Obscura" (see note 19); Arthur K. Wheelock, Jr., *Perspective, Optics, and Delft Artists Around 1650* (New York: Garland Press, 1977), 283–301; Arthur K. Wheelock, Jr., "Constantijn Huygens and Early Attitudes towards the Camera Obscura," *History of Photography* 1 (1977), 93–103.

38. Constantijn Huygens, *De Briefwisseling (1608–1687),* ed. J. A. Worp, 6 vols., The Hague (1911–17), vol. 1, 1911, 94. "Il ne m'est possible de vous en declarer la beauté en paroles: toute peinture est morte aux prix, car c'est icy la vie mesme, ou quelque chose de plus relevé, si la parole n'y manquoit."

39. The question of Van Leeuwenhoek's relationship to Vermeer during his lifetime has never been adequately addressed. For the argument that they knew each other and that Vermeer represented Van Leeuwenhoek in *The Astronomer* (see fig. A27) and *The Geographer* (see fig. A28), see Wheelock, *Vermeer,* 13–15, 136–138.

40. Huygens, *Briefwisseling,* 1, 1911, 136.

41. J. Leurechon, *Recreation Mathematicque* (Pont-à-Mousson: 1616), 3: "Sur tout il y a du plaisir à voir le mouvement des oyseaux, des hommes, ou autres animaux & le tremblement des plantes agitées du vent; car quoy que tout cela se face à figure`renuersée: neantmoins, cette belle peinture, outre ce qu'elle est racourcie en perspectiue, represente naifuement bien, ce que iamais peintre n'a peu figurer en son tableau, à scauoir le mouvement continué de place en place."

42. Hoogstraten, *Inleyding*, 263: "Ik ben verzekert, dat het zien van dezen weerglans in 't donker 't gezicht van de Schilderjeugt geen klein licht kan geven; want behalve dat men de kennis van de natuer verkrijgt, zoo zietmen hier wat gros of generael een recht natuerlijke Schildery behoorde te hebben."

CHAPTER I. *Saint Praxedis*

1. Ficherelli was born in San Gimignano in 1605. As a young boy he went to Florence where he began his training in the studio of Jacopo Chimenti, called Jacopo da Empoli (1554–1640). For a time he lived in the palace of Alberto de' Bardi, who worked closely with Cardinal Carlo de' Medici, another influential patron of the arts. The artist received many commissions for the churches of Florence and the surrounding area, including Sant'Egidio and the Certosa. Despite his quiet, modest nature, which earned him the nickname "il Riposo," his favorite subjects were scenes of dramatic action, even violence, in particular martyrdoms and famous murders of the past. He died c. 1669 in Florence and was buried in the church of Santa Maria sopr'Arno.

2. Gregor J. M. Weber, "Antoine Dézallier d'Argenville und fünf Künstler namens Jan van der Meer," *Oud Holland* 107 (1993): 300–301, has argued that the painting by Ficherelli never left Italy and that the artist who copied it was not Johannes Vermeer of Delft, but Johan van der Meer from Utrecht (c. 1630–1688), who is known to have been in Rome in the mid-1650s, and who reportedly painted in the manner of Guido Reni. Though Weber has an admittedly intriguing thesis, the stylistic and thematic connections of *Saint Praxedis* to the paintings of Vermeer of Delft are far more compelling

than to the few surviving paintings by Van der Meer from Utrecht.

3. John Michael Montias, *Vermeer and His Milieu: A Web of Social History* (Princeton: Princeton University Press, 1989), 141, for example, mentions that a copy of an *Interment* by Titian made by Cornelis van Poelenburgh was in the 1657 inventory of the Amsterdam art dealer Johannes de Renialme. Renialme, who owned a number of Italian paintings, also had in his possession a now-lost painting by Vermeer, entitled *Visit to the Tomb*.

4. John Michael Montias, *Artists and Artisans in Delft* (Princeton: Princeton University Press, 1982), 247–250. For further discussion of Italian paintings in the Netherlands, see F. Lugt, "Italiaansche Kunstwerken in Nederlandsche verzamelingen van vroeger tijden," *Oud Holland* 53 (1936): 97–135.

5. Montias, *Artists and Artisans,* 250, note hh.

6. Montias, *Vermeer and His Milieu,* doc. 341. Vermeer and the other expert, the Delft painter Joannes Jordaens, concluded that the paintings in question were "not outstanding Italian paintings, but, on the contrary, great pieces of rubbish and bad paintings."

7. I would like to thank H. Defoer for sharing with me information about the history of the Catholic Church in the Netherlands in the sixteenth and seventeenth centuries.

8. The painting was first publicly viewed in 1969 when it was exhibited at the Metropolitan Museum of Art as a work by Felice Ficherelli in the exhibition *Florentine Baroque Art from American Collections,* no. 39. Vermeer's signature in the lower left was

noted in the catalogue after the painting had been examined by Ted Rousseau and members of the conservation department at the Metropolitan Museum of Art (information courtesy of Spencer Samuels). The painting was owned from 1943 to 1969 by Mr. and Mrs. Jacob Reder of New York City. Its earlier provenance is not known. The painting was first attributed to Vermeer by Michael Kitson in his review of the exhibition in *Burlington Magazine* 111 (1969): 410. Albert Blankert, with contributions by Rob Ruurs and Willem L. van de Watering, *Johannes Vermeer van Delft 1632–1675* (Utrecht and Antwerp: Het Spectrum, 1975), revised and translated into English as *Vermeer of Delft: Complete Edition of the Paintings* (Oxford: Phaidon, 1978), 75 n13, rejected Kitson's attribution, calling the painting "no more than a copy after the Florentine painter Felice Ficherelli." Christopher Wright, *Vermeer* (London: Oresko Books, 1976), 8, 9, fig. 3, included the painting in the introduction to his book, although not in the catalogue, as attributed to Vermeer. The first extensive defense of the attribution was Arthur K. Wheelock, Jr., "*St. Praxedis*: New Light on the Early Career of Vermeer," *artibus et historiae* 14 (1986): 71–89. Vermeer's *Saint Praxedis* and Ficherelli's *Saint Praxedis* were subsequently the subject of a focus exhibition, *Jan Vermeer van Delft: St. Praxedis,* Wawel Royal Castle, Cracow, Poland, 1991 (catalogue edited by Jozef Grabski). The present text is derived in large part from my contributions in these two latter publications.

9. This suggestion was made by Egbert Haverkamp-Begemann.

10. Hermann Kühn, "A Study of the Pigments and the Grounds Used by Jan

Vermeer," *National Gallery of Art: Reports and Studies in the History of Art* 2 (Washington, 1968), which was published before the rediscovery of *Saint Praxedis.*

11. I would like to express my gratitude to John Michael Montias for this observation.

CHAPTER II. *Diana and Her Companions*

1. Wolfgang Stechow, "The Myth of Philemon and Baucis in Art," *Journal of the Warburg and Courtauld Institutes* 4 (1940–1941): 110–113, for example, has shown that the Ovidian story of Philemon and Baucis was seen to parallel the Christian story of "the sudden revelation of gods (or God) to mankind." This Christian interpretation of the story is particularly evident in Rembrandt's 1658 painting of *Philemon and Baucis* in the National Gallery of Art, Washington, D.C. (inv. no. 1942.9.65).

2. It also appears that Vermeer must have blocked in some type of form in the area presently occupied by the thistle, but its character cannot be determined. A preliminary shape, perhaps a large tree trunk, can also be detected on the left just above the rock. Unfortunately, examination of the painting with infrared reflectography did not provide any information about the underdrawing or underpainting, perhaps because the ground layer was an off-white.

3. Because of its Rembrandtesque character, *Diana and Her Companions* was thought to be by Nicolaes Maes (who had studied with Rembrandt in the late 1640s and early 1650s) when the painting was acquired by the Mauritshuis in the nineteenth century.

4. A curious similarity in the two paintings is the identical position of the dog seated in the lower left.

CHAPTER III. *A Woman Asleep*

1. See, in particular, John Walsh, Jr., "Vermeer," and Hubert von Sonnenburg, "Technical Comments," *Metropolitan Museum of Art Bulletin* 31, no. 4 (1973); Maryan Wynn Ainsworth et al., *Art and Autoradiography: Insights into the Genesis of Paintings by Rembrandt, Van Dyck, and Vermeer* (New York: Metropolitan Museum of Art, 1982), 18–26.

2. These changes have been carefully analyzed by Ainsworth, *Art and Autoradiography,* 18–26.

3. Reproduced in Ainsworth, *Art and Autoradiography,* 18–26.

4. The painting has been variously interpreted in the literature. Seymour Slive, "'Een dronke slapende meyd aen een tafel' by Jan Vermeer," in *Festschrift Ulrich Middeldorf,* ed. Antje Kosegarten and Peter Tigler (Berlin: 1968), 452–459, has argued that the title given the painting in the Dissius sale in Amsterdam in 1696 ("A drunk sleeping maid at a table") was essentially correct and that the woman is inebriated. In the most extensive article on this painting, Madlyn Millner Kahr, "Vermeer's Girl Asleep: A Moral Emblem," *Metropolitan Museum Journal* 6 (1972): 115–132, associates the woman's pose with the allegorical figure of Accidia (Sloth) from Cesare Ripa, *Iconologia* (Amsterdam: D. P. Pers, 1644), 518. She stresses the moral component of the painting and postulates its message to be: "Let us be alert to avoid the snares of sensual pleasures. All worldly satisfactions are but vanity. The freedom of our will makes each of us responsible for renouncing the earthly in favor of divine truth" (p. 131).

5. For a discussion of aspects of melancholia in seventeenth-century thought and art, see H. Perry Chapman, *Rembrandt's Self-Portraits: A Study in Seventeenth-Century Identity* (Princeton: Princeton University Press, 1990), 414–415. For "woman's melancholy," see Robert Burton, *The Anatomy of Melancholy,* ed. Holbrook Jackson (London: J. M. Dent, 1932), 26–33.

6. Otto van Veen, *Amorum Emblemata* (Antwerp: Henrici Swingenij, 1608), 55: "Love Requyres Sinceritie."

7. Good evidence of the complexity of paint layers in this section of the painting is found in Hermann Kühn, "A Study of the Pigments and the Grounds Used by Jan Vermeer," *National Gallery of Art: Reports and Studies in the History of Art* 2 (Washington, 1968), 181. Kühn identified six separate paint layers above the ground in the red of the tablecloth near the lower edge of the painting.

8. Brown, *Carel Fabritius,* doc. 28, dated 10 April 1660, mentions a wall painting Fabritius executed for a brewery in Delft. Samuel van Hoogstraten, *Inleyding tot de Hooge Schoole der Schilderkonst: Anders de Zichtbaere Werelt* (Rotterdam: Frans van Hoogstraeten, 1678), 274, praised Fabritius' illusionistic wall paintings in Delft that he made for, among others, "the art-loving late *Dr Valentius.*"

9. Both the manner in which this painting was created and its function have been a matter of some dispute. See: Arthur K. Wheelock, Jr., "Carel Fabritius: Perspective and Optics in Delft," *Nederlands Kunsthistorisch Jaarboek* 24 (1973): 63–83; Walter Liedtke, "The 'View in Delft' by Carel Fabritius," *Burlington Magazine* 118

(1976): 61–73; Arthur K. Wheelock, Jr., *Perspective, Optics, and Delft Artists Around 1650* (New York: Garland Press, 1977), 4–11.

CHAPTER IV. *The Little Street*

1. P. T. A. Swillens, *Johannes Vermeer: Painter of Delft, 1632–1675* (Utrecht and Brussels: Spectrum, 1950), 93–96, proposed that Vermeer painted the old men's and women's almshouses directly behind his house across from the Voldersgracht. Albert Blankert, with contributions by Rob Ruurs and Willem L. van de Watering, *Johannes Vermeer van Delft 1632–1675* (Utrecht and Antwerp: Het Spectrum, 1975), revised and translated into English as *Vermeer of Delft: Complete Edition of the Paintings* (Oxford: Phaidon, 1978), 38, accepted Swillens' proposal, stating that the painting is "probably an absolutely exact transcription of a view from the rear window of Vermeer's house." Blankert further proposed that this painting should date 1661, arguing that Vermeer decided to represent this view to record the house and gateyard on the right before they were demolished to allow for the construction of a building for the Saint Luke's Guild. This theory, though appealing in many respects, is not convincing. The guild, by order of the burgemeesters on 13 October 1661, was to be situated in the renovated Saint Christoffel, or old men's house chapel. For a history of the guild see: F. ten Hengel, "Waag, Vleeshal en Lucasgildehuis," in *De Stad Delft: cultuur en maatschappij van 1572 tot 1667* (Delft: 1981), 1, 57. No mention is made of razing any dwellings. Braun and Hogenberg's 1581 map of Delft identifies the old men's chapel, and it is clear that no houses exist between it and the Voldersgracht. Other objections to this theory exist, namely that no old men are to be

seen in the painting, only women and children. Stylistically, the painting is quite unlike Vermeer's works that can be placed in the early 1660s. For further objections to Swillens' theory see A. J. J. M. van Peer, "Rondom Jan Vermeer van Delft," *Oud Holland* 74 (1959): 243–244.

2. The possibility also exists that Vermeer created his composition by combining two buildings from different locations. It is well known that Pieter de Hooch imaginatively combined real elements to form his courtyard scenes. Vermeer could have adapted the same approach in *The Little Street*. For a discussion of Delft sixteenth-century dwellings, see W. F. Weve, "Woonhuizen," in *De Stad Delft: cultuur en maatschappij tot 1572* (Delft: Stedelijk Museum het Prinsenhof, 1979) 1, 74–80.

3. Hermann Kühn, "A Study of the Pigments and the Grounds Used by Jan Vermeer," *National Gallery of Art: Reports and Studies in the History of Art* 2 (Washington, 1968), 184, identified the reddish brown paint on the building as consisting of red ocher and madder lake.

4. For an illustration, see Peter C. Sutton, *Dutch & Flemish Seventeenth-Century Paintings: The Harold Samuel Collection* (Cambridge: Cambridge University Press, 1992), 121, fig. 1.

5. For a discussion of the importance of the threshold within the realm of Dutch genre painting, see Susan Donahue Kuretsky, *The Paintings of Jacob Ochtervelt (1634–1682)* (Oxford: Phaidon, 1979), 34–39.

CHAPTER V. *Officer and Laughing Girl*

1. Hermann Kühn, "A Study of the Pigments and the Grounds Used by Jan

Vermeer," *National Gallery of Art: Reports and Studies in the History of Art* 2 (Washington, 1968), 183, identified the blue paint on the map as natural ultramarine mixed with lead white.

2. The only extant example of this map can be found in the Westfries Museum, Hoorn. For a discussion of the maps in Vermeer's paintings, see James A. Welu, "Vermeer: His Cartographic Sources," *Art Bulletin* 57 (1975): 529–547.

3. See Arthur K. Wheelock, Jr., *Perspective, Optics, and Delft Artists Around 1650* (New York: Garland Press, 1977), 290, for a discussion of this possibility.

4. James A. Welu, *Vermeer and Cartography*, Ph.D. diss. Boston University, 1977 (Ann Arbor: University Microfilms International, 1981), 107, found the association between the girl and the map to have negative implications. He suggested that the young woman may "belong to the demimonde. . . . If this young woman is, as it seems, a personification of worldly vice—in effect a contemporary Vrouw Wereld—the large map behind her, displayed so that it appears to rest on her head, must have been intended as the woman's main attribute."

5. Bärbel Hedinger, *Karten in Bildern: Zur Ikonographie der Wandkarte in holländischen Interieurgemälden des 17. Jahrhunderts* (Hildesheim: Georg Olms Ag, 1986), 79–84. The Dutch text reads, in part: "De Hollanders zijn door de bant groot, langh, wel gemaeckt, vast op haer leden, beleeft, geschicht, ende borgerlijck van seden, in allerhande konsten en hantwercken seer kloeck; . . . Dit getuygen soo veel hooghgeleerde mannen, konstige schilders, glaesschrijvers, ende plaet-snijders uyt Hollandt voort-gekomen: maer voornemelijck het

voorsichtigh ende van Godt gesegent beleydt, waer mede zy tot allen tijden hare vaderlandtsche vryheydt zoo mannelijck hebben voorgestaen. . . . De Hollandtsche vrouwen zijn van nature schoon, eerbaer, kloeck in 't huyshouden" (p. 185).

6. See H. Perry Chapman, "Propagandist Prints, Reaffirming Paintings: Art and Community During the Twelve Years Truce," in *The Public and Private in Dutch Culture of the Golden Age,* ed. Arthur K. Wheelock, Jr., and Adele Seeff (Newark: University of Delaware Press, forthcoming).

CHAPTER VI. *The Milkmaid*

1. Albert Blankert, with contributions by Rob Ruurs and Willem L. van de Watering, *Johannes Vermeer van Delft 1632–1675* (Utrecht and Antwerp: Het Spectrum, 1975), revised and translated into English as *Vermeer of Delft: Complete Edition of the Paintings* (Oxford: Phaidon, 1978), cat. 7, 157.

2. The term was first used in a sale in Amsterdam, held on April 20, 1701, no. 7: "Een Melkuytgietstertje . . . krachtig gegeschildert." For a full listing of the various sales and sales catalogue descriptions in which this painting appeared, see Blankert, *Vermeer of Delft,* cat. 7, 157–158.

3. See Ilja M. Veldman, "Images of Labor and Diligence in sixteenth-century Netherlandish prints: The work ethic rooted in civic morality or Protestantism?" *Simiolus* 21 (1992): 227–264.

4. For a thorough discussion of this work see the entry by William Robinson in Peter Sutton, *Masters of Seventeenth-Century Dutch Genre Painting,* exh. (Philadelphia: Philadelphia Museum of Art, 1984), 240, cat. 65.

5. Rembrandt's *Flora,* signed and dated 1634, is in the Hermitage, St. Petersburg, inv. no. 732. Hendrick ter Brugghen's *Sleeping Mars,* signed and dated 1629, is in the Centraal Museum, Utrecht, cat. no. 52.

6. The Doric design of the fireplace, as has been noted by Keith P. F. Moxey, *Pieter Aertsen, Joachim Beuckelaer, and the Rise of Secular Painting in the Context of the Reformation* (New York and London: 1977), 52, note 2, is borrowed from Sebastiano Serlio, *Reglen van Metselrijen* (Antwerp: 1549), folio XXXIIIr.

7. As has been seen in the discussion of *Woman in Blue Reading a Letter,* Vermeer used a more diffused contour line for similar purposes in his works from the mid-1660s.

8. Occasionally the glaze flows over the denser paint and its highlights.

9. Roemer Visscher, *Sinnepoppen* (Amsterdam: Willem Iansz., 1616), 178, emblem LVI.

10. The subject of the next-to-last tile on the right cannot be identified with certainty.

11. I would like to thank Ella Schaap for discussing this matter with me.

CHAPTER VII. *View of Delft*

1. This text is drawn from two previously published articles: Arthur K. Wheelock, Jr., and C. J. Kaldenbach, "Vermeer's *View of Delft* and his Vision of Reality," *artibus et historiae* 6 (1982): 9–35; and Arthur K. Wheelock, Jr., "History, Politics, and the Portrait of a City: Vermeer's *View of Delft,*" in *Urban Life in the Renaissance,* ed. Susan Zimmerman and Ronald F. E. Weissman (Newark: University of Delaware Press, 1989), 165–184. The examination of *View of Delft* could not have been made without the generous cooperation of the former director of the Mauritshuis, H. R. Hoetink. Arrangements to examine the painting were also facilitated by the kind assistance of F. J. Duparc, the current director.

2. Vermeer included about 15 figures in his painting. The costumes of the six figures in the foreground designate their social standing, from the fashionable attire of the three burghers standing by the boat, to the simpler regional or peasant garment of black skirts and jackets with white collars and shoulder cloths of the other women. A figure of a man just to the right of the two women was painted out by Vermeer. Information on the costumes has been kindly supplied by M. de Jong of the Costume Museum in The Hague.

3. W. Thoré-Bürger, "Van der Meer de Delft," *Gazette des Beaux-Arts* 21 (1866): 297–330, 458–470, 543–575. 298.

4. John Michael Montias, *Vermeer and His Milieu: A Web of Social History* (Princeton: Princeton University Press, 1989), 363–364, doc. 439.

5. S. J. Stinstra sale, Amsterdam, 27 May 1822, no. 112. The translation is taken from Albert Blankert, with contributions by Rob Ruurs and Willem L. van de Watering, *Johannes Vermeer van Delft 1632–1675* (Utrecht and Antwerp: Het Spectrum, 1975), revised and translated into English as *Vermeer of Delft: Complete Edition of the Paintings* (Oxford: Phaidon, 1978), 159.

6. See, for example, Blankert, *Vermeer of Delft,* 40.

7. The most careful analysis of the site is that found in Wheelock and Kaldenbach, "Vermeer's *View of Delft.*"

8. For a reconstruction of the Kethelstraat façades' appearance see Wheelock and Kaldenbach, "Vermeer's *View of Delft*," 15–16, note 8, fig. 5.

9. The extent to which they project can clearly be seen in two drawings by Josua de Grave in which the gate is seen from a location to the far right of Vermeer's painting. See Wheelock and Kaldenbach, "Vermeer's *View of Delft*," 19, figs. 11, 11a.

10. The examination of *View of Delft* with infrared reflectography was kindly undertaken by J. R. J. van Asperen de Boer in collaboration with the author.

11. One may compare, for example, the bridge in Vermeer's painting to a 1695 drawing by Josua de Grave showing the bridge from the inside of the city. See Wheelock and Kaldenbach, "Vermeer's *View of Delft*," 24, fig. 16, and note 11.

12. Some artists, however, wanted to show more buildings within their frames and compressed the scene. All topographical views of this scene vary slightly, however, and no single view can be relied upon as accurate.

13. Although the spire burned down in 1872 and was replaced with a somewhat taller neogothic one, the size of the base remained the same and accurate calculations based on contemporary photographs of the site can be made. Compared to the total width of *View of Delft* (1175 mm.) the tower (61–62 mm.) occupies about one-nineteenth of the width. Compared to present-day photographs taken from near Vermeer's point of view, Vermeer's tower is two times too wide. These calculations have been made by Kaldenbach on the basis of a photograph he took in 1981 with a 40-mm wide-angle (diagonal angle 57) lens from the third floor

of the building at Hooikade 29. See Wheelock and Kaldenbach, "Vermeer's *View of Delft*," 31, fig. 22.

14. For scientific measurements undertaken by W. F. Weve of the Delft Polytechnic, see Wheelock and Kaldenbach, "Vermeer's *View of Delft*," 19, note 13, 32, fig. 23.

15. Although *The Little Street* depicts an exterior setting, it is a far more intimate work than this large and imposing painting.

16. Blankert, *Vermeer of Delft*, 153, document no. 62: "De Stad Delft in perspectief, te sien van de Zuyd-zy, door J. vander Meer van Delft."

17. The transaction is discussed in John Michael Montias, *Artists and Artisans in Delft* (Princeton: Princeton University Press, 1982), 185–188.

18. Montias, *Artists and Artisans*, 861–863.

CHAPTER VIII. *The Music Lesson*

1. For a summary listing of comparable instruments by Andreas Ruckers the Elder see Christopher White, *The Dutch Pictures in the Collection of Her Majesty the Queen* (Cambridge: Cambridge University Press, 1982), 144. A harpsichord by Ruckers, dated 1640, in the Yale University Collection of Musical Instruments, bears the same inscription and hand-printed paper with the sea horse design. For further information on the Ruckers family, including an inventory of instruments, see *Grove's Dictionary of Music and Musicians*, 5th ed., ed. Eric Bloom (New York: St. Martin's Press, 1955), 279–324.

2. A number of such instruments, including harpsichords and clavichords, are found in Dutch paintings from this period. For an overview of such paintings, see Lucas van

Dijck and Ton Koopman, *Het Klavecimbel in de Nederlandse Kunst tot 1800: The Harpsichord in Dutch Art before 1800* (Amsterdam: De Walburg Pers, 1987).

3. Otto van Veen, *Amorum Emblemata* (Antwerp: Henrici Swingenij, 1608), 2. The emblem is entitled: "Only one." A line in the explanatory text reads, "a louer ought to loue but only one." The same figure of Cupid reappears in Vermeer's *A Lady Standing at a Virginal* from the early 1670s (see fig. A33).

4. Jacob Cats, *Proteus ofte, Sinne en Minnebeelden verandert in sinne-beelden* (Rotterdam: Pieter van Waesberge, 1627), 85, emblem 42.

5. P. C. Hooft, *Emblemata Amatoria* (Amsterdam: Willem Ianszoon, 1611), 32–33, emblem 9. The Dutch verse is as follows: "Mijn Vrouwe blinckt / en set haer claerheyt and're by; / 'Tis weerschijn van haer glans / licht'er yet goedts in my." The French translation for the emblem title is "Amovr n'a rien a soy" and the French verse reads "Amour est au miroir tout esgal ce me semble, / Il prend d'ailleurs lueur & la redonne ensemble."

6. A. Pigler, "Valerius Maximus és az újkori Képzomuvészetek (Valère Maxime et l'iconographie des temps modernes)," *Hommages à Alexis Petrovics* (Budapest: 1934), 87–108, has identified the story as coming from Valerius Maximus, *Factorum et Dictorum Memorabilium,* book 9, chapter 4. The story, which appears in a section entitled "De pietate in parentes," describes how Pero visits her aged father Cimon in jail and nourishes him by giving him her breast after he had been denied food. This painting was almost certainly among those inherited by Maria Thins, and thus was

hanging in Vermeer's household. See John Michael Montias, *Vermeer and His Milieu: A Web of Social History* (Princeton: Princeton University Press, 1989), 122.

7. Benedict Nicolson, *Vermeer: "Lady at the Virginals" in the Royal Collection* (London: 1946), 6, on the other hand, found no significance to the jug. "And the earthen ware jug must waste its sweetness on the bulky table, an exquisite side-show that serves no purpose."

8. Onno Ydema, *Carpets and their Datings in Netherlandish Paintings* (Woodbridge, Suffolk: Antique Collectors' Club, 1991), 44, identified the carpet type as a "Medallion Ushak." She noted that this "group is characterized by an apparently coarse weaving structure" and that Vermeer meticulously copied the design, "even the individual knots of the pile."

9. Although no cross sections have been taken in this area of the painting to confirm the layering, microscopic examination indicates that Vermeer created the marked texture of the yellow by first applying a series of thick dabs of lead-tin yellow paint. For analyses of the cross sections that have been taken, see Hermann Kühn, "A Study of the Pigments and the Grounds Used by Jan Vermeer," *National Gallery of Art: Reports and Studies in the History of Art* 2 (Washington, 1968), 190–191.

10. This shift is evident in the reflectogram where one can see the extension of her hairband to the left of her head and the original position of the black vertical stripe of her jacket to the right of its present location.

CHAPTER IX. *Woman Holding a Balance*

1. The parcel-gilt frame was revealed when later black overpainting covering the frame was removed during the painting's restoration in 1994. The artist of the *Last Judgment* has remained an enigma. No exact prototype for this composition of the Last Judgment is known. It appears, however, to be the work of a late sixteenth-century Flemish painter. One distinct possibility, kindly suggested by Pieter J. J. van Thiel, is Jacob de Backer (Antwerp 1540–1595), a student of Frans Floris and an artist who specialized in similar Last Judgment scenes. One peculiar characteristic of this composition that is often found in De Backer's works is the image of Christ with both of his arms raised. Vermeer probably owned this painting of the Last Judgment, or at least had it as part of his stock as an art dealer. In the instances where we know the actual painting Vermeer owned, as for example Dirck van Baburen's *Procuress,* now in the Museum of Fine Arts, Boston, a painting that appears in *The Concert* in the Isabella Stewart Gardner Museum, Boston, and *A Lady Seated at a Virginal* in the National Gallery, London, his depictions remain rather faithful to the actual painting, modifying only the color schemes and the scale of the painting to satisfy his compositional needs. He probably made similar adjustments in the scene of the *Last Judgment.* For documents relating to the Baburen painting see A. J. J. M. van Peer, "Jan Vermeer van Delft: drie archiefvondsten," *Oud Holland* 88 (1968): 220–224. For other instances of Dutch artists altering the dimensions of paintings within paintings see Wolfgang Stechow, "Landscape Painting in Dutch Seventeenth-Century Interiors," *Nederlands Kunsthistorisch Jaarboek* 11 (1960): 165–184.

2. A review of the diverse interpretations of this painting in the literature appears in Arthur K. Wheelock, Jr., *Dutch Paintings of the Seventeenth Century* (Washington, D.C., and New York: National Gallery of Art and Cambridge University Press, 1995).

3. Herbert Rudolph, "*Vanitas* Die Bedeutung mittelalterlicher und humanistischer Bildinhalte in der niederländischen Malerei des 17. Jahrhunderts," in *Festschrift Wilhelm Pinder zum sechzigsten Geburtstage,* (Leipzig: A. E. Seemann, 1938), 409. Because Christian iconography treats the pearl, the most precious jewel, as a symbol of salvation, it would be unusual for it to have strong vanitas connotations. See George Ferguson, *Signs and Symbols in Christian Art* (New York: Oxford University Press, 1959), 23.

4. Cesare Ripa, *Iconologia* (Amsterdam: D. P. Pers, 1644), 144, 432. Ripa describes how the balance is one of the attributes of equality, "Vgualita" or "Gelijckheyt" ("Door de Weeghschaele wort verstaen de opruchte en waerachtige rechtvaerdigheyt, die een ygelijck geeft, dat hem toebehoort"), and of justice, "Giustitia" or "Gerechtigheyt."

5. The mirror is frequently considered the attribute of "Prudentia" and truth. For a discussion of the various connotations of the mirror in emblematic literature of the mid-seventeenth century, see Hans R. Hoetink, *Gerard Ter Borch,* exh. (The Hague: Mauritshuis, 1974), 98.

6. Otto van Veen, *Amorvm Emblemata* (Antwerp: Venalia apud Auctorum, 1608), 182. The full verse is as follows: "*Fortune is loues looking-glass/* Eu'n as a perfect glasse doth represent the face, / Iust as it is in deed, not flattring it at all. / So fortune telleth by aduancement or by fall, / Th'euent that shall

succeed, in loues luick-tryed case." For further discussions of Vermeer's use of *Amorvm Emblemata* see Eddy de Jongh, *Zinne- en Minnebeelden in de schilderkunst van de zeventiende eeuw* (Amsterdam: 1967), 49f.

7. Eugene R. Cunnar, "The Viewer's Share: Three Sectarian Readings of Vermeer's *Woman with a Balance,*" *Exemplaria* 2 (1990): 501–536. Although Cunnar overinterprets the painting in many respects, he presents a fascinating range of theological issues current in the seventeenth century.

8. *The Spiritual Exercises of St. Ignatius,* trans. Anthony Mottola (Garden City, N.J.: Image Books, 1964), 85.

9. Kimberly Jones, "Vermeer's *Woman Holding a Balance*: A Secularized Vision of the Virgin Mary," lecture delivered at the Mid-Atlantic Symposium, National Gallery of Art, Washington, D.C., 1989; Cunnar, "The Viewer's Share."

10. The theory that the woman is pregnant was first exposed by Richard Carstensen and Marielene Putscher, "Ein Bild von Vermeer in medizinhistorischen Sicht," *Deutsches Ärzteblatt-Ärztliche Mitteilungen* 68 (1971): 1–6. The authors concluded that the woman, following an old folk tradition, was weighing pearls to help her divine the sex of the unborn child. Since then, many authors have accepted as fact her pregnant state of being, including John Walsh, "Vermeer," *Metropolitan Museum of Art Bulletin* 31 (Summer 1973): 79, and Ernst Günther Grimme, *Jan Vermeer van Delft* (Cologne: 1974), 54, who, as a consequence of the supposed pregnancy, attempted to identify the model as Vermeer's wife, Catharina Bolnes, mother of his 14 children (11 of whom survived infancy). Nanette Salomon, "Vermeer and the Balance of Destiny," in *Essays in*

Northern European Art Presented to Egbert Haverkamp Begemann on His Sixtieth Birthday, ed. Anne-Marie Logan (Doornspijk: 1983), 216–221, suggested that a pregnant woman holding scales would have been interpreted as a Catholic response to the religious controversy about the moment a Christian soul obtains grace and salvation. Instead of the predetermined state of grace accepted by the followers of Arminius or the efficacy of good works preached by Gomanus, Salomon argued, a Catholic would have understood that the state of grace of the unborn child was as yet undetermined. This opinion was also accepted by Peter Sutton in *Masters of Seventeenth-Century Dutch Genre Painting,* exh. (Philadelphia: Philadelphia Museum of Art, 1984), 342–343.

11. Cunnar, "The Viewer's Share," corrects a number of misconceptions about the theological arguments advanced by Salomon, and focuses rather on the meditative character of the image. He then analyzes the ways in which a Catholic, a Protestant, and an Arminian viewer might have responded to this work in light of their beliefs. He also accepts as fact that the woman is pregnant and attempts to relate the image to biblical texts, specifically Genesis 3:15, by interpreting the support underneath the table as the vision of a dragon described in Revelation 12. Though one may question the likelihood of this latter interpretation, Cunnar's assessment of the various possible theological responses to the painting is useful.

12. For an argument that Vermeer represented here "the divine truth of revealed religion," see Ivan Gaskill, "Vermeer, Judgment and Truth," *Burlington Magazine* 126 (1984): 558–561. To support his argument Gaskill refers to one of the personifications of Truth

described by Ripa in the Dutch edition of the *Iconologia* (see note 4).

13. It is difficult to determine whether the woman is pregnant. As seen in numerous paintings by Vermeer's contemporaries, Dutch fashions in the mid-seventeenth century seem to have encouraged a bulky silhouette. The short jacket the girl wears, called a *pet en lair,* covered a bodice and a thickly padded skirt. The impression created, that of a forward thrusting stomach, was evidently sought as a desirably fashionable effect. Albert Blankert argues that she is not pregnant; see Gilles Aillaud, Albert Blankert, and John Michael Montias, *Vermeer* (Paris: Hazan, 1986), 181.

14. Staatliche Museum, Berlin-Dahlem, no. 1401B, oil on canvas, 61 × 53 cm. See *Picture Gallery* (Berlin, 1978), 212. The comparison of this painting with Vermeer's *Woman Holding a Balance* is not new. For comparisons with slightly different emphases see Wilhelm von Bode, *Die Meister der holländischen und vlämischen Malerschulen* (Leipzig: E. A. Seeman, 1919), 86–89, and Rudolph, "Vanitas," 405–412.

15. A possible source for such a motif is Gerard Dou (1613–1675). Although Dou's painting style is far more minute than Vermeer's, many of the genre scenes painted by Vermeer have precedents in Dou's oeuvre. See Keil Boström, "Peep-show or Case," *Kunsthistorische medelingen van het Rijks-Bureau voor kunsthistorische documentatie* 4 (1949): 21–24.

16. De Hooch's woman weighs her gold before a wall richly decorated with a gilded leather wallcovering and a half-open door leading into a second room. Neither of these elements reinforces the basic thematic gesture of a woman with a balance as

strongly as does the painting of the *Last Judgment*. Given the penchant among contemporary Dutch artists for moralizing themes, one would suspect that De Hooch was suggesting the vanitas of being concerned with material possessions. No explicit evidence of moralizing, however, exists in the painting. Thematically as well as structurally his work lacks the inner coherence of Vermeer's painting. Finally, the serenity of Vermeer's woman as she stands contemplating her scales establishes a mood that shields her from the limitations of moment and event. Vermeer transcends the genre orientation of the scene; De Hooch, who emphasizes the woman's actions instead of her thoughts, does not.

17. Vermeer's use of a brown or reddish tone under his blues seems to be a characteristic technique. A similar selected ground, or imprimatura layer exist in *Girl with the Red Hat* (see fig. 84). Microscopic examination also indicates that he used a reddish tone under the blue tablecloth in *Girl Interrupted at Her Music* (see fig. A13), and under the basin and parts of the blue dress of *Woman with a Water-Jug* (see fig. 75).

18. No original paint existed under the overpaint, as had been previously believed.

19. The same pattern may exist in other paintings, however, x-radiographs do not always include the edges of paintings, so a proper determination of the extent to which the edges of Vermeer's paintings have been altered cannot yet be made.

20. Albert Blankert, with contributions by Rob Ruurs and Willem L. van de Watering, *Johannes Vermeer van Delft 1632–1675* (Utrecht and Antwerp: Het Spectrum, 1975), revised and translated into English as *Vermeer of Delft: Complete Edition of the*

Paintings (Oxford: Phaidon, 1978), 153, doc. 62. "Een Juffrouw die goud weegt, in een kasje van J. van der Meer van Delft, extraordinaer konstig en kragtig geschildert." It sold for 155 florins, the third highest price in the sale.

21. Nothing more is known of the box in which it sat, but at the very least the box was a protective device designed to keep light and dust away from its delicate surface. Whether the composition was conceived to be seen within the box and whether the box was itself painted are questions that cannot be answered. In the inventory of Jacob Dissius' collection of 1683, three of Vermeer's paintings are listed as being in boxes (*kasies*). See John Michael Montias, *Vermeer and His Milieu: A Web of Social History* (Princeton: Princeton University Press, 1989), 359, doc. 417. Presumably one of these was *Woman Holding a Balance*.

CHAPTER X. *Woman with a Water Pitcher*

1. Why these reserved areas have remained visible in the reflectogram where they are overlapped by the dark window frame is uncertain, unless Vermeer preserved these reserved areas when he blocked in the window frame. The brownish tone he used for the final color of the window frame remained transparent in infrared light.

2. In an earlier publication, Arthur K. Wheelock, Jr., "Pentimenti in Vermeer's Paintings: Changes in Style and Meaning," *Holländische Genremalerei im 17. Jahrhundert: Symposium Berlin 1984, Jahrbuch Preussischer Kulturbesitz* 4 (1987): 391, I suggested that this underlying map could have been the same as that appearing in the *Art of Painting* (Claes Jansz Visscher's

Seventeen Provinces), but it seems far more likely that the change represents a shift in the position of the same map rather than a substitution of one for the other.

3. James A. Welu, "Vermeer: His Cartographic Sources," *Art Bulletin* 57 (1975): 534–535, has identified the map, a version of which, dated 1671, is located in the University Library, Leiden (Bodel Nijenhuis Collection, no. P1N69). Welu noted that Allart acquired the plates from an early seventeenth-century source and reprinted the map with added decorative elements.

4. Bärbel Hedinger, "Karten in Bildern: Zur politischen Ikonographie der Wandkarte bei Willem Buytewech und Jan Vermeer," in *Holländische Genremalerei im 17. Jahrhundert: Symposium Berlin 1984, Jahrbuch Preussischer Kulturbesitz,* 4 (1987): 159–162, finds in this shift of the map's position a political statement, which appears to me to be unsupported by the context of the painting.

5. For an illustration of Lievens' painting, which is in the Stedelijk Museum De Lakenhal, Leiden, see Werner Sumowski, *Gemälde der Rembrandt-Schüler,* 5 vols. (Landau and Pfalz: PVA 1983): 3, 1180.

CHAPTER XI. *The Concert*

1. *The Geographer* (see fig. A28) is dated 1669, but the date appears to be a later addition. Whether the date is based on a lost inscription is not known.

2. These two paintings are first recorded in a sale in Rotterdam on 27 April 1713, no. 10 and no. 11. Albert Blankert, with contributions by Rob Ruurs and Willem L. van de Watering, *Johannes Vermeer van Delft,*

1632–1675 (Utrecht and Antwerp: Het Spectrum, 1975), revised and translated into English as *Vermeer of Delft: Complete Edition of the Paintings* (Oxford: Phaidon, 1978), 166, cat. 24.

3. Metsu's *Woman with Glass and Tankard* and *Woman Peeling an Apple,* both of which are in the Louvre, are good examples of paintings representing illicit and virtuous behavior. See, for a discussion of this issue, Franklin W. Robinson, *Gabriel Metsu (1629–1667)* (New York: Abner Schram, 1974), 25, and 111, figs. 20 and 21.

4. Jan Hermansz Krul, *Minnelycke sangh-rympies* (Amsterdam: Pieter Iansz Slyp, 1634), bound in Jan Hermansz Krul, *Eerlycke tytkorting* (Amsterdam: Pieter Iansz Slyp, 1634).

5. See chapter 1, note 10.

6. This assessment of the painting's condition is based on observations made before *The Concert* was stolen from the Isabella Stewart Gardner Museum in 1990. The current condition of the painting is, thus, unknown.

CHAPTER XII. *Girl with the Red Hat*

1. Vermeer frequently shaded faces with thin brown or green glazes. Similar green glazes occur on faces as, for example, in *Girl Interrupted at Her Music* (see fig. A13) and in *The Concert* (see fig. 80).

2. The panel measures 9⅛ × 7⅛ in. (23 × 18 cm.). The attribution issues concerning *Girl with a Flute* are complex. See Arthur K. Wheelock, Jr., *Dutch Paintings of the Seventeenth Century* (Cambridge: National Gallery of Art and Cambridge University Press, 1995).

3. Hermann Kühn, "A Study of the Pigments and the Grounds Used by Jan Vermeer," *National Gallery of Art: Reports and Studies in the History of Art* 2 (Washington, 1968), 195.

4. Vermeer may have used an emulsion medium in these highlights.

5. The attribution of *Girl with the Red Hat* to Vermeer was doubted by F. van Thienen, *Jan Vermeer of Delft* (New York: Harper, 1949), 23, no. 25; and rejected by P. T. A. Swillens, *Vermeer: Painter of Delft, 1632–1675* (Utrecht and Brussels: Spectrum, 1950), 65; Albert Blankert, with contributions by Rob Ruurs and Willem L. van de Watering, *Johannes Vermeer van Delft 1632–1675* (Utrecht and Antwerp: Het Spectrum, 1975), 167; Albert Blankert, with contributions by Rob Ruurs and Willem L. van de Watering, *Vermeer of Delft: Complete Edition of the Paintings* (Oxford: Phaidon, 1978) 172; Yvonne Brentjens, "Twee meisjes van Vermeer in Washington," *Tableau* 7 (February 1984/1985): 54–58; and Gilles Aillaud, Albert Blankert, and John Michael Montias, *Vermeer* (Paris: Hazan, 1986), 200–201.

6. The first art historian to note this discrepancy was R. H. Wilenski, *An Introduction to Dutch Art* (New York: F. A. Stokes, 1929), 284–285. He hypothesized that the peculiar arrangement of the finials arose because Vermeer composed this work with the aid of a mirror. His reconstruction of Vermeer's painting procedure, however, is untenable. Although Wilenski did not doubt the attribution of the painting to Vermeer, the position of the finials has been a determining factor in the arguments against the attribution advanced by Blankert in his various publications (see

note 5). Blankert, *Johannes Vermeer,* 109, also emphasized this discrepancy in his arguments against the attribution of the painting to Vermeer.

7. John Michael Montias, *Vermeer and His Milieu: A Web of Social History,* (Princeton: Princeton University Press, 1989), 359, doc. 417.

8. Montias, *Vermeer and His Milieu,* 364, doc. 439.

9. Although no exact parallels exist for the soft, flat red hat in Dutch art, a similar hat is seen in Rembrandt's portrait of *Saskia,* c. 1634, in the Gemäldegalerie, Dresden (Br. 101).

10. Although only a portion of the tapestry is visible, it appears that two rather large-scale figures are depicted behind the girl. The patterned vertical strip on the right is probably the outer border. A. M. Louise E. Muler-Erkelens, keeper of textiles, Rijksmuseum, Amsterdam, (private communication), relates this format to late sixteenth-century tapestries of the southern Netherlands. She also notes that other tapestries in Vermeer's paintings belong to the same period.

11. Charles Seymour, "Dark Chamber and Light-filled Room: Vermeer and the Camera Obscura," *Art Bulletin* 46 (1964), 323–331.

12. This misconception lies at the basis of the interpretation of Vermeer's use of the camera obscura advanced by Fink, "Vermeer's Use of the Camera Obscura—A Comparative Study," *Art Bulletin* 53 (1971), 493–505.

13. As suggested by Seymour, "Dark Chamber," 323–331.

14. The painting is in the Museum voor

Stad en Lande, Groningen, panel, 38.5 × 31 cm.

15. Blankert, *Johannes Vermeer,* 130, document 40.

CHAPTER XIII. *The Art of Painting*

1. John Michael Montias, *Vermeer and His Milieu: A Web of Social History,* (Princeton: Princeton University Press, 1989), 338–339, doc. 363.

2. Cesare Ripa, *Iconologia,* (Amsterdam: D. P. Pars, 1644), 338. "Wy sullen *Clio* een Maeghdeken met een Lauwerkrans afmaelen, die in de rechter hand een Trompet houd, en mette slincker een boeck, alwaer boven op sal geschreven zijn THUCYDIDES."

3. Ripa, *Iconologia,* 452–453.

4. For a representation of this allegorical figure, see Frans van Mieris the Elder's depiction of *De Schilderkunst,* 1661, in the J. Paul Getty Museum, Malibu, California.

5. Ripa, *Iconologia,* 452. "Een goed Schilder altijt in gestadige gedancken is, om soo wel de Natuyre, als de Konst, en voor soo veele de Perspective en 't voorwerp van 't oogh belangt, to volgen: En daer toe is 't noodigh, dat hy gestaedigh de fantasien van de sichtlijcke vercken in 't hoofd hebbe."

6. Ripa, *Iconologia,* 453. "Dese proportien of evenredentheden, die het fondament of de grond van de Schilderkonst zijn, in de teyckninge moeten zijn, aleermen de handen aen de verwen leyt, want zy moeten eerst bedeckt en in een volmaeckt werck, verborgen zijn. En gelijck het een groote konst is by de Orateuren of Redenaers, haer werck alsoo te maken datter geen konst in blijcke, alsoo is 't mede by den Schilders, datse alsoo weeten te schilderen, dat haer konst niet blijcke, ten zy aen de verstandige."

7. Ripa, *Iconologia,* 453. "En dat lof, dat een kloecksinnigh Schilder van een goed gerucht verwacht, is van de Deughd voortgekomen."

8. Samuel van Hoogstraten, *Inleyding tot de Hooge Schoole der Schilderkonst: Anders de Zichtbaere Werelt* (Rotterdam: Frans van Hoogstraeten, 1678), 79. See the introduction for a fuller discussion of this issue.

9. For a theoretical interpretation of this curtain and the painting, see H. Miedema, "Johannes Vermeer's 'Schilderkunst,'" *Proef* (Amsterdam: September 1972), 67–76.

10. The costume was seen as outmoded by Charles de Tolnay, "L'Atelier de Vermeer," *Gazette des Beaux-Arts* 41 (1953): 268 and note 5; and by J. G. van Gelder, *De Schilderkunst van Jan Vermeer,* with commentary by J. A. Emmens, (Kunsthistorisch Institut: Utrecht, 1958), 14. Hermann Ulrich Asemissen, *Jan Vermeer: Die Malkunst* (Frankfurt am Main: Fischer, 1988), 38–39, however, has noted its connections to contemporary fashion.

11. That the relationship of painting to the liberal arts was of some concern at this time in Delft is evident in the decorative ensemble Delft artists created in 1661 for the newly refurbished Saint Luke's guildhouse. P. T. A. Swillens, *Vermeer: Painter of Delft, 1632–1675* (Utrecht and Brussels: Spectrum, 1950), 35–37, translates Dirck van Bleyswijck's long text on the decorations (Dirck van Bleyswijck, *Beschryvinge de Stadt Delft,* 2 vols. [Delft: Arnold Bon, 1667], 2:646 ff.), which notes that as part of that ensemble, Leonaert Bramer painted "the wooden vault consisting of eight spaces with the seven free arts, adding for the eighth space the art of painting." Vermeer was certainly familiar with Bramer's work because

on 18 October 1662 he had been chosen a headman of the guild.

12. The only extant copy of the map is in the Bibliothèque Nationale, Paris; see James A. Welu, "Vermeer: His Cartographic Sources," *Art Bulletin* 57 (1975): 536–538 and note 41, for a discussion of its history. Welu indicates that Visscher's maps were also published by his son, Nicolaus Claesz Visscher (1618–1679) after his father's death, so it is not certain just when the map depicted by Vermeer was issued. James A. Welu, "Vermeer and Cartography," Ph.D. diss., Boston University, 1977 (Ann Arbor: University Microforms International, 1981), 75ff, was the first to identify all of the city views flanking the map of the United Provinces. See also J. A. Welu, "The Map in Vermeer's 'Art of Painting,'" *Imago Mundi* 30 (1978): 9–30.

13. See, in particular, Tolnay, "L'Atelier de Vermeer."

14. Welu, "Vermeer: His Cartographic Sources," 541, note 62, calls attention to this fact. As Welu notes, in 1566, a century before Vermeer executed the *Art of Painting,* "the Dutch met at Breda to form the compromise of Breda and began the rebellion that led to the division of the Netherlands." Bärbel Hedinger, *Karten in Bildern: Zur Ikonographie der Wandkarte in holländischen Interieurgemälden des 17. Jahrhunderts* (Hildesheim: Georg Olms Ag, 1986), 115–120, expands upon Welu's comments and notes that in 1667 Breda was site of the truce with England. In that same year another important political decree was made at Breda, the "Ewige Edikt," which was designed to prevent the Stadtholder from reassuming political and military power in the Province of Holland. These ideas are accepted and expanded upon by

Asemissen, *Die Malkunst,* 25–34, 52–64. Asemissen (p. 52) also stresses that the viewer would have recognized that the text panel beneath the map would have stressed the history as well as the geography of the 17 provinces, and thus would have served a comparable role to Clio, the muse of history, who stands in front of it.

15. Bleyswijck, *Beschryvinge,* 2, 859–60.

16. For the relationship of this topos to Dutch art, see Arthur K. Wheelock, Jr., "*Trompe-l'oeil* Painting: Visual Deceptions or Natural Truths?" in *The Age of the Marvelous,* ed. Joy Kenseth, exh. (Hanover, N.H.: Hood Museum of Art, Dartmouth College, 1991), 182.

17. For an analysis of Vermeer's perspective, see: K. G. Hultén, "Zu Vermeers Atelierbild," *Konsthistorisck Tidskrift* 18 (1949): 90–98. Hultén noted that a small hole, the size of a pin, is located at the vanishing point. He suggested that Vermeer may have used a pin, in conjunction with threads, to help construct the orthogonals.

18. For a discussion of the optical characteristics of monocular and binocular vision, see M. H. Pirenne, *Optics, Painting, and Photography* (Cambridge: Cambridge University Press, 1970).

19. Hoogstraten, *Inleyding,* 263. See the introduction.

CHAPTER XIV. *Mistress and Maid*

1. Bernice Davidson in *The Frick Collection, an Illustrated Catalogue: I, Paintings* (New York: The Frick Collection, and Princeton: Princeton University Press, 1968), 296, suggests that the painting is unfinished. Albert Blankert, with contributions by Rob Ruurs and Willem L. van de Watering, *Johannes*

Vermeer van Delft 1632–1675 (Utrecht and Antwerp: Het Spectrum, 1975), revised and translated into English as *Vermeer of Delft: Complete Edition of the Paintings* (Oxford: Phaidon, 1978), 83, who cites in particular the figure of the letter writer, also states that the painting is unfinished.

2. Hermann Kühn, "A Study of the Pigments and the Grounds Used by Jan Vermeer," *National Gallery of Art: Reports and Studies in the History of Art* 2 (Washington, 1968), 198, indicated that he found this brown-black layer in all the samples he took from this painting.

3. An example is the hand of the maid.

CHAPTER XV. *The Guitar Player*

1. Arthur K. Wheelock, Jr., *Jan Vermeer* (New York: Harry N. Abrams, 1981), dates this painting c. 1672. The earlier date proposed here is based on a number of considerations: the relatively large scale of the figure in the composition, which seems related to a number of works of the late 1660s; the abstractions of form that are comparable to *The Lacemaker,* which must date c. 1669–70; and the freedom of brushwork that has more kinship to images from the late 1660s than to those that must date in the mid-1670s (see, for example, *A Lady Standing at a Virginal*).

2. Elise Goodman-Soellner, "The Landscape on the Wall in Vermeer," *Konsthistorisk tidskrift* 58 (1989): 79–83. The model for the painting on the wall has been attributed to the Delft artist Pieter Jansz. van Asch (1603–1678). See Gregor J. M. Weber, "Johannes Vermeer, PIeter Jansz. van Asch un das Problem der Abbildungstreue," *Oud Holland* 108 (1994): 98–106.

3. Aneta Georgievska-Shine has kindly brought my attention to this pastoral song tradition. See, in particular, Howard M. Brown, "The Madrigalian and the Formulaic: Andrea Gabrieli's Pastoral Madrigals," in *Studies in the History of Art: The Pastoral Landscape,* ed. John Dixon Hunt (Washington, D.C.: National Gallery of Art) 1992, 89–109.

4. I would like to thank Stephen Ackert, music specialist at the National Gallery of Art, Washington, D.C., for discussing the role of the guitar in seventeenth-century music with me.

5. Hermann Kühn, "A Study of the Pigments and the Grounds Used by Jan Vermeer," *National Gallery of Art: Reports and Studies in the History of Art* 2 (Washington, D.C., 1968), 199, identified the yellow as lead-tin yellow.

6. *The Lacemaker,* to judge from the similarly abstract forms of the figure, must date just prior to *The Guitar Player,* probably about 1669–70.

7. John Michael Montias, *Vermeer and His Milieu: A Web of Social History,* (Princeton: Princeton University Press, 1989), doc. 361, 338. This complicated contract, dated 27 January 1676, is further discussed by Montias on pages 217–218.

CHAPTER XVI. *Lady Writing a Letter with Her Maid*

1. Indeed, Vermeer not only abstracted the form of the left sleeve of the greenish-ocher dress but also its color. The illuminated portions of the sleeve are almost entirely white, whereas the shaded planes are indicated with a darker ocher paint.

2. The area of shadow that should have

existed can be postulated by dropping an imaginary line from the window frame to the intersection with the floor. Other light effects are similarly manipulated. The shadow under the chair at the right, for example, is illogical; it should not connect the two legs of the chair and it should have an irregular contour, reflecting the bottom edge of the crosspiece that has created it.

3. Jacques Foucart, "Peter Lely, Dutch History Painter," *Hoogsteder-Naumann Mercury* 8 (1989): 17–26, attributed this painting to Lely (1618–1680), who worked in the Netherlands as a history painter until he moved to England in the early 1640s. Lely, who trained in Haarlem in the entourage of Frans Pieter de Grebber, would have known De Grebber's son Pieter de Grebber, who also painted this subject in a similar fashion (signed and dated, 1634, Dresden, Staatliche Kunstsammlungen, Gemäldegalerie; illustrated in Christian Tümpel, et al., *Het Oude Testament in de Schilderkunst van de Gouden Eeuw* [Zwolle: Waanders, 1991], 56, fig. 40).

4. I would like to thank D. Dinderer and C. Rupprath, who independently brought to my attention the connection between the finding of Moses and divine providence in the 1758–60 Hertel edition of Ripa, *Iconologia*. See: Cesare Ripa, *Baroque and Rococo Pictorial Imagery*, ed. Edward A. Maser (New York: Dover, 1971), 162. Although this connection has not yet been found in a seventeenth-century reference, the association probably is an old one.

5. See E. de Jongh in *Tot Lering en Vermaak*, exh. (Amsterdam: Rijksmuseum, 1976), 268–271.

INDEX

◁≈▷